LANDFALL 240

November 2020

Editor Emma Neale
Reviews Editor Michelle Elvy

Founding Editor Charles Brasch (1909–1973)

Cover: Yonel Watene, Wizard Looking at a Door, Level 4, 2020, oil on denim, 1600 x 1000mm.

Published with the assistance of Creative New Zealand.

OTAGO UNIVERSITY PRESS

CONTENTS

EMMA NEALE

Landfall Essay Competition 2020 Judge's Report

There were eighty-five entries to this year's *Landfall* essay competition: a bumper crop, and so again it was a mixture of delight and strain trying to winnow out not only the wheat from the chaff, but the diamonds from the aquamarines. Selecting competition winners is a far less lenient process than selecting work to publish in a journal or anthology. If an otherwise striking essay needs a lot of proofreading and copy-editing, or if it suddenly loses heat in the final page, paragraph or even the closing line, a judge has to ditch it. Whereas if it was submitted to a journal or a book, the editor can choose to get into a dialogue about style, gaps, evasions, and help to nudge the work over the publication line.

This year, in the essays I had to shake off despite early fascination, I came across everything from gifted writing—where the author hadn't yet managed to confront the central nub of their own impulse to address a topic (so there was a hot core of anger and injustice smouldering but the deep psychic exploration into its origins hadn't begun)—to a wide range of worthy, urgent subjects confronted in clear and direct journalistic prose. Yet in the latter cases, often that very simplicity seems surface-skimming alongside more detailed, nuanced and in-depth exploratory writing.

I've been asked, elsewhere, whether certain themes become prevalent either in an issue of *Landfall* or in essay competition entries. This year I did anticipate more commentary on lockdown and social isolation. But one of the things about responding to current events is that it takes time for the event to be fully digested. Initially it seems the emotions of shock, confusion, distress, grief—all those heavyweight, complex, potent reactions—either destabilise or clog the writing, or alternatively are held at bay, as the writer hasn't yet diagnosed or captured the essence of the experience. This may mean that we see more quality lockdown-related non-fiction in another six months to a year—or even later. Global or national disasters also prompt an outpouring from people who don't usually write, and as a result topical work—to be

blunt— is often bad. It preaches, or harangues, or it's runny with sentimentality. It seems few writers can actually plunge their hand into the fire and come up with something finely forged right in the midst of upheaval.

As with previous competitions, there was very little distance between the essays in the winning placements and those in the highly commended and commended spots; and there was a queue behind them of work I would love to see in print, so readers can deal out their own imaginary top ten, fifteen or thirty.

First Place
A.M. McKinnon, 'Canterbury Gothic'
This essay makes a deceptively comfortable start with an affectionate character study of a favourite great-aunt, and soon becomes a lightly etched history of aspects of white settler Christchurch/Ōtautahi architecture, before it handles a bracing gear change into an exposure of the place of women and the treatment of the mentally ill in the 1940s—all while taking on the distinctive chill of a crime story. This seems to me an excellent example of a personal narrative neatly interlocked with one of wider social themes or phenomena. By the end we have a sense of how individual potential and fate can be grossly constrained by the values of the culture, time and place.

Second Place
Tan Tuck Ming, 'My Grandmother Glitches the Machine'
This quirky and thoughtful essay has a magic quality: it makes a strong initial impact but has a level of expressive and thematic complexity (it explores the metaphysical, the mysterious and intangible) that make re-reading it feel even more rewarding. It also tells a very personal narrative while managing to explore a constellation of topics along the way: technology and its machines and the way these figure in our personal relationships; the difficulty of translation across languages, countries and generations; the notion that the imperfect, the hesitation, the accidental might spark potentially fruitful, generative, creative or connective material or moments. It's one of many essays submitted that wore a cape of grief, and yet here, the essay also carries the silken inner warmth of ancestral links felt as an ongoing presence.

Third Equal
Anna Blair, 'Notes Towards a Subjective History of Honey'
A gorgeously poetic exploration of an expatriate New Zealander's upbringing, touching on a family background in beekeeping, the myths and history associated with bees and honey, memories of family and place, a tentative discussion of the body, sexuality, what we should preserve of the past, and what we should allow to wither away from memory.

Siobhan Harvey, 'Living in the Haunted House of the Past'
A strong autobiographical piece about the connection between physical and psychological shelter, the nature of home, and the challenges in constructing a clear internal space when raised in an abusive family. The piece moves to and fro in time, exploring memories triggered by the process of building renovations and conversations with the builder, and investigating the work of other poet-essayists who might help to find a way through. The author tries to sketch a kind of floorplan of identity that might both stand stable on the difficult platform of the past, and satisfyingly fill the silent space left by a year-long writer's block.

Highly Commended
Sarah Barnett's 'Unladylike' is an excellent study of the 'performance' of gender, and femininity in particular, drawing on academic texts and personal experience.

Shelley Burne-Field's 'If the words "white" and "sausage" in the same sentence make you uncomfortable, please read on' is an indictment of racism in Aotearoa from the mother of children whose heritage shows in their physical appearance to differing degrees. The language is direct, upfront, no-nonsense, and presents an informed and heartfelt wero to readers.

Anna Knox's 'Ziusudra & the Black Holes: Re-reading "The First Essay"' is another well-researched and potent essay about gender, this time about the erasure of women's presence in any number of historical accounts, and specifically focusing on the history of the essay form.

I found **Una Cruickshank**'s 'Waste', on whales, ambergris, plastic and pollution, absorbing and well controlled. Even as it teaches us, yet again, how we have failed and desecrated the natural world, it also reopens the reader to wonder at that world's interconnectivity.

Commended
Mikaela Nyman: 'Through a Glass Darkly'
Matt Vance: 'Lines of Desire'
John Horrocks: 'The Certainty of Others: Writing and climate change'
Tim Grgec: 'Drinking More Fruit Juice Won't Help'
Emily Duncan: 'Character Building'
Elese Dowden: 'Half-Gallon Quarter-Acre Pavlova Pretext'
Laura Surynt: 'Feeling Around the Room in the Dark'
Sarah Young: 'The Space to Feel'

A.M. McKINNON

Canterbury Gothic

Great Auntie Beryl lived on a hill, dabbled with a lavender rinse and rarely went to bed before three in the morning. By the time I knew her she was stooped with age and widened by fruitcake. When I think of her, I see her dressed for cold weather: worsted skirts, thick tights, flat shoes, cream blouse and wool cardigans. She wore her hair in a permanent curl and a cross around her neck. She always remembered birthdays.

Beryl was a feature, and an emblem, of our visits to Christchurch, as much as the cathedral, the gardens, the sense of comfort. We'd stay with my grandparents where Beryl might call at any hour, though her nocturnality prejudiced her in favour of late afternoons. She would appear at the door with a blue leather handbag the size and weight of a small planet, knitting needles and bibles and bits of paper sticking out in all directions. She had round, rouged cheeks, fair skin and a voice as soft as a brook. Her greetings were full of God's blessings as she dispensed kisses and face powder to all. It felt like a visitation from a retired but still conscientious cherub.

When I was coming up for ten and Great Auntie Beryl was seventy-two, she decided to marry for the first time. Her husband-to-be was a widower of similar age called Peter, who was ex-RAF. After the war he'd left England for Christchurch and a career of religious devotion. This was how he and Beryl had met.

The wedding itself, I understood from snatched snippets, was to be in the cathedral. 'Of course she's having it there,' uncles and aunts laughed, not unkindly. And I agreed. Of course Beryl would marry in the cathedral. Someone said, 'It's what she's always wanted.' This latter was my first clue, unrecognised then, that lifelong spinsterhood hadn't always been Beryl's goal.

A fairy-tale ceremony was planned, driven by a pre-Raphaelite aesthetic. Beryl wore a high-necked and long-sleeved wedding dress with plenty of smocking. My older female cousins were maids of honour, my three-year-old

sister a flower girl, and Beryl's three other great-nephews and I were pages. We wore blue corduroy knickerbockers with white hose, cream shirts with Fauntleroy collars and blue silk ribbon bowties.

During the service I sat at the front of the cathedral on the cold tiles and tried to keep my younger brother still. Across the chancel from us a beautifully dressed aunt governed my youngest cousin's mischief and my sister fell asleep across the altar steps.

<center>*</center>

I still have a copy of the service order, found years later amid Beryl's possessions. It reminds me that the final hymn was one of my favourites, 'Love Divine, All Loves Excelling'. I had it as the second hymn at my own wedding:

> Changed from glory into glory,
> Till in Heav'n we take our place,
> Till we cast our crowns before Thee,
> Lost in wonder, love, and praise.

As the final notes rose to the rafters we followed in Beryl's wake down the aisle. There were photographs first, of a vast and elderly wedding party gathered on the cathedral steps. Behind them, engraved into a limestone block inside the porch, was a small blue arrow pointing to the ground, and beneath it an inscription that read something like, 'This is the Christchurch benchmark; from this point all levels were taken.'

<center>*</center>

The earthquake-damaged cathedral that now stands in the centre of Christchurch was once the physical expression of the city's heritage as an Anglican colony and the aspirations of its English settlers.

Christchurch was the dream of the Canterbury Association, a colonising force in clerical robes that was founded on 27 March 1848 and, in quick succession, gained a Royal Charter and two and a half million acres of Māori land for ten shillings an acre.

The first organised colonists arrived in December 1850. Shortly before their departure, at a farewell service at St Paul's Cathedral, the Archbishop of Canterbury himself, John Bird Sumner (known at Eton as 'Crumpety'),

anointed them Pilgrims and bade them cross the earth and found an ideal Anglican society in the south seas, away from the corruption of mid-Victorian London. They even had their own, eponymous, hymn:

> Heaven speed you, brothers brave,
> Waft you well by wind and wave,
> Heaven shield you; Heaven save!
> Canterbury Pilgrims!

Maybe it still rang in their ears as they were outward bound from Plymouth Sound a few days later on what came to be known as the First Four Ships— the *Cressy*, the *Sir George Seymour*, the *Charlotte Jane* and the *Randolph*. The aim was to transport a cross-section of society, from sturdy labourers to landed squires. The differentiation began at the ticket office. Those who booked cabins were colonists and served by a steward; those in steerage made their own meals and were known as emigrants. The Pilgrims brought cows, an organ, and even a bell to go in the first church, where it would ring on the hour as the colony's only timepiece.

The journey took a hundred days, with prayers each morning and a church service every Sunday. At last they rounded the daunting earth fortresses that we now call Godley Heads, beyond which Lyttelton Harbour cuts deep into the land, a lapis harbour that used to be a volcano. Caldera walls form a steep and rocky barrier, and land suitable for settlement is limited. With summer starting, the Pilgrims moved over the hills via a precipitous bridle path to see their new world.

What they surveyed was the massive expanse of the Canterbury Plains stretching 60 miles to the mountains. It was known as Waitaha to its Māori residents, to whom it had been home for some 500 years. Roughly translated the name means 'river margin', and the Pilgrims would have seen those wide blue gashes tumbling from the Southern Alps, and marshland at their feet.

The Pilgrims first built huts with flax roofs. These 'whares', as they called them, borrowed both name and architecture from Māori, who I imagine would have been as surprised as anyone to learn that they had sold several million hectares for a few hundred pounds to a London-based property developer (who on-sold it for six times the price). The spot where these new arrivals first settled on the plains is now known as Pilgrims' Corner. It's

marked with a little cairn, well known by most boys I boarded with as a good shady place for drinking beer bought from the old Nancy's off-licence at the far side of the park.

There were long hot summers, and icy winters when snow capped the alps and blanketed the plains. The Pilgrims cleared woodland for farms and lined the banks of the Avon River with weeping willows. When the serious building began they chose local black volcanic stone, perfectly suited to the Gothic revival that was to become Christchurch's trademark.

The style's rise has been attributed to the French. Blood-soaked revolution and Napoleonic wars put an end to easy travel to the continent to absorb classical models. Instead, Englishmen looked to home for inspiration. Once barbarous Gothic castles and abbeys—the word Gothic was initially pejorative—were re-associated with chivalry, and the style was now seen as flexible and free, pastoral and democratic, wholesome and liberal. In contrast, the classical architecture of France and Italy was cast as rigid, unnatural, the style of absolutism and despots. Think Camelot versus Versailles.

In England the revival was led by the church, taken up by gentry, then immortalised by Augustus Pugin (the son of a French refugee) and Charles Barry at the Palace of Westminster. The timing was perfect for Christchurch, and the style's morality suited the colony's self-professed progressive goals.

In a world of high-rises and cheap glass it's easy to forget now that the original medieval Gothic architecture was all about letting in light. Norman or Romanesque buildings needed thick walls to support the weight of a stone roof. Windows had to be narrow and deep and admitted little sunshine. The development of load-bearing buttresses allowed for shallower walls and wider windows. Wealthy churches filled these with coloured glass, the better to communicate God's majesty. You can imagine the red- and blue-washed awe of labourers, soldiers, villeins, as they came to give thanks for whatever horror they had just avoided.

We now see the Gothic revival as gloomy: it's rain-soaked stone beneath grey skies; it's Edgar Allan Poe or the Addams family. Yet in its time it was anything but. Horace Walpole's mansion, Strawberry Hill, which started it all, was light, airy and picturesque. The style was approachable, romantic. It was flexible, practical. It let people see what a building did while speaking to supposedly ancient values. The Gothic revival was both ancient and modern,

in Canterbury as in England. It looked backwards but was meant to speak forwards.

Thus the new city rose in spires and finials, turrets and towers and battlements. There were public schools, and provincial council chambers for the voices of the (European) citizens. The Canterbury Museum was opened in 1870, about a decade after the Oxford University Museum, which it in part resembles. The new university would have been England's fifth. There was even Sunnyside, a specialist asylum made to look like a French château. The mentally ill had previously been housed in gaols.

Here indeed was the perfect progressive Anglican city and, at the centre of it all, expressive of religion and community, the cathedral: great doors, rose window, asymmetrical single spire, slate and stone. Designed by one of the Gothic revival's protégés, George Gilbert Scott, it was then adapted and implemented by Benjamin Mountfort, a local architect, whose own later Gothic efforts gave old Christchurch much of its look. The dean of Westminster Abbey (whose brother had claimed the South Island for Britain) donated the font.

From the cathedral's doors radiate squares and avenues, laid in a grid to aid land sales and loosely based on Savannah. Christchurch's original plan is called the Black Map. It sits in the Canterbury Museum, and you could navigate with it even today. Its surveyors also christened the city's landmarks. With their feet up on a table in a ramshackle study at the end of the day, at the edge of the world, they bounced names off each other 'to hear if they sounded well'. The result was streets and avenues named for imperial Anglican sees (hence Barbadoes, Colombo, Montreal), the squares for martyrs, the marketplace for the Queen.

<p align="center">*</p>

After Beryl's wedding we drove in cavalcade down Gloucester Street towards thousand-acre, oak-filled Hagley Park, tracing its boundary before turning into Fendalton Road. We turned in at a Gothic folly of a gatehouse, all steep roofs and fretwork beside high grey gates, and followed the gravel drive for half a mile. On one side were flower beds, on the other the Avon River. The driveway widened, the trees stood back and there in front of us was a large two-storey brick and stucco house with a high roof. The cars drew up, one by one, beneath a brick porte-cochere that enclosed the massive black front door

like a fortress. We were escorted into a double-height hall with an enormous stone fireplace, bigger than me, in one corner. Ahead of us a dark staircase rose around two walls to an ornate gallery. The hall was dim, the day's dying light further muted by a large stained-glass window.

This was Mona Vale, and it had once been Beryl's home.

<p style="text-align:center">⋆</p>

I have never found the house beautiful. The brick ground floor and white roughcast and timbered upper storey seem mismatched; the twin gables that face the river are a shade too high and give the house a top-heavy look, like a pair of thick eyebrows raised in surprise. And the roof really ought to be slate: the orange Marseille tiles clash with the red brick. But I can see in Mona Vale the echo of the Pilgrims' aspirations. Here is the ancient manor transplanted halfway round the world. But of course it's not. It was commissioned at the start of the twentieth century by a man who owned abbatoirs. Even its name is something of a forgery. Originally named Karewa, it was renamed by Annie Townend (then the country's wealthiest woman and the building's second owner) for her mother's home in Tasmania.

The occasion of Beryl's wedding was my first visit, even though Mona Vale had long been owned by the city and open to the public. Devonshire teas were sold to bridge groups and tour-bus parties on the ground floor, there was a rose garden to circle, and punt tours on the river from a landing at the edge of the lawn below the drawing room.

As a ten-year-old I followed the elderly up the carved staircase. At the top was a large open space, painted white and brightly lit. Guests sat on metal chairs covered in red velour. The high table ran along the north side above the front door. One aunt pointed out that Beryl was sitting in what used to be her bedroom. How funny, I thought, to get married in your bedroom.

There's a verandah in the centre of the house on the first floor, set between those high gables. Behind the verandah had been the main bedroom, the room where Beryl's father had died in 1954. A rich man, his death duties amounted to 5 percent of all those collected by the state that year. My mother told me about the death only years later. She has a good ear for stories. Her own twenty-first had been a medieval revel, complete with faux-heraldic banners at a fake castle on the Cashmere Hills.

<p style="text-align:center">⋆</p>

By 1859 Christchurch was a Bishop's see and Canterbury had been parcelled up into 200 vast landed estates. The leaseholders paid nominal rents and no one questioned the validity of their tenure or their profits. It was a system designed to attract people and hence revenue, so that John Robert Godley and other leaders of the Canterbury settlement could pay for their Gothic spires. There was a pastoral boom. This new gentry flourished.

With the estates came grand homes, sprouting from the land in the prevailing style of gables, dormers, towers, sometimes even battlements, an escutcheon carved above a doorway or a coat of arms on the side of a chimney. Their owners built similar residences in Christchurch and would come to town for the races or to meet at the club. Mansions appeared on the lower Port Hills, then in Papanui, Fendalton and Merivale. As much as the gardens and stone towers, they helped to define a certain selective public image of Christchurch.

In a city of grand homesteads, Mona Vale became one of the city's great estates, if perhaps a little showy. That's how it was known, as the 'showpiece of Christchurch', about the time Beryl's father bought it.

<p style="text-align:center">★</p>

Beryl's father Tracy was no Pilgrim. He arrived as a thirteen-year-old boy with his parents in 1900, by which time the vision for the city was largely complete. The year 1900 was the fiftieth anniversary of Christchurch and Canterbury. The celebrations included a military parade, the singing of the ancient hymn 'Te Deum' and a speech from the governor. One historian has noted that, by this time, 'Edwardian Christchurch was an elegant colonial city.'[1]

Mark Twain had visited in 1895 on his world tour, lecturing his way out of bankruptcy. He reported positively:

> It was Junior England all the way to Christchurch—in fact, just a garden. And Christchurch is an English town, with an English-park annex, and a winding English brook just like the Avon—and named the Avon ... It is a settled old community, with all the serenities, the graces, the conveniences, and the comforts of the ideal home-life. If it had an established Church and social inequality it would be England over again with hardly a lack.[2]

Tracy and his family would have landed in Lyttelton, uplifted their baggage, carried it to the station and taken the tram into town. Tracy's father, a

cabinetmaker from Birmingham via Redfern in Sydney, opened a shoe shop on High Street. Tracy joined him. It wasn't the fashionable end of town, but over a dozen years it seems they were successful.

Tracy's father translated this success into a brick and stone home in Fendalton called Leeham. Tracy changed his profession from boot-seller to salesman and married a daughter of the First Four Ships. Decades later, her family name would be etched on one of the plaques cemented to the ground before the cathedral. For the marriage certificate Tracy used his father's address (though electoral records indicate he wasn't living there), and shot his hands into his trouser pockets for the photo.

The children started to arrive a year later: a girl first, called Alison, then Beryl (shunting Tracy well down the Reserves List just as conscription came in), and finally my grandfather in 1919. By the time they needed serious schooling Tracy could afford the best in town. The girls attended St Margaret's, at that time in Cranmer Square, and my grandfather went to Christ's College, a series of grey castles around a billiard-green lawn. The college was founded to serve the sons of the newly landed squirearchy, but a look at the school list shows that in 1934 many boys came from similar backgrounds to my grandfather: Christchurch mercantile and professional.

Tracy had had limited education, and sending children to these schools showed him joining that allegorical world of the Pilgrims. The migrant shoe salesman was a convert. A few years later he moved from shoes to tractors, selling large numbers to the government as it battled the Depression with make-work projects. On the eve of World War Two he went from Canterbury convert to Canterbury conquest by buying Mona Vale. It was his apotheosis.

The family worshipped up the road at stone-clad St Barnabas with its crenellated tower (where my own parents were later married). Beryl took up opera singing. They learned to ride at Mrs Southgate's in North Canterbury, took French lessons from a 'Viennese Jewess' who'd fled fascism. Tracy stalked deer, had his cutlery engraved with a claimed crest and filled the house with treasures: crystal, medieval furniture, silver, heavy oils.

Generations later, after the earthquakes that claimed so much of Gothic Canterbury, I stumbled across a small packet of snapshots no bigger than playing cards. They were in a box beneath a bed in my grandparents' damaged house, which I was now trying to clear out. There in black and white

are Beryl, my grandfather and another girl, who I guessed to be their sister Alison. They're standing by the lily pond that Tracy installed at Mona Vale. There are dark hedges, giant urns. Beryl is blonde, aquiline, with a black spaniel at her feet. My grandfather is in a flannel suit with Oxford bags. Alison is very pretty. They're walking around the grounds and squinting into the morning sun.

Another photo: black tie in the drawing room, the young at the back, Tracy and the adults in front. It's New Year's Eve 1940, and they've become the perfect Canterbury family living in a Tudorbethan fantasia. They're happy and the war seems a long way away.

But it's not. Tracy has started adding armour plating to the tractors and calling them tanks. And within a few months two of the people are missing.

<div align="center">*</div>

The Gothic revival's blend of ancient roots with modern outlook is neat but facilitates deception: brand new buildings that try to look ancient; a new settlement that claims antique links; a southern paradise made to look European; a city of stone built on flax and marsh; English estates on Māori land; a happy family that isn't.

My great-grandmother Julia died at fifty-four just a few months after that photo was taken. Sixteen days earlier my grandfather had received a letter from one of his sisters saying that the gardeners had been busy (they employed a dozen) and that Mummy was outside enjoying the sunshine.

Death at fifty-four wasn't unheard of, but was still premature. The death certificate listed three causes:

- Coma, 12 hours
- Acute Mania, 14 days
- Diabetes

Acute mania is an old-fashioned term meaning the opposite of depression. Here it could be a portmanteau for a woman written off as mad. The diabetes likely caused the coma via hypo- or hyperglycaemia. It's still odd though. Julia wasn't old, she could afford good care, and insulin had been in use for twenty years—unless she took too much, or too little.

Three days before her mother died Alison was removed from Mona Vale, first to Sumner, a seaside village where the family had once lived, and a few

hours later back to town to the old Harley Chambers by the Avon. Both visits were to doctors, each of whom attested to her insanity. This was enough for the courts, who sectioned her under the Mental Defectives Act. Alison arrived at Sunnyside Mental Asylum at 5pm on 27 May 1941. Her admission notes record bruising to her arms and torso.

Sunnyside was Mountfort's final masterpiece of the Canterbury Gothic: mansard roofs, gables, towers, chimneys and movement. It tries to say resort, not prison. But in the 1940s the death rate across the country's asylums was 8.5 percent per annum. The recovery rate was just over half that. Two died for every one who left. Janet Frame described admitting herself as a voluntary boarder in 1948: 'My life was thrown out of focus ... I was terrified.'[3] One 1946 pamphlet was entitled *Misery Mansion: Grim tales of New Zealand asylums.*[4]

Alison's notes record her complaining loudly about 'that bloody woman'. She was treated for schizophrenia with a combination of sedatives and convulsants, the latter to jolt her back to her senses.

On 1 June 1942 Alison had been there a year and had just endured the anniversary of her mother's death. She was given the convulsant Cardiazol at 5pm and again at 3am the next morning. The following day, the anniversary of her mother's burial, Alison was given morphine at 11.50am. The next entry simply says 'Died 12.00'. The coroner ruled it was myocardial failure—a heart attack, most likely from the drugs. Alison was twenty-eight. She was buried two days later, the vicar of pretty St Barnabas presiding as he had for Julia.

<div align="center">★</div>

Julia died on a Friday. There was a concert that night in town, and Beryl was carded to perform. Her choice was the 'Indian Bell Song' from the opera *Lakmé*, about tragic love between a Hindu girl and a British officer:

> Where will the young Indian girl,
> Daughter of the pariahs,
> Go when the moon dances
> In the large mimosa trees?
> She runs on the moss
> And does not remember
> That she is pushed around
> The child of outcasts ...[5]

<div align="center">★</div>

Beryl ran away from Mona Vale after Alison's death. She went to Dunedin and trained as a volunteer nurse. She had no money and few marketable skills and her brother was in the air force. It couldn't last. Just before my grandfather was demobbed, in 1945, Beryl was checked into an offshoot of Sunnyside. Once in, she couldn't get out. She went through electro-convulsive therapy. After three years my grandfather secured Beryl's release: she was thirty-two, alone and immersed in religion.

<div align="center">★</div>

Eleven days after Tracy buried his daughter Alison, he married his long-time secretary and the children's former nanny. They continued to live at Mona Vale with its little Gothic gatehouse, the Avon River as a moat.

Notes

1. Geoffrey Rice, Christchurch Changing: An illustrated history (Christchurch: Canterbury University Press, 2007)
2. Mark Twain, Following the Equator: A journey around the world (New York: American Publishing Company, 1897)
3. Janet Frame, An Autobiography (Auckland: Century Hutchinson, 1989)
4. Arthur Sainsbury, Misery Mansion: Grim tales of New Zealand asylums (privately published in multiple editions 1946–48)
5. Lakmé, an opera by Léo Delibes to a French libretto by Edmond Gondinet and Philippe Gille

Glass Sky

The sun hangs high, shiny as a coin, spilling clean shadows across the empty roof. Light petals warm across Roland's body, full of late autumn and closeness to the earth, the afternoon still as glass.

WAH-YA! WAH-YA! WAH-YA! The shriek of the alarm splits the quiet. Roland tenses. Windows shudder in their frames. Joists tremble. Roland checks behind him, hunted. No one there.

Riverside Gardens waits. The alarm is prone to going off—a few sudden shrieks cut off mid-yell. Someone cooking toast, or incense curling near the sensor. Once, at 2am, a couple of students smoked a joint too close to the intake.

Ten, twenty seconds go by. Roland swivels his head. All clear. He stands to leave.

He is the first to reach the pavement. Strange, as he had the farthest to come, down six airless flights of stairs. He stands on the narrow pavement, back to the road, examines the building for signs of smoke. Hot and shadeless, his neck prickles in the afternoon sun. He wishes he'd remembered his sunglasses. They implicate him, next to the Coke can on the dusty roof. He lifts his hand to visor his eyes, forehead damp where his hair recedes. Waits for the occupants to pour out.

<center>*</center>

Mrs Pomodoro exits the jaw of the foyer, her toy poodle scooped in her arms like a baby. They both have the same tight curls—the dog's the colour of honey, hers a supermarket-blonde. She smooths a hand across the dog's back, squints. Roland follows her gaze back to the building, dim and grey. No sign of fire.

Next comes the single mother with her baby propped on her hip. Its gummy eyes roam over Roland. Roland sometimes smiles at the young mother in the hallway. She never smiles back. Her eyes dart to the floor, the ceiling, as if mapping her escape.

On the pavement now Roland tries to catch the mother's eye. She bounces the baby on her hip, mutters to herself. Sweat flowers on Roland's forehead. He wipes his face with the top of his sleeve. Staleness clings to his armpits. He wonders when he last showered.

More residents trail out. A young couple, the girl with fingerless mesh gloves pulled to her elbows. She loops her arms around the boy's neck. He holds her by the hips as if propping her up, palms slung low. Roland wants to look away but can't. A hint of nakedness in the way they stand … Roland can see them, new bodies sliding—

He slaps his forehead with the heel of his hand, turns his gaze to the older couple who wait, decorous, half a metre apart. They watch with large eyes. The husband turns to the wife, says something. Roland can't hear him, but even if he could he would not understand. They are taciturn, foreign: he knows them the least, though still better than they imagine. He knows all the residents, the seams of their secrets, in ways they couldn't guess.

Roland plunges his hands into the pockets of his cargo shorts, jangles his keys. Good for his fingers to have something to do. He thumbs the spiked metal like a worry stone.

<p style="text-align:center">*</p>

Six storeys high, Riverside Gardens is just another cheap development, leaky like the rest. Damp pervades the place, like an apple spoiled from the inside. Dark patches grow in the eaves, stains spider the walls. The exterior is clad in engineered panels that later, on a similar building, will prove devastatingly flammable.

Any connection to a river is tenuous in Grafton Gully: there's only a culvert nearby—a brown streak of water ambling near the motorway, full of dumped shopping trolleys and rusted-out fridges. An underpass, visible from the upper storeys, leads to a windblown park. Marooned on the cold southern side of a hill, the building always threatens to slide further down.

Roland got the job of building manager a few years after it opened, met the man from the management company on the verge where he stands waiting for the fire engine to arrive. He can't picture him now, remembers only a sweaty thick-fingered handshake. The man showed Roland around the complex—the concrete bunker of a carpark, stale rubbish storage, dim and rubbery plant

room. No gardens, just built-in boxes filled with half-dead bushes, skeletal and brown.

The last part of the tour was the roof, a flat space accessible for repairs but otherwise off limits due to the skylights. Each top-floor apartment had a glazed rectangle the size of a beach towel cut from its ceiling. Roland would be expected to wash the skylights, clear errant leaves occasionally—with permission from the affected resident of course.

Roland doesn't know if anyone else applied. Sweaty-hands implied it was hotly contested but called him a few hours after the interview, offered him the job. He didn't even check Roland's carefully crafted references.

<p style="text-align:center">★</p>

Still no sign of the fire engine. Roland lights a cigarette, pulls smoke into his lungs, a reassuring curl of rope. The single mother eyes him, turns the baby away from the stream of his exhale. Accused, he pulls at his shirt, drags it down past his waist, makes sure no flesh is exposed.

He tries to remember what he left on the roof. Sunglasses, Coke can—the only traces, he's sure. The can, stuffed with cigarette butts and faded orange by relentless sun, is mildly incriminating. He always smokes when he visits the roof.

It started about a month into the job. He settled into his cramped ground-floor apartment, became accustomed to its small discomforts: the pile of rotted leaves on his tiled patio, the hum of the plant room through the wall, the way sun glanced off the exterior walls without reaching his room. Roland, a crepuscular shadow.

The first time it happened he was sweeping leaves and debris from Mrs Singh's skylight with a long-handled broom. He leant over to dislodge a stick and there she was, standing beneath him wrapped in a towel, hair plastered in fat Medusa curls around her neck. She was meant to be out. She had agreed to the cleaning but it must have slipped her mind.

After a moment she dropped her towel, stood motionless, seeming to enjoy the air on her wet skin. A current ran up Roland's spine. He got a little hard, even though her body sagged and patches of scalp were visible through her thin hair. She bent for the towel, folded it over her arm and walked into the next room, out of view. Roland went to the corner of the roof behind the

air-conditioning housing to relieve himself. Afterwards he stubbed out his cigarette on the wall, took the empty Coke can from the ledge, fed the butt into the hole.

He checked the roof daily after that, barely believing what the skylights revealed. What people did when they thought they were alone.

In most apartments the skylight was positioned above the lounge. Residents watched TV, talked, ate dinner on their laps. Sometimes these scenes were enough to get him off. Other times he caught occupants at it, together or, even better, alone.

It changed when he peered into the single mother's skylight and saw her lying on the sofa, her head on the armrest. The baby must have been asleep. Slowly she slid her fingers inside her jeans, threw her head back.

Sweat prickled in Roland's armpits, the soles of his feet got slick. His breath grew ragged. Reckless, he leant right over the skylight. Her mouth was open but her eyes were shut. When she finished there was a pause, a silvery moment that Roland memorised, before she got up, switched on the TV.

Roland didn't need to go behind the air-conditioners that day; watching was enough.

<p style="text-align:center">*</p>

The first woman Roland ever saw naked was his mother. The two of them lived in a one-bed apartment; Roland slept on a fold-out couch. His mother liked to take long baths. Water lapped against the sides of the tub while he watched TV in the next room. Sometimes she read, but mostly she lay in darkness, alone.

The toilet was in the bathroom and Roland had to wait until his mother emerged to use it. She'd come out wrapped in a yellowed robe, hair turbaned on her head, face shiny and pink. He caught a faint whiff of baby powder as she brushed past.

One night she stayed so long Roland couldn't hold it. He rapped on the door, asked how long she would be. She told him to come in; the door was unlocked. Reluctantly he complied, careful to keep his eyes straight ahead while he stood, legs splayed apart above the toilet.

After he finished he washed his hands, turned to face the other wall, slowly edged out.

'It's okay, Roly,' his mother said, her voice an odd whisper, 'you can look.'

A reflex, the way his eyes swung around. A line of scum clung to the sides of the tub. His mother was half-submerged in soapy water. Her knees pierced the surface, large saggy breasts floated above. Her rounded belly rose through the tide of water; below it, a mound of ginger hair.

He snapped his eyes shut, ran out of the bathroom.

She laughed and shouted after him, 'Don't be such a prude!'

After that, whenever she took a bath he walked down four flights of stairs to pee in the bush behind the carport. No matter how many women he saw naked, he couldn't erase her flaccid form from his mind.

★

The firefighters park their gleaming truck on the verge and pile out dressed in heavy beige overalls, thick coats. There is no fire. Roland knows this. They suspect as much. Still, they must examine the fire panel, check the building before anyone is let back in.

The single mother stares at Roland. He leans from one foot to the other. She shifts the baby to the other hip, turns away.

Heat rises, bunches, settles on their shoulders. Mrs Singh has a sweat moustache beaded across her top lip. The older couple move into the shade. Mrs Pomodoro fans herself with a slim notebook pulled from her handbag. It's too humid to talk. The young couple lean together. Her gloves hang limp from her jeans pocket, her cheek rests on the curve of his shoulder.

Patches of sweat seep under Roland's arms. All his shirts have yellowed halos at the seams, little angels of sour flesh. He maintains a discreet distance from the residents, arms loose by his sides.

★

No surprise he was on the roof when the alarm went off; it's where he spends most of his spare time. The young mother hasn't touched herself since that first time, not in his view at least. But the thought of her head flicked back, the round 'o' of her mouth, her slim hand, sliding away—she might.

He waited for weeks, impatient, while she switched on the TV, made a sandwich, only the top of her glossy head in view. Nothing of her sleek body unfolded. He tried to take matters into his own hands, knocked on her door, mumbled about checking her lightbulbs, breathless with the scent of her—

spoiled milk and coconut. She thanked him, said the lightbulbs were fine, closed the door in his face.

He tried to collect her mail—he had the master key, could say it was delivered to his box. He opened the silver slot every day for a week but never found anything more than a grimy film of dust.

Once in the hall he tried to help her with her shopping. She had straining bags hooked over the handles of the pram, a bag of toilet paper balanced on the sunshade. When he lifted his hand towards the bags she jerked the pram away, shook her head. Roland reached for vanishing air.

After these encounters Roland considered himself in the mirror—paunchy, widening forehead, dirty hair, grey stubble. He took his face in his hands, pulled his cheeks, bared his teeth. Something must be written there, the way she cowered. No matter how he twisted his nose, scrunched his eyes, he couldn't read what it said.

Roland didn't visit the other skylights now, only hers. He should have been caught over and over, the number of times he'd laid his cheek on the cool glass of her, imagined her bones beneath his.

<p style="text-align:center">★</p>

Right before the alarm went off he had watched her feed the baby, a fine stream of orangish liquid that she spooned out of a small jar. The baby pushed it away, sunny splotches dripping down its front and hers. The child pawed at them with wet fingers. Roland eyed the sheen of her hair like the orb of a star moving about the room.

She wiped the baby with an abundance of cloths, put it to bed. She returned a few minutes later, lay on the floor beneath the skylight. Roland peered over, resting his gaze on the ridge of her. She closed her eyes, moved her hands towards her belly. Roland's pants twinged. She didn't lower her hands any further, laid them on her stomach, held still.

A few minutes passed. Roland took a chance, put his foot on the raised frame, levered himself up, lay carefully on the glass. He stretched himself along the length of her body, suspended, like a beam of light.

The skylight fogged beneath Roland's open mouth. Latent electricity in the air. A gravitational force pulled him towards her, between them the glass sky. He imagined zipping himself up inside her bones. She opened her eyes.

The blue of her eyes changed. Fractured like a blade of ice. Her mouth dropped open. She screamed.

Then she was gone. Roland rolled off the skylight onto the dirty roof. Time stopped, caught him in its suspension. Then restarted when the sudden alarm shot through his body like a spear, echoing her scream.

<p style="text-align:center">★</p>

The firefighters are back, talking among themselves. The single mother approaches, touches one on the forearm. The firefighter leans in, solicitous, then squints at Roland, who turns away.

Roland chooses this moment to approach, introduce himself as the building manager. The mother lowers her eyes, scuttles a few metres back beside a young oak. The men assure Roland all is well, tell him someone triggered the alarm. The tall one reminds him the building owners can be fined for false alarms, he'll need to warn the tenants. He says they'll send a report.

Over by the slender-trunked oak, the girl's attention is on the baby. She talks to it softly, whispers a mother's secrets.

Roland isn't sure whether to leave. He hovers, indistinct. Someone tells him they have the all-clear to return. He moves towards the entrance. The residents follow, uncertain at first. He gestures with his arm. They lope towards him like animals disturbed from grazing in the lowering sun.

<p style="text-align:center">★</p>

A cool change sweeps through in the night. Roland wakes to his door banging, the bony tap of a ghost. He closes the window, lies in the blued-out dark.

The next day the thought of the roof gets Roland through his long morning of work. After breakfast—cornflakes eaten from the box with his fist—he re-planes a door. Sawdust settles in his hair. He checks lightbulbs, clears the driveway with the leaf blower. When there is nothing left to do, he goes to the roof.

The fire-door is heavy in the dark stairwell, and he groans as he lugs it aside. A rush of air hits him bright as a slap. He walks towards her skylight, fourth from the end, a frame onto the whole glistening world. He bends down, freezes. Every inch of glass has been taped over from the inside with newspaper.

He worked in Invercargill one summer at the Edendale milk processing plant, swam once at Ōreti beach. But even the Southern Ocean wasn't as cold as what drenches him now. His skin contracts. The blood in his veins rushes from his skin to his heart.

Roland bends closer to the glass, scrabbles with his fingers for a chink, a gap. It's completely sealed. He claws at the paper, unreachable under the glass.

How could she do this? How did she? The ceiling is several metres high. She would have needed a ladder, equipment. He remembers the firefighter, the one who looked sideways at him, didn't smile.

He sits on the dusty ground, blows on his fingers. His scaffolded heart creaks. She was supposed to understand.

The wind picks up, eddies the dust. He climbs up, lies on the pane of glass. He wants to be close to her. He seashells his ear to the skylight, the soft bumps of her moving around below muffled by the glass. Gusts push the many hairs on his legs to attention. Cold recedes, replaced by numbness. His paunch flattens against the skylight, his body floats of its own accord in the glassy sky.

Quiet below. He wonders if his shape casts a shadow across her room—a passing cloud.

Up here. I'm waiting.

He closes his eyes, imagines her room. The echo of yesterday's alarm shudders through his body. Her finger on the switch. The vibration in his bones.

After the swim at Ōreti beach it took him forever to defrost. His muscles convulsed, his lips went blue as blood receded to his lungs, his heart. But he did thaw. His skin pinkened, sharp pains shot through his fingers and toes as circulation returned. After a few hours he felt more alive than before.

He presses the rounds of his closed eyes to the glass, flat as coins, and waits. The world still as a held breath.

Saddle Club

We used to ride the school benches at lunchtime, gallop with invisible reins in our embroidered jeans, or tie pink jump-rope around our waists, pulling each other across the field, born of *Saddle Club* and mossy hills, *hello world, this is me, life should be*, growing and growing and taller we go, into longer legs and thicker manes, velvety treasures lolloping from pub to flat to bed, fun for everyone, braying over Tinder, counting each lover another tuft of dust bit by a hoof.

Our people are great riders, we know from the old days, and there weren't any reigns until 1840. I suppose I've grown into my reins, their obsidian shine and leather clasps, pearl buttons and metal locks, they excite and delight, a stimulus from the navel to the nape, something to push and pull against with the throat and the jaw. But to ride freely? To clasp a grassy back and, with no more than a nudge on the hip, fly beneath Ranginui's pelvis? To merge with the horse of the bone and become a wisp of racing smoke? To bend weightless in between realms once thought lost, to exist as a myth and shed all sides of the false self? To bruise the inner thigh a gentle shade of plum and unfurl like the curl of our many symbols, from the shadow of the church, into transparent delight? To gallop into the sunset with a stomach and breasts and clit and heart bouncing proudly, all of us aware of our mortality and the need to mould ourselves around explosions of pleasure and love?

That is something to reclaim.

JENNIFER COMPTON

Ears and Graces
(the deep green sea)

The Kaiwhara' rip
bangs athwart
the Eastbourne ferry,
lifts us, drops us, rocks us,
just off Matiu/Somes.
I was hoping for some action
crossing this homesick harbour.
Queens Wharf to Days Bay
and back. Quicksilver chill
on the deck, chill to the bone.

> a small moment of lift, of loss
> a moment, a small moment of
> swell and hulking tilt, breaking
> reach, a moment, a small moment
> of slap and heft and heel, green as
> the slice that looms, that goes deep

'He's a great boss. He doesn't toss for coffee, no.
He asks us what we want and he makes it for us.
He's got no ears and graces.'
—overheard in the Shepherds Arms

Friday drinks, a scrum of men
in shirtsleeves, kicking back.

The brunt of them
have homes to go to.
They peel off.
The swing doors swing.

Once alone, two men alone,
lean in across their beers.

'Oh man, it's just got so dark.
It's all turned to shit.'

And it's dark in the beer garden.
They are standing silhouettes.

One man is looking down
and the other tilts his head.

'Everything turns to shit.
In the end.'

 they touch foreheads
 almost, a breath
 between them

 drain glasses
 set them down
 with a dull thunk

 as if someone else
 will deal with them
 which they will

 they leave together
 with slow and stolid grace
 casting their faces about

 to catch the light
 or to escape it

(the people of the land)

they were singing me in
as i landed, at first light
their voices are the pathway
but then i lose the way
and again, there they are
singing me in

Leverage

Gibbzy was a cunt, no two ways about it, with his mag wheels and his forearms, so I couldn't have been happier when Ashley told me he was leaving.

'I hear we're losing you, mate,' I said in the tearoom.

'Got headhunted,' he said. 'The Auckland branch want me.'

'You'll still be with Manning and Leggett, though,' I said.

'What?'

'If you're headhunted, it means a totally different outfit wants you. Somewhere better.'

'If you say so, Dick,' he smirked, and dropped his used teabag in the sink.

'Richard,' I said.

<div align="center">*</div>

They sent around an email asking us to sign a card for him and make a contribution to a gift—*we'll leave the amount to your discretion.* Ashley was collecting it all in an envelope, and I watched the entire department file into her cubicle to write their messages and cough up. Fucked if I was putting in any money. I should've taken something out, more like; there were a couple of fifties in there—*fifties.* Ashley handed me a biro and turned away to do some filing. 'Give you a bit of privacy,' she said.

I couldn't think what to write; everything had already been taken. *Good luck for the future! Congrats on the big move! We'll miss you! Go you good thing!* In the end I put *Don't be a stranger* and scribbled my name so it could have been anyone.

'Your problem,' Gibbzy told me at his leaving do, one arm slung around my shoulder, 'is you've got no guts. You never take any risks. Want to know what I've just done?'

'What have you just done,' I said.

'Bought an investment property.'

'Is that right.'

'Brand new apartment on the Viaduct. Granite in the kitchen, fully tiled bath. I'll live in it for a year, then rent it out and buy another one. Grow a portfolio. You can make a killing, mate, a killing.'

'Good on you,' I said.

'It's all about leverage,' he said.

'Okay,' I said.

He was so close to me I could see every follicle on his scalp. He was one of those guys who shaves his head each morning, and he must have put a lotion on there too, or a fancy serum, because the skin was glossily taut.

'Get a room, boys,' said Ashley as she passed.

'I will if you will, babe,' said Gibbzy, which made no sense, but Ashley laughed anyway.

He must have noticed me staring at his scalp then, because he said, 'You can touch it if you want.'

'What?' I said. 'No. No thank you.'

He tousled my hair. 'You should think about it yourself. Drives the girls crazy. They're always asking if they can rub it.'

I had a couple of drinks in me by that stage and I said, 'Why would anyone choose to go bald? Unless they're raising awareness for some kind of disease.'

'Vin Diesel,' he said. 'Jason Statham. The Rock.'

'Did you choose baldness?'

'Some girls don't even ask. They just barrel up to you and start rubbing. Isn't that right, Ash?' he called.

'So you didn't choose it.'

'Look, mate,' he said, shoving his forehead in my face, 'see that? That's a hairline. Right where it should be.'

Someone dinged a glass, and Ashley brought out a carrot cake and an ergonomic footrest with a bow on it.

<p style="text-align:center">★</p>

I stalked him online for a while after he left—I don't know, I just wanted to see if he failed. Plenty of people do when they move to Auckland. His Facebook page was full of pictures of him with his shirt off, striding into the surf or drinking fuckwit cocktails on the balcony of his Viaduct apartment. The place looked pretty small, from what I could tell—*my executive studio* he

called it on one post, meaning it didn't have a bedroom—but yeah, I would have lived there.

'It's not the same without Gibbzy,' Ashley kept saying, and she was right. No teabags staining the sink, no *Morning, Dick*.

One day, when everyone was at lunch, I had a poke around his old cubicle. Prick hadn't even cleaned out his desk—I found a whole chain of paperclips coiled in the bottom drawer, a snapped shoelace, and the good stapler that had been missing for months. Right at the back, some ancient business cards: a 24-hour gym, a florist ... and a clinic called Hair When You Need It. *Restore the confidence that left with your hair*, it said, and underneath, in Gibbzy's handwriting, *Friday 4.30*. I shot back to my own cubicle and jumped on the website.

We specialise in micropigmentation of the scalp (otherwise known as tattooed hairlines). Let our cosmetic tattooists give you the look of a full head of shaved hair. Undetectable results!

And when I scrolled down, there he was, before and after. They'd put a black strip over his eyes but you could tell it was him.

I couldn't help myself. I made a fake Facebook profile and friended him, and then I screen-grabbed his pictures from the clinic and posted them to his wall. He deleted them that afternoon, but not before hundreds of his friends—hundreds—had seen them and laughed at them and shared them. Even Ashley.

<p style="text-align:center">★</p>

It must have been around the same time that I saw the Property Uni ad on my Facebook feed—my real one—in between a shot of my stepsister's morning tea and footage of a dachshund nursing piglets. *At the Property Uni were dedicated to helping everyday Kiwi's interested in property understand the Ins & Outs of property.* A young guy, about my age, standing in a vineyard in a suit that looked Italian. *Learn why theres no better ways to grow a portfolio using little to NO MONEY DOWN.*

They were giving a free seminar at the Novotel the following weekend, so I decided to skip indoor netball and see what it was all about.

<p style="text-align:center">★</p>

The conference room was windowless and my feet sank into the black-and-gold carpet. On the back of every chair hung a Property Uni bag, with a Property Uni pen and fridge magnet inside.

At ten o'clock a woman in a pinstripe skirt clapped her hands like a teacher and said, 'Jason is on his way down, so let's get started, people. Have you all had a chance to grab a coffee and a mini-muffin?'

I hadn't noticed the refreshments, but everyone was taking their seats and I was worried I'd miss out on an aisle spot; I didn't like being in the middle of a crowd in case there was a fire or a tsunami or something. You think people are good at heart, but then the siren goes off and they're trampling your throat.

'Please do make sure your phones are switched to silent,' said the woman. 'We have a very strict policy regarding phones. If your phone interrupts Jason, he will ask you to leave.'

I sat next to an older couple who introduced themselves as Bryce and Tricia. They each had a plate with a stack of mini-muffins on it—banana and white chocolate, it looked like. Fuck.

'Why are you here, Richard?' said Bryce.

'I ... I want to grow a portfolio,' I said.

'We woke up the other day and panicked,' said Tricia. 'Do you think the government's going to look after us when we retire?'

'No?' I said.

'We should've started decades ago. You've got the right idea, Richard.' She bent down to put her phone away, and I saw another lot of mini-muffins in her handbag, stuffed in a serviette.

The woman in the pinstripe skirt clapped again, and when everyone was quiet she played a video: the guy from the Facebook ad explaining a graph, starting his keyless Maserati, walking around a building site and pointing in a hard hat.

'That's him!' whispered Tricia. 'That's Jason!'

Don't build someone else's dream, said the voiceover as the screen faded to black. *Build your own.*

Then the door opened and Jason appeared in his Facebook suit. 'Do you want freedom?' he yelled.

One or two nods.

'I said, do you want *freedom?*'

'Yes please,' said a few people.

'I can't hear you! *Do you want freedom?*'

34

'Yes! Yes!' we shouted.

He put up a slide of a bare bedroom, with just a single bed, a cheap computer desk and a plastic garden chair. 'This was my room at my parents' house,' he said. 'I was working at Carpet Warehouse, and I'd just started studying to be an accountant. My dad drove a taxi and my mum was a cleaner. I won't lie, I ate a lot of instant noodles.'

'No nutritional value,' whispered Tricia.

'I thought my uni degree would be my ticket to a better future—but a few weeks in I started looking at what my career prospects actually were, and how much I'd actually earn after all that work. And to be totally up front with you, it wasn't pretty. I realised I'd be spending years studying just to get a job building someone else's dream.' Another slide: a student in graduation regalia, with a big red X across the picture. Jason took a sip of water, balanced on the balls of his feet for a moment. 'At the end of today's seminar I'm going to make you an offer worth $18,000. How many of you would pay eighteen grand to make a million dollars? I see a few of you not raising your hands. Let's try that again. Some of you might be at the wrong seminar.'

I put up my hand.

<div align="center">*</div>

He showed us before and after pictures of properties he'd bought—1970s A-frame houses and ugly little duplex flats tarted up with new toilets and flatpack kitchens. 'And you might look at these examples and say, "But hey, Jason, you just got lucky. You bought at the right time." So let me ask you: when is the right time to invest in property? When is the right time to go all in? Raise your hands.'

'Now?' said a man down the back.

'Lynda, a spot-prize,' said Jason, and the woman in the pinstripe skirt ran down the aisle with a Property Uni mouse pad. 'Now is the right time,' said Jason. 'They're not making any more land, are they? And history shows us that property doubles in value every decade.'

'What about the investigation?' someone over by the door called out, and we all turned to look at him. 'That lady you scammed in Auckland. The one with the brain injury.'

'I told you that'd come up,' murmured Bryce.

Lynda started to make a phone call, as Jason said, 'Fair question, mate,'

and took another sip of water. 'It kind of got blown out of proportion in the media, but basically, her lawyer gave her some bad advice, and she sold the place to us for what was essentially a bit below market value. Happens all the time—divorces, deceased estates. We don't know the reasons people want to sell up, and it's not our job to pry into their private lives. As soon as we found out about the bad advice, though, we topped up the purchase price. Legally we didn't have to, but we just decided it was the right thing to do.'

'Well, the Commerce Commission decided that, didn't it?' said the man by the door.

'She made a killing,' said Jason. 'And you can too. It's all about leverage. Who's heard of that? Raise your hands.'

Just then Bryce's phone started to ring.

'Ah,' said Jason. 'Lynda would have made that very clear at the start.'

'Sorry, sorry,' said Bryce, fumbling to turn it off.

'Rules are rules, I'm afraid,' said Jason. 'My hands are tied, mate. You'll have to leave.'

'I'll take notes,' whispered Tricia, but nobody else said a word; we all just watched Bryce go.

I double-checked my phone was off.

Jason spoke for another hour or so, taking us through the different strategies—renovate and flip; negative gearing; buy and hold. 'And you can spend hundreds of thousands trying to figure this stuff out for yourself, and make some really expensive mistakes,' he said, 'or you can join us at Property Uni. Normally we charge eighteen grand for our mentoring scheme—and when you think that in a few short years you could make your first million, that's a pretty decent return, right? But if you sign up today, you'll get all the mentoring, all the templates and the webinars, for only $6998. That includes unlimited email support from myself and/or Lynda for a year. Sound good? Sound fair? Raise your hands. Awesome.'

Lynda began laying out clipboards and forms on the refreshments table.

'So what I need from you now,' said Jason, 'is proof that you're willing to go all in. Proof you're a winner, not a loser.' He held up a $50 note and said, 'First one to grab it keeps it.'

I don't even remember jumping out of my chair; all of a sudden there I was at the front of the room, lunging for the $50 with one hand and shoving Tricia

away with the other. Someone wrenched my pinky finger, and someone else—the man who asked about the Commerce Commission—stamped on my foot. No worse than indoor netball, I guess, though my finger bloody hurt when I signed up for the mentoring.

<div align="center">★</div>

On Monday morning I went straight over to Ashley's cubicle.

'I've come into a bit of money recently,' I said. 'From the portfolio I'm growing.'

'Oh right,' she said, and sniffed.

'So I thought you might want to help me celebrate. Go out to the movies or something.'

'Oh right,' she repeated, and then she started to cry. 'It's Gibbzy,' she said, pointing at her screen.

'What about Gibbzy?'

More tears. 'He ... he hanged himself.'

'Shit,' I said. 'Is he okay?'

'He *hanged* himself, Richard,' she said. 'With electrical cable, on his bathroom door handle. He's dead.'

'Shit. Shit.'

People were posting messages to Gibbzy, as if he might be able to see them. It was weird.

'So what do you reckon, Ash?' I said after we'd read a few of them.

'Yeah,' she said, scrolling down Gibbzy's page till she came to a picture of him at the Rakaia, his fingers hooked under the gills of a massive salmon. That set her off again, and I put my arm around her shoulders and held her, but not in a creepy way. I could feel the sobs rolling through her body and into my forearm. We both just looked at Gibbzy holding the fish, and I thought about the bathroom door handle, and the electrical cable, and if the real estate agent would have to mention anything.

After a moment I said, 'He was a bit of a cunt, though.'

Ashley stobbed crying and stared up at me. 'What?' she said. '*What?*'

Loser. Fuckwit. Dick.

Stillness on the Bay

The world has stopped.
Into the breach float quarking and shoretalk,
the fuss of featherlife bedding down.
Bundled cumulus cools to indigo.
The lights of Port swim closer.
The last islands of summer heat
have sailed over the land,
the last dazzling low angles
of the southern sun sinking
under an inky zag of ridgeline.
A dog trundles along boundaries
sampling musky notes.
Unguarded windows reveal set pieces,
quiet kitchens, the flicker of game shows.
Stars assemble in formation.
Outside we listen to the old sounds of night.
Our fingers brush and twine.

if found please return to:

She will forget the house. It will leave her one window at a time, breaking off
in pieces of pine and lace and quartered glass. She will forget the feel of the
rooms on her skin, the stir of their smell when she walked them. The cool of
the hall which held the scent of sour fruit and locked mahogany, so her
footprints couldn't help but slow in its long, polished gloom. The sharp
kitchen sunlight striking the steel bench with its rack of illuminated drips.
The froth of the laundry, the soapy fluff churned from the tub, her forearms
chugging in their glisten. She'll forget she could never get through the weekly
scrub without a cheeky song. Something sudsy, because she felt spring-time,
bubbly with showtune and get-go and sweat. The bugger of a wringer with its
rubber cogs squealing, the slithery feed of shirts gushing into her bucket.
She'll forget him, scragging boots off at the back door, a stompy, gruff dance
on concrete steps, shovelling his coat pockets for tobacco and stray tools.
She'll forget him saying *hey up missus. Smoko.* She'll forget his dip, down into
the pursed hair of her nape, her collar flustered, *ooh leave off you.* Forget his
leathery sip. The roof of her mouth will forget their bedroom's simmer of late
afternoon dust.

<p align="center">★</p>

She'll forget the words. She'll forget the name for the things her son stands in
a jar by her bedside, ruffles of red that flag and bruise on their sticks. This
new room is easily forgotten. It has never sunk in. It's only the smudge of
linoleum, a yard of grey flecks, wipeclean with loneliness. It's only the grizzle
of trolleys wheeled in to tip her head and rattle in pills. She'll forget the use of
the black balloon they strap and pump to her pulse rate. She will forget the
numbers on the glass stem they slot in the woozy vowels of her dentures.
She'll forget why they lever her over, a tutting struggle on the steel-bridged
bed, why she's sandbagged with white. She'll forget how to work herself
upright, except for wild starts in the night, when 3am seems to tug her wires,
and she rumbles from her monitors, escapes a few muddled steps. Of course

she'll forget where she is, and the names of the people she meets in the nowheres she wanders to. Of course she will falter and two-step and turn and the loneliness will just stretch down new corridors, a grey route that empties in numberless doors through which she still remembers no one.

<div align="center">⋆</div>

She's forgotten her baby. She left him at the shops. Didn't she? Had him swaddled, had him snug in his pram of peachy wool, had him drowsy with pavement-roll and dopey milk, had his snowflake bonnet on, had his plump chin shining in pleats of ribbon, the cleanest, chubbiest face of snuffled content you'd ever be likely to see, and she parked him in the shade, and she nuzzled at his thick vanilla sleep and she murmured *Mumsie's back in a trice my bub*, and then she just popped into the butcher's, just popped in a tick, it was honestly only three-shakes-of-a-lamb's-tail, and then somehow, somehow she propped up her parcel like always in her astrakhan coat, cool with blood in its corded wrappings, and spongy with the comforting slouch of meat, and she marched with it all the way home, and her next-best heels on the pavement clapped a stout little singalong. She hummed, just in musing over putting the kettle on, just in portioning the pot with its few black feathers of tea. And then her nipple buzzed. The drizzle of what she'd forgotten burst out on her breast. And she dashed, she bolted, she raced back, a blat down the bricks, until the lane brought her up against the braked pram, its dark trunk hooded, its wide wheels glinting, and she stared down and down, slopping big tears into his snooze. She was the worst mother. Ever. But it was all right. The baby forgot.

<div align="center">⋆</div>

One foot. What's next? She will have forgotten. She'll sway in her slippers in the ultraviolet. She will have forgotten her mouth is open, and oxygen and words spill down. Her neck is a tremor. Her voice comes out of it nothing like a hymn. Is it help or hello? Her tongue has forgotten. It blinks in and out of her pleading. The corridor throbs and splits four sealed grey ways and she shakes on its cross of clean roads. All she will want is to make her way back to her blue cell, to her crocheted crawlspace. But she'll have forgotten which side of the world it is on.

<div align="center">⋆</div>

She will forget the clock. It is lines on the moon. It is stones in a pool. She will remember, somewhere, a pool, for a second, and she will see herself, trailing a tide of pale hair, all slipped from its pins, which she knows is like silk to the boy she teases, which she knows is as good as a lure, which is golden and sultry and tugging at her scalp with her flounces of toying and leading him on, with whinnies of bad, so she takes him, on a dance at the end of her dangled mane, takes him off on a shimmery goosechase, through slashes of birch and stumble of fence, through breezy laughter and muddy romp, and they come to a pool, and she lets him brace her, his shivery length along her frock, at the water's edge, she lets him cup her cool palm with the tilt of a good flat stone, and he teaches her to skim, and she remembers the scud of the pebble, its grazing rebound off the gleam. They forget the time. The hands they know about are under their seams, are urging at cloth. The hands they'll remember are clammy, and paddling with heartbeats of want under heavy serge. The hands are making her dip and rise again, arc and lap and rise. She'll forget the clock. She'll forget what time her father wants her home.

<p style="text-align:center">★</p>

It's the music that doesn't forget her. Where do they play it? Is she in church? She will forget she never liked the carry-on of scripture, couldn't stomach all its uppity fuss. She's never liked the vicar who warbled and strutted around his pulpit, a finicky font of shalt nots. She's never liked the disc she has to suck from his index, doesn't like the goblet with its plasma slurp, his gown's musty swish. She doesn't like his crouch down to bless her, breath as bad as his flowery twaddle about sin. She doesn't like the mortified picture of Christ tacked up in his loincloth, chickenskin white. She's got no time for pomp. But she can't fault the music. Against her better judgement, against her grudges, those notes press in, make her chest swell. Her breathing rears. Her wristbones hallelujah. And she'll forget she's an oldie in velour, forget she's been tucked in with crochet squares. She'll forget that the tune is being henpecked out on a keyboard of corny plastic watts, by a troop of god-botherers the likes of which she once used to dodge on her street with merry snorts of scorn. The bones in her feet know the tempo and bob in their pumps. The bridge nods her balding head. Her eyelids fill: *Jesu*.

<p style="text-align:center">★</p>

Down at the base of her skull the siren has picked out the crossings of terror in her blood. The shelter, the shelter—she's forgotten the way. And now the road hairpins, there's billows of brick, the buildings making jagged shifts, the chapel coming at her in floes of stone. Out of its white side she watches the next hit blowing the blueprints of stainedglass God.

Where is the shelter? Where is it? Where? She should know—her father walked her, chanting, mapped it, over and over and over. But now there's nothing where she should turn left, the landmarks crushed to haze. The shops are chalk. She calls his name, but her teeth are liquid. She takes unwieldy steps, fresh alleys scraped by fire, black girders, her shoes blunted with blood. Windows she recognises stretch their last gleam, then ignite. The pavement fishtails, breaks the grip of her feet, tips her face first into dust.

The bombs go off until all the world feels bloodshot.

When her father finds her, much later, there's no talk between them. Their mouths brim with silt, their hearing numbed. Atoms still hang in the air in spasms trying to find the shapes they were blasted from. She stumbles with him home. She doesn't question. They slip and blink. They pass what they have to. A man whose sleeves unspool into nothingness. A child tugging at the tongue of a boot, above the ankle his parent a load of smoke. She follows her father's trudge.

She will forget they're the lucky ones. Because her father never recovers. He gets her home then he lies down and does not get up. He stays put, woundless and whole. He lies in his bed, what they've seen like a stone on his chest, his name carved cold. He dies of it. She watches him die of it. He dies of not being able to forget.

<center>★</center>

At night the walls of her room will be a bare screen for small things being forgotten. Willows over a plate, in blue shivers. Cockles dropped with soft clacks in a bucket. Pine needles picked from the staves of his boot. The scallop shell where he tapped his ash. The school gate swinging on its crisp hinge of lichen. The tongue of a scrabbling lamb, its warm-ribbed suckle. White shirts breaching on the shrill back line. An east wind chiselling light through trees. Never enough to keep the film running, never enough to still a scene. She blinks and they're watercolour. Tries to speak and they pass like dreams or breath. Her lids are a vanishing point.

All forgotten.

*

The boat will move in her mind like forgetfulness. She won't remember the sway of it there. She will forget the ache of it rolling, days lost to salt in the lurch of its tread. She's left one world, split off from the wharf, and has no pictures to bring her the next one. What will the next world look like, and who will she be, standing fatherless in its fields? She seems to forget anything but the ocean—ocean rising in iron lines of swell, or sleek as glass in the wide landless glare. For nights she latches herself in her cabin, bolts herself away still dressed, her heels in their buckles, the sweat streaking into her coat—she won't meet the alarm (which she knows must come, as sirens do, they always do) with indecent skin in the moonlight, a spectacle of bare limbs sunk. She lies down terrified, groomed and buttoned, waiting for the sure SOS. But the rock of the ocean speaks to her, enters her clothes, the blackwater rhythm of smooth and shock. She slips to the deck, a graceless stagger on boards. And finds that she loves it. The water moves like whiplash. The wind laughs in her throat. Her hair blurs with stars. She raises her arms in the silky overhang of cloud, says the word *starboard* like it is beautiful.

*

She will forget the photographs he pins to the wall beside her bed. The faces in them will go out like lights, the trees and streets standing in the wash of past, nameless. Some days he will lift them from their thumbtacks, he'll float them in figure eights above her gaze, *Remember Mum, eh Mum, look, you remember*. But she will forget the girl by the birdbath, her bulldog huddled to her gingham dress. She will forget the low stone wall with its slurry of muck, its gaggle of piglets, the child in giant galoshes who gives squealing chase. She'll forget the man by the gangway, holding out the woven tropic nonsense of a hat, mock bandito, his grin in its tequila glaze, his fool shins sunburnt. She will forget the same man, stooping to mortar the base bricks of their house, shirt a white straggle poking from his back pocket, the sun working north along the bones of his spine, against the grain of his sweat (she'll forget how much she loves each seam that liquid runs). She'll forget the roly-poly woman with her Xmas tipple in her crêpe paper hat, laughing at the chit of the cracker joke until she topples off her chair, takes a rush of tinsel with

43

her. She will forget the joke. She will forget the stitch on the blanket that the woman is rocking—shell, chain or crocodile?—forget the lullaby she's humming down into the bundle's drowsy face. Is it 'Danny Boy'? He can't remember either, as he pins the dark snuffed squares back to the wall.

<center>*</center>

She'll forget the white rabbit. She'll be out by the washline and flick up the catch to let the little thing out. She'll be strapping out the heavy slumps of sheets to set their wet loads cracking in the northerly, and she'll let the baby jumble around on his bum on the dewy grass to get to the lemons, scattered from the tree in dimpled thuds. She'll let him suckle on their pocked yellow balls. She'll shoo the rabbit closer to him just to make him gurgle, clapping his podgy hands at its flops. It's the sheets, it's the sheets that conceal it, the black and white bullet of the next-door's dog. It comes in and out the sheets, their wet white banners, the bloody lightspeed launch of the dog, that hits the creature, flings it up, figure-eight, in a grisly snarling jolt. And the sheets will bluster her outstretched hands and coat her mouth and blanket her calls. And it won't be until she beats to the end of their terrible flapping corridors that she knows what it is that runs wet in the dog's manic growls, that she'll know what is pinned and barbed in its muzzle. She'll forget to bring the washing in. But in two days' time she will refill the coop with a small bright bunny, a twin of bornagain fuzz. The baby forgets. The baby will never know the difference.

Did she forget? She must have left the cage open again. The dogs have got to her memory.

<center>*</center>

She will forget her teeth. She will watch them in their blue cup of soak and not know they were ever hers, their pearly stained curve, their arches of caramel. What did she say with them? Who did she open them for, clicking through the puzzle of sounds, her tongue swishing the glyphs. She watches the bubbles that lift off the molars like syllables. The half-moon palate fizzed with translucence. A beaded vocabulary sizzling, and lost. Anyway, it will be easier to let go the words now she's forgotten them. She can let them go soft. They can run off the edges. If her mouth can't make them neither can her mind.

<center>*</center>

She'll forget that he's already gone. He was always getting ahead of her—into the bookies for a flutter, the pub for a pint and a yarn, down the wharf to-see-a-man-about-a-dog. She could never keep up. And is that him now, hooting down the hall, with talk full of blarney, all smiles and tall-stories, roping everyone in with the scheme of his grin? She'll forget supper, be dragging the kid by the hand to hunt him down, to smarten him up, talk sense, get him on the straight track home. But you can't knock that grin, how he'll nod *fair enough*, fall in step, turn his racket of charm on her and the boy, and he'll canter them home, all cheek and malarkey, the kid a fool for his chuckles, smitten. And her no better: how can a woman be expected to fend that off, the wow of it? How can she store up the scores against him, the list of sorepoints and fibs and flaws? She'd dare any red-blooded woman to do it, faced with the dimpled no-good of that grin. She knows the moment she'll give in—he'll pledge to clean up, and he'll hand her the razor. Kitchen chair straddled, he'll cantilever back—into her fingers he'll stretch his dark throat. He'll say nothing, but hum as she grazes, philtrum, shadows, Adam's apple, the blade in the soap a bristled hiss. She'll forget it all. She'll willingly forget.

<p style="text-align:center">⋆</p>

The nurses are a side effect of forgetting. The face of one nurse slides into another. Their blue zip tunics and tough white shoes fill with ghost after efficient ghost. Even her son will forget their names. But he'll say to the last one, as he's hunched by the bed, *there must be a word for this.* And she'll pause behind him, place a palm on his shoulder. No, she'll say. *Without a word for it, you can let it go.* He won't believe her but he'll drop his head, let her voice in. Repeating: *in time, you'll forget.*

<p style="text-align:center">⋆</p>

Kisses in the threshed barn, the itchy glow of hay. Catching her breath in his laboured clothes, his musk of pine and turpentine and honey. A picnic table at the foot of a gorge. The deep-fried rustle of fish and chips. Playtime, zipping her boy into his parka, the plastic crunch of old rain. Flax moving to the creek in fibrous whispers. Bathing the baby in the late afternoon, laying him out on his shawl to babble, her face above him teasing up squeals and kicks, his fingers waggling for ends of her stray hair—just let her remember this—wordless gurgles of love.

SOPHIA WILSON

Mirror

Someone offered bags of shimmering confetti for a birthday—
another dubious item it takes
concerted effort to keep out.

A summer's day: inebriated kererū wing-stagger overhead and
the children have filled a bowl with water, scattered their glitter,
added snail shells, twigs, dirt, grass.

They stir up frothy, unsteady tide,
whirlpool plastic waste—murky depths of toxic plunge
charged with grime and grunge—

lay aside their sticks, observe debris drifting,
water settling, clarity in which sky appears—
a lightly swept cloud, the kauri's curved arm, calm.

Squabble. The bowl's kicked over,
water spilled and
I'm scraping confetti into the trash.

Nude Rabbit Run

Red was driving to Warrington, north from Dunedin, to look at puppies. Wanting a taste of winter air he retracted his stationwagon's sunroof. Air eddied around him. The low sun made bright blades across the motorway. Squinting, Red lowered the visor.

'Put your sunglasses on.'

Before setting out, Red had mounted his phone on the dash. Sherry was there on screen.

'Yeah,' he said.

'The sun visor down?'

A stand of eucalypts briefly cancelled the glare. Red was enjoying it—the scenery, the open road. Not that the motorway wasn't busy. Cars with racked mountain bikes. SUVs loaded for day trips. A surprising number of campervans. Lockdown was over, but unlike this lot, Sherry wasn't leaving the house. She'd let the lease expire on her shared desk and now did all her work from home. But Red didn't have that option and that left Sherry lonely and isolated, which was where a new dog came in.

'It's good to be going somewhere,' Red said.

He would have liked some music, but then he wouldn't hear Sherry. He glanced at her.

'What?' she said.

'Remember Moeraki that time?'

The road dipped to the right. Braking, Red turned the wheel hard. When he got lined up he accelerated. Having her there on the dash, it was distracting.

'Did you say Moeraki?'

'Nude rabbit run,' he said, enunciating. 'Remember?'

Two horses hung their heads over a fence. Grass sparkled. After a fast straight bit he went under an overbridge, entering a darker uphill section. Misshapen pines black from exhaust. Looming berms. Frosted mud in the ditches and obviously no coverage because Sherry had frozen too. The Pump

bottle was in a holder between the front seats and Red took it up, drank, and then replaced it. Ahead—a yellow 65 sign—the road went away to the right. Checking his mirrors, he eased off the accelerator.

'Okay,' he said out loud.

'Red?'

He stayed quiet for a moment and entered the corner. With his speed too high the car batted over the midline cat's eyes, but Red smoothly re-laned and accelerated towards the crest. Well off the motorway, on a broad section of gravel, cars were parked. Riders unloaded bikes and pulled on helmets. An older man watched Red pass. Out ahead the sea pressed against the black and green of the coastline. Waikouaiti, and after that Hampden, Moeraki and on to Ōamaru.

Ages it had been since they'd gone anywhere.

'Hey!' she said.

It startled Red. Her face in the screen was big.

'I said, do you love me?'

The road started a steep fall, but Red was ready, putting the car through a shallow turn and increasing speed as he hit a long downhill straight.

He rippled his fingers. The slope and the speed—it reminded him of skiing in Hokkaido. He was twenty then—almost ten years ago. With skiing the idea was to lean out over the slope. It was scary—the sensation of falling—but it meant getting onto your edges and that meant control.

Driving, he supposed, was different to that.

'Red?'

Bowie he would have liked. Or Queen. Something to get his blood boiling. Instead, calmly, like she hadn't barked, he said, 'I am driving here you know, love.'

A flat section ahead of another long uphill. More fences. Gorse. Another overbridge, dirty struts decorated with graffiti.

'Can't we still talk though?'

He felt tuned in to the vehicle. Paired somehow. It was weeks since he and Sherry had been so far from each other.

'I am here, sorry. Just let me negotiate this passing lane.'

'Did you say negotiate?'

Ahead in his lane were three vehicles. Setting his face for battle, Red put the

accelerator on the floor. There was a moment's delay before the car pulled. Landscape reeled past and his timing was sweet, coming up hard on the back car as the road flared, giving him a vacant passing lane. Checking his mirrors, he indicated and made a graceful curving move, around the first vehicle, past them all—a wagon like his, a grey sedan, a squat truck—before settling back into his lane, back to a more reasonable speed.

The successful manoeuvre under his belt, Red took up his Pump bottle, squirting vodka into his mouth like it was water and he was a sportsman of some kind.

'I do *know* you're driving, Red,' Sherry said as if she'd said this already and was worried he hadn't heard.

He looked. On their bed as usual. Her neatly combed short hair. Of course he loved her. He smiled.

She smiled back. 'We don't like patchy coverage.'

'We don't,' he said, and then, shaking his head, making a big joke of the memory, 'All *those rabbits*.'

Her laugh came through the speakers like music. What would his Japan-self feel if he saw him now? Disappointment? Surprise? Red had no idea. What he sometimes told Sherry was that he was still waiting for a clear idea of what adult life was actually about.

There was the urge to say something big to her. Instead he asked, 'Did the ad say how many puppies?'

He'd seen off another crest and was into a long downhill section. One lane his direction, two the other. Bordered by impenetrable-looking bush was a great sweeping bend. All that road, but no other cars to pass! Just a logging truck on the other side, working against gravity.

Red took a drink as a white SUV, indicator flashing, sling-shotted past the truck, up past Red.

With a shared sense of good passing technique, Red smiled and waved. But the energy of his greeting took his own car towards the road's edge. Light on the wheel, Red eased back into the correct position before returning to the Pump bottle.

Sherry had frozen again; now she came back. 'Red?' Then she re-froze with her face at a new angle.

What Red could say for sure was that his old self would have been surprised

at the pleasure driving gave him. Quieter stuff—maybe that's where satisfaction lay. Kids ... were they what was needed?

'The ad said three puppies. Well, five, but only three for sale.' She was looking at her laptop.

'Roger that,' he said. He was on the flat—the road running parallel with a rocky stream that ran through boggy paddocks. A sign for Waitati. Then the turn-off for Waitati. Past the dairy that had once been a petrol station and retained a petrol-station look.

The endless FaceTime stuff—it had started during lockdown. Sherry was scared shitless of Covid, but she was particular about what they ate, so he'd used FaceTime to keep her involved in grocery shopping. Then it just became habit—having her on his phone. At the bakery, the petrol station, going for takeaways at Level 3. They'd developed this off/on style of conversation—taking into account his having to deal with a shop attendant or whatever. It was company—they were together, but also sort of not.

Now what Red heard himself saying was, 'We should have children—that's what I think.'

Sherry's face moved, but then went still. She was smiling though.

What had served Red over the years was this don't-think-too-much approach. And so, having said what he'd said, he dedicated himself to the last bit of open road before Warrington. A great, undulating straight. On one side railway lines and then the estuary he'd just seen from above. Steep-sloped paddocks on the other. He remembered goats by the roadside when he was small, but now it was just grass patched with broom. Still no other traffic in his lane—he must have burnt them off. Way ahead a motorbike—its one eye shining—pulled out of what Red understood was a craft brewery but which over the years had been different things. Café/restaurant. Furnishing store. A cheese factory? Or was that further up the road?

'What?' said Sherry.

New York. Aged twenty, that's where he'd have expected to find himself. The heart of the world—not that you'd want to be there now. Making a postural adjustment, Red took in the speedometer. At some point he'd obviously put on his sunglasses. He took them off and reached for the Pump bottle as something slithered under the car, raising it. Heavy went the steering wheel as the car angled strangely and then became something else, something facing blue sky—

his white Subaru a space shuttle—and, as Sherry flew past, and as the car continued its cartwheel, Red's hands went up for balance like he was on a ride of some kind.

<p style="text-align:center">★</p>

To see better, Sherry changed the way she held her phone. Things were moving. There was noise, then stillness and a totally new view.

'Red?'

She looked at her laptop—at the sneakers she was thinking about buying—and then back at her phone.

'Red?'

There was new noise. Clapping, sort of. Was it sky she was looking at?

'Red?'

The sky swooped. Then there was a totally new man.

<p style="text-align:center">★</p>

Sherry was hanging washing. Jarvis stood near the basket holding a pair of Alan's undies. Through the sliding door, in the lounge, the vacuum cleaner was on. Jarvis liked to sit on it—feeling the warm air combing up over his face—and Sherry hadn't got around to turning it off. With the weather the washing didn't have much chance, but the machine had run through its cycle and beeped and when that happened you got the washing out and hung it up. Later maybe Alan would get home and set the clothes-horse up near the fire and then all this stuff—this business shirt for example—might dry.

Probably, before he settled into the kinder version of himself, Alan would say something about how Sherry should have done that herself.

Smiling, Sherry took the undies from Jarvis. 'Grots,' she said, 'Daddy's grots.'

Out on the road, a truck went past rattling hard.

Sherry lifted a fitted sheet. It hung wetly. Jarvis took an end and then shoved it aside, showing his face.

'Boo!' went Sherry.

'Boo!' went Jarvis.

It was close enough to lunchtime that after this she could put Jarvis in his high-chair, poach them both an egg, and have some time with him at the table before his nap. Then maybe she'd try and get some work done. Or maybe she'd sleep.

Leaving the sheet, Jarvis went to a pot where there used to be some parsley but was now just potting mix. A piece of Duplo was there too. He picked it up and put it in his mouth.

Sherry turned her attention to Alan's jeans.

She met him the day Red died. Alan had been drinking at the craft brewery and went outside with other people in response to the noise. Red's phone had been on the road. When Alan picked it up Sherry was there.

'Red?'

'I'm Alan—there's been an accident.'

He'd stayed. Right through. Through her scream, her demands. Most people would have excused themselves, but Alan didn't relent. Holding the phone so she could see the scene, so she could see the ambulance on that long straight with what was left of the Subaru in the foreground. He wasn't getting too close though. Sorry, no. She could look at his ugly face. He wasn't sure of the right way to handle this, but that was his decision, he wasn't going in tight— her friend or whoever was dead. The wreckage, she could see the wreckage, it was like a small plane had come down and the person in there was deceased, he was so sorry, maybe that was something someone more qualified should be saying, but they didn't have the phone, he did.

Red left that morning and Alan arrived—drove with Red's phone mounted on his dash—in the early evening.

Sherry hung two of his socks. Jarvis had trailed around the house towards the steps that led to the road.

'Jarvis, Jarvy-bird?'

Right away he came back, dragging an old tea towel.

'Good boy—good little man.'

Something larger than your average tradie's ute roared past. It stopped Jarvis. He raised his arm pointing, and then disappeared again, following the noise.

'Jarvis?'

She was almost done. Quickly she hung a tea towel and then one of the cloths they used for face and hands.

'Jarvis?'

Here he was. On the trike. He had Alan's nice features, his brown eyes.

'Hello love,' went Sherry, bending, holding herself by the knees.

All the medication. Pregabalin. Antidepressants. Benzodiazepine. She'd

disappeared from herself—knew herself in relation only to the fact she'd lost Red and that since lockdown she didn't leave the house.

Jarvis got off the bike, made a face and pushed it like it had somehow wronged him.

Inside, the vacuum cleaner droned. The sun had come out, making the little patches of water on the deck shine. Alan only knew some of what went on. Not always did she share information about a new drug she was starting. What she knew was that she probably shouldn't be in charge of Jarvis. She was easily distracted. Combine that with a sensation of removal—like her life was a movie she was watching. Though that sort of admission might be too heavy on Alan. He'd absorbed a lot.

Sherry was looking at the remnants of a broken peg. She worried that Alan had this limited well of empathy.

Standing, she went around the house. Jarvis was working a broom across the pavers. Another truck passed.

'Some sort of truck show on?' said Sherry.

Jarvis looked. 'Tuck,' he said.

'Truck,' that's right. 'Truck.'

Jarvis blew into the end of the broom like it was a didgeridoo.

She sat on the step. Above her on the footpath people walked past. At work Alan was this one version of himself. At home another. Transitions were where things got a bit sour. Immediately on getting home he'd go around taking in all the different things she hadn't done—cook tea, vacuum, make beds—and criticise her.

Nothing really nasty. Just enough though to get Sherry crying or flinging something, which was when the role-change would happen and Alan would become this better, more caring model. But overall, she loved him. Didn't she? They'd met in this weird way, but … where are you supposed to meet? Work? Masked-up on a bus? Sherry didn't like being alone and now she wasn't. She had Alan, she had Jarvis.

Her bum had absorbed the cold from the step.

The other role Alan played was 'horny lover'. A couple of times a week he'd take up this Sean Connery version of himself. A deeper voice, a sort of waggle in his lower back, insistent eye contact …

Jarvis looked at Sherry. Sherry smiled.

Red had been way better in bed.

'Sex is the only reason I keep Red around.' Pre-Covid it was the sort of thing she'd say to friends. A joke, but also a bit true. Really, Red was hopeless. A child in a nice body. They wouldn't have lasted. Lockdown, Sherry's anxiety—that's what prolonged them.

Jarvis moved past her. She kissed his cheek, tasted peanut butter. The sun came on. Maybe that washing would dry. Alan would be amazed.

Jarvis.

'Jarvis?'

She turned and went up the stairs. The gate was open. Jarvis wasn't at the top.

'Jarvis?'

Cars were parked both sides of the street. She looked up the footpath. Turned, looked down. Went between cars onto the road.

'Jarvis?'

Her body was low, arms wide like she was preparing to make a tackle. A woodpigeon bombed by.

'Jarvis?'

She allowed herself to shout. So humiliating, she'd lost her child. Her tongue went dry.

A car passed. Then a motorbike.

'Too fast, too fast,' she called.

She went back onto the footpath and down the hill. Past their garage. Past a low white fence that stood before the neighbours' grey villa. She stopped, turned, and ran back onto the road. The place of most danger was where you needed to be.

'Jarvis?'

Further up, on the corner, was a house with chickens out front. Alan sometimes took Jarvis there. It was something to cling to. She hadn't run for a long time. Her feet fell hard on the road and then the footpath. Music played. She was outside. She was in the world. And she'd lost Jarvis. The cars shone. The chickens were there, but not Jarvis. A van went past. Kidnapping? An abduction? She ran back onto the road, trying to catch the rego. Only the van's air was still there.

'Jarvis?' She yelled so loud the chickens startled.

Alan. She had to call Alan. She ran. Her stomach and other organs felt wrapped tightly like furniture ready for removal. Their orange mailbox. Their stairs. She flung herself along as if shot from a gun. The doormat, the thing they left their shoes on, the smell of the bathroom. The vacuum cleaner. And Jarvis. Jarvis there, riding the vacuum cleaner.

<p align="center">⋆</p>

Red was outside smoking. Drinking a beer with the huge moon on him. Inside, Sherry watched through the window. They'd lit the fire, drunk wine, dragged a mattress out into the lounge and had all kinds of sex. Sherry shifted her legs, re-settling the memory of him. Red out there naked.

'Gotta cool off, my god,' he'd said, kissing her.

Light caught on his back muscles as he inhaled. The neat V his hair made on his nape. His ears. Never had she met anyone so pure, so *animal*.

She hoped he'd turn and he did, grinning and raising his beer. Beyond him was a huge lawn, sloping up to where they'd parked.

He'd won some money gambling and rented the house for the weekend. Three weeks they'd known each other. Moeraki. Maybe tomorrow they'd see the boulders. Maybe they'd just lie around drinking and screwing. Now Red turned back to her, a different expression on his face, gesturing at where something was moving on the lawn's fringe.

A rabbit. Two rabbits. A whole lot of rabbits. Spilling carefully onto the lawn.

'Shit,' went Sherry.

Red made a what-the-hell? sort of expression and then tilted his bottle, tipping beer into his mouth. The rabbits, let's say twelve, had settled, feeding separately. Sherry held her wine. The fire popped, glowing, and now out the window Red ran. Turning up grass like a bull. His cock joggling mightily, tracing a clock's face, twirling as he turned again, tearing up the slope. The rabbits were stunned. Pressed low in terror as Red sped back towards Sherry, leaping one rabbit, dodging another. Turning again for another pass and this time one ran, exploded up towards the car, and the rest of them must have been tuned into its confidence, because they too zipped away. But even with the lawn clear Red kept at it, circling, weaving, jumping.

Sherry raised her glass. Certainly what it looked like was love.

ELLA BORRIE

Ōwhiro Bay

After Brian Turner

The road follows
the scoop of the coast,
the glassy sea
and sky
smoothed out
at dusk.

Bike wheels purr
along tarseal;
standing, pedals still,
I feel the slope of the land
pulling me
on and on.

ART NAHILL

Inoculum

A cough can travel
eighty kilometres an hour.

The skin sloughs
nine pounds of cells per year.

A dressing gown hangs
in the wardrobe.

The toothbrush
in a plastic cup.

We leave the flotsam
of ourselves
everywhere.

Luckily
the blood remembers.

The body knows
what is self
and what is sea glass.

King Mithridates of Pontus
took tiny aliquots of poison

to inure himself
to assassination.

One's man's inoculum
is another's disease.

The mourning doves' call
is on endless repeat. I listen
with my teeth clenched.

The fog this morning
is preparing me
for your absence.

LIZ BRESLIN

A Handy Guide to Reality

everything is perception, bitches
the stuff you think you know
is only sensory and retinal illusion
with neuro contextual bias and effects

everything is perception, bitches
the feel of the thousand count sheets
the sugar you don't need to eat
what you think of the kid with the braces
sentences that start with I'm not a racist, but

everything is perception, bitches
the stories you tell yourself about short skirts
which way and how your heart jerks
when someone says Metiria or Trump or dead meat
or got your feminickers in a twist

everything, bitches, is perception
money's a plastic promissory
government the corporate conspiratorial artifice
and you—what are you gonna do about this?
nolite te bastardes, bitches
plant garlic to the moon, mine tweets
make digits dance on the page, direct
your energy, check your chakras, your
privilege and your bottom line, bitches, lean in

everything is perception, except
you can't fix Syria with biofeedback

techniques—empty bellies, bitches
hollow politics, neo-Nazis in the mainstream
in the streets, pollution past redemption
vitamin deficiency, the big unfreeze
shoes without feet, people with holes in them
guns, drones, sunshine, lions
those, bitches, are real

JILLY O'BRIEN

Simon Armitage stole a girlfriend off me in the 80s

which meant nothing to fresh Dewsbury
clutching GCSEs and a Saturday bus route

to the hillside crest, alone on Scar Lane
drawn on windows, made of stone

cold glances on the dance floor
at the Changing Lights, where they know you

say tongue wrong, but make you feel the rush
of aching air on the late train. You don't belong

in Salford or Rusholme nor should you
trust in slightly older boys

for a mix tape. Luckily the Colne flows past
Golcar so you can follow it back. I wonder

who she was and whether 'Fools Gold' was her first
12-inch as well as mine

BRENT CANTWELL

Some Rakaia

because it was warm,
he wore gumboots
without socks
though they squelched—
lung-black—
making a wet cough
of walking
and at the top—
near the bulge of his calf—
a red ring
formed the last red scar
of the kiss
that kept
the rubber taut.
They were easy
to pull on
when he wanted milk
for coffee
and the service station
on the highway
was close.
But most of all
he could walk
the side-road edge
then down the middle—
smoke on his lips—
lost
in some Rakaia

WANDA BARKER

Mermaids

I want my Mermaids alluring with blue hair
Big flukey tails, scales gleaming with chrysoprase, hermatite
Lapis. Topaz for their slits of cat-eyes
Hissing with foam and salt
Mermaids who think like shards of shimmering fish
And are faster than sharks
With pearls and tusks for teeth

Who eat the bad men, with legs dangling over
Old fisher ships made of wood, with leaks they
Don't know about
Mermaids who bite ankles and chew one hundred foot bones
Toss them like severed seals into the cloudy air
Before swallowing them whole
Return for their begging legs
Deaf to their whiny pleas

I want the Mermaids to be badder than the bad men
Not full of palliating smiles or patience
Not gathering shells or coins from treasures lost
Not stashing them for rainy days
Not giving their plans or pennies away

Mermaids full of sea-rage and charcoal storms
that suck dumb ships
Down into whirlpools and rampant vaults
Full of stinky sailors who steal all the fish
And take women for slaves on their poxy days off

I want Mermaids who gather armfuls of bones like jewels
And make castles of them on the ocean floor
And fill them with all the sandy drowned children waiting to be claimed
Where trunks of emeralds and sapphires are washed clean
With indigo hair
Where their scales are soft one way, unless ruffled
And then they're keen and cruel
like needles

One to Many

His email had said, 'Unfortunately, I will only be able to meet you once.'

He hadn't provided a photo, although she had sent hers.

She waited in front of the station exit, biting the inside of her right cheek—it was already raw. She scanned the male faces around her with dizzy certainty. *I'm too early*, she thought. *Whatever—it's not like meeting someone for a date.*

In her ears, a distant roar was approaching. *Is this what it's like to pass out?*—but up in the blue, there it was: a glint of metal wings. Nothing personal. She was one person on the ground, looking up at a plane, caught in a surge of others.

She had re-read his email so many times.

It went on: 'There are hundreds of you, I'm told.'

From a distance she was a dot on the ground among others just like her, devoid of meaning. An abstract good, not an individual. A product, so easy to create.

She saw how a plane could drop bombs: the abstract many had a weaker claim than the one. In this case she was the many; like it or not, she always would be.

That email again, a niggling earworm: 'I want to ensure that I can offer the same amount of contact to everyone who applies for my information.'

Fair. As the clinic said, he could reflect with pride that he had anonymously 'helped so many family wishes come true'. He had 'given the gift of life'. He was 'not responsible for the children created in any way'.

She had been the gift so generously given: one of many packages tossed out of a plane for ten dollars a pop. She should be grateful. She was lucky he'd agreed to meet at all.

That email: 'My time is limited.'

True. Nothing personal. So was hers. She had searched for years after finding out the truth as an adult. Who wouldn't want to know who their

biological father was? The origin of the blueprint written in the cells of their body. Heritage and ancestry.

A complete medical history? People have died for lack of one: because they were lied to about their parentage and didn't know they were at risk from hereditary conditions. Her teeth clenched until she tasted blood.

One awkward meeting? Even when he didn't want to know her?

Yes.

She had one biological father; one life to live. A childish singsong: *You get what you get and you don't get upset.* The plane had disappeared.

There he was now, rushing along; biting the inside of his right cheek. Their eyes met. She saw his familiarity—which instantly lent new sense and meaning to her own reflection—but also how familiar *she* was to him, how familiar this situation. How he could treat her with detachment, like a stranger.

The email concluded: 'I wouldn't be able to sustain a relationship with you: it wouldn't be fair to your brothers and sisters.'

PETER BELTON

Willows and Water

It is noted the river is always the same and always
Different with the sun slipping behind cloud, or is it
Cloud that wipes the face of the peeping sun and then
Casts a shadow onto swift, yet smooth, water to throw
Something recollected as diaphanous as a woman's
Shift over the pool of light into which I stand? Now, to
Slip feet into a skin of slippery stones and a wet
Embrace. My mother, my sister and my daughter
Come and go likewise and I try to hold their glances with
Mine, the slips of breaking smiles, as fugitive as running
Water. And, how can I hold on to this when they are gone?
To stand in the gentle Whangamoa Stream, my place to
Be with memory in my hands, and the progress of water
Under the willows laden with the scents of recollection.

PETER BELTON

Vincent's Starry Night

Vincent. He insisted on being called
just Vincent. The signature tells us.
The missing bit of ear is somewhere in his
starry night, spiralling out through the deep
plughole of the Universe. Not a straight line
anywhere. The bottles arranged on his terrace
become cypress trees sweeping and thrusting
feverishly into the starlight where the traffic of
lanterns in Arles would confuse together and the
moon capture the yellow bright of the sunflower.
And, all his hammering of indigo and ultramarine is
stirred into the bedspread of night becoming.
Hard to walk a straight line when your head is
full of pain and stuffed with medications.

ROBYN MAREE PICKENS

Praise the Warming World (Try To)

after Adam Zagajewski

Try to praise the warming world.
Remember the crisp delineation of seasons; the sting of winter
and the pond that froze each year, blades clinking on ice.
The pinecones that fell around the edges and lay entombed
all winter long and your mother who swept away fresh snow each day.
You must praise the warming world.
You watched icebergs shear off Antarctic glaciers.
One of them floated off the coast of your city
while others melted into the scent of salt.
You've seen the refugees going nowhere.
You've heard the silence of detention centres and deportation.
You should praise the warming world.
Remember when I licked warm honey from your burns
in a quiet room bright to the eyelid with sun.
Return to that small hut perched on the edge of the lake.
You traced ripples made by oars with your hand
and snow filled in the earth's furrows and sores.
Praise the warming world
and bare branches strung with bird song
and the stray light brushed with wing beats
on a clipped winter's day by the pond.

water tower

at the highest point of the valley a red light waits fifteen seconds
to go green. when the light goes green it means you can go
shovel up your breathing and pitch forward
into the black. from the lighthouse

blue and smoking-pistol-brightness fading from the walls
of the lighthouse. little kids leap under your arm and throw
shadows unto earth and the blinking green-red
leap of faith. away from gravity

steam billows through a holey cloak of forest and follows
no newton's law. soon your brother will come up to find you
iron-fisted on the handrail and shaking cold
with the chlorine. no ocean from

whence you came clings to you still so you smell of mineral and
pale chlorinated freshwater. children's choruses are the only noise
spinning invincible threads through air and the whole
valley is children. you are one

rain and tinny-glowing-sound thunders on your shoulders and runs
down your chin. as a toddler you drowned in the deep pool
or nearly did your dad swore and fifteen years later you're
back here alive. from the city

where there are sombre solid ground levels and no flying permitted
unless firmly tethered. tomorrow after taupō your city will call you too
old for waterslides, but for now you're here, suspended in red
and green light. The light says,

go.

70

TIM UPPERTON

Green Monkey Soap

Best toy I ever had was my green monkey soap. It wasn't really a toy, not like a soft toy. It had no fur, no stuffing on the inside, no glass eyes. It didn't even have arms and legs, or a tail. Its physical details were bumps and indentations in the soap, which flaked and chipped over the course of that year, the year of the green monkey soap. Its features blurred, and towards the end it didn't look like a monkey at all. It was just a small lump of green soap, and finally its soapy scent was gone, but still I held it in my hand and whispered to it in the dark.

YONEL WATENE

Wizard Doctor and Patient, 2020, oil on denim, 1200 x 1600mm
Coffee, Level 3, 2020, oil on denim, 1500 x 950mm
Routine Check-up, 2020, oil on denim, 700 x 600mm
Driver after Guston, 2020, oil on denim, 1200 x 950mm
Wizard with Gloves, 2019-2020, oil on denim, 755 x 2130mm
Sick Wizard #1, 2020, oil on denim, 1400 x950mm
Untitled (Judy, legs and boots), 2018—2020, oil on denim, 1500 x 1000mm
Wizard Looking at a Door, Level 4, 2020, oil on denim, 1600 x 1000mm

Yonel Watene's paintings, which tend to work in themed series, pulse and bop with energy, comedy, drama, poignancy and mystery. Watene describes the figure in this Wizard series as 'a wimpy verison of Gandalf—super anxious and human—sad even'. In this new suite, colours evoke emotions perhaps more intensely than in his earlier work. The falling colours in *Sick Wizard #1* are like a rainbow ice-cream hitting overwhelm: the character seems to be all feeling, no rationality, in the midst of a major emotional meltdown. In *Wizard Doctor and Patient* the walls are a weak bilious yellow, the soap a heavy noxious green, having somehow taken on the qualities of what it's meant to eradicate. The enlarged dark pupils of both human figures are like those of spooked trapped animals, the rings of their irises appear to well with fear, pain, or, in the wizard-doctor's case—to thin with a jaded resignation. In the image of the wizard cocooned in a homely patched quilt who stands looking at the red door, Watene seems to capture a sense of shelter and safety, and yet dread and longing. The playfulness of the cartoon figure, the simplicity of the shapes, also offer a leavening, a lightness of spirit: we're laughing at the dark even as it treads closer.

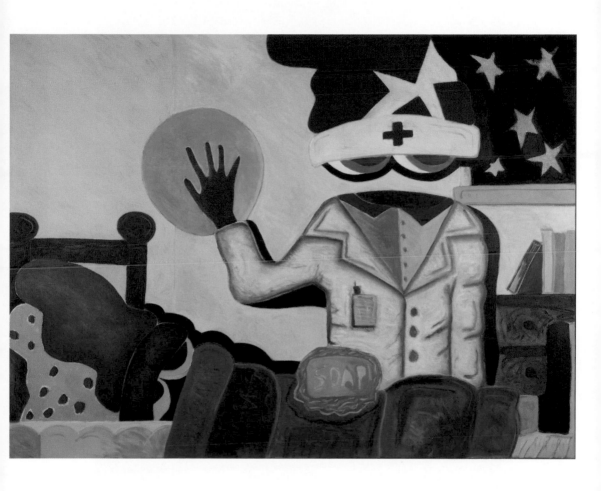

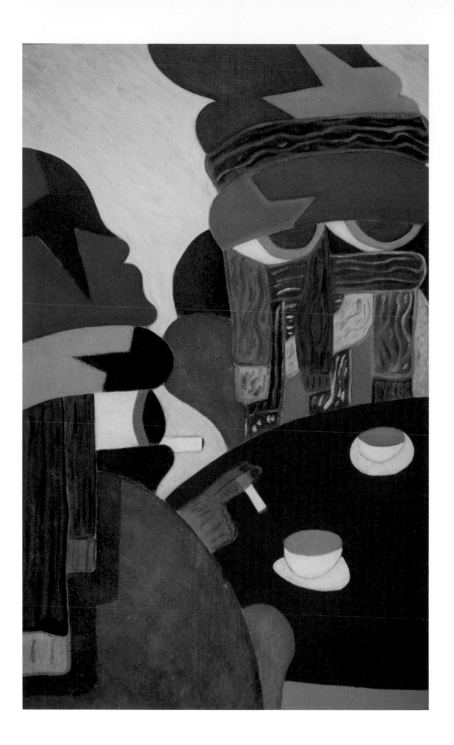

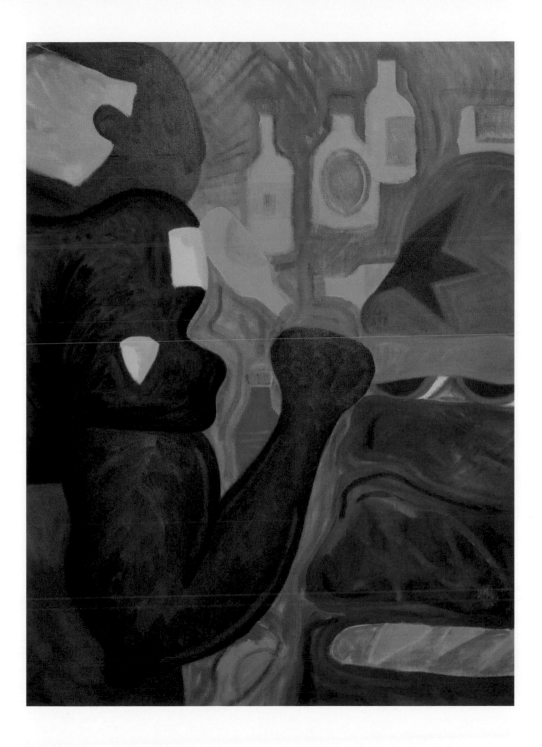

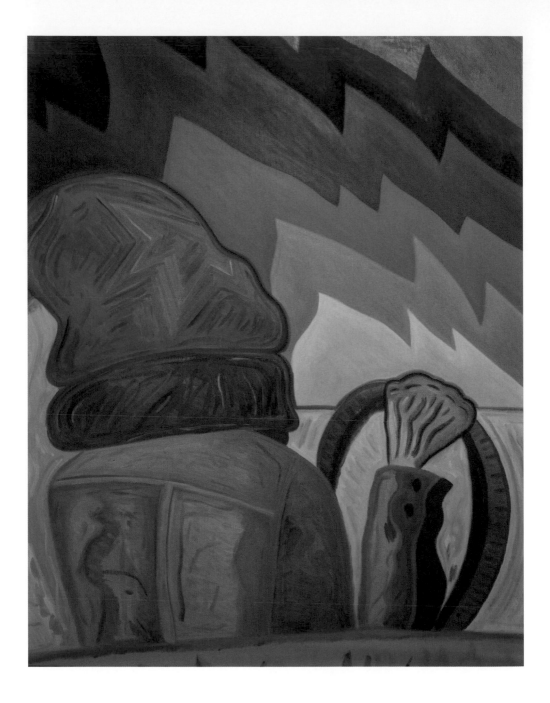

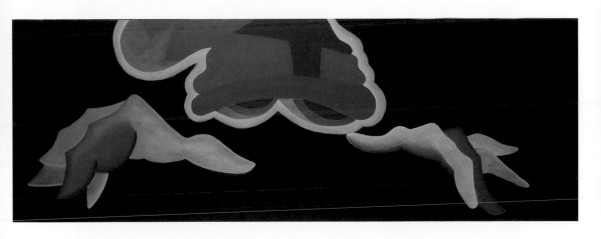

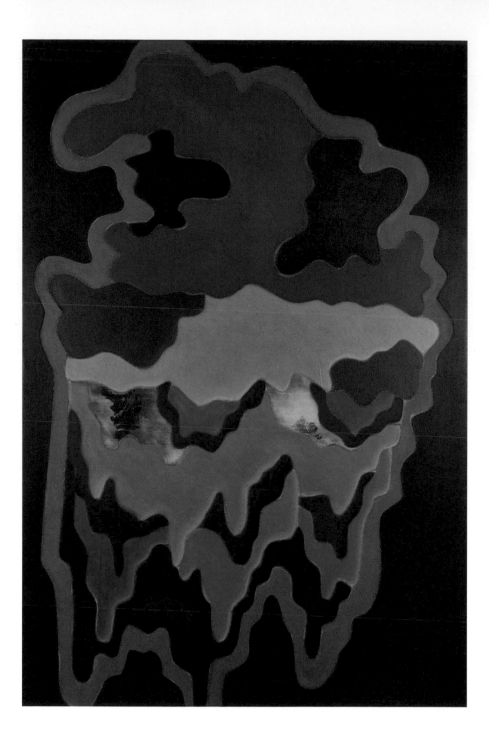

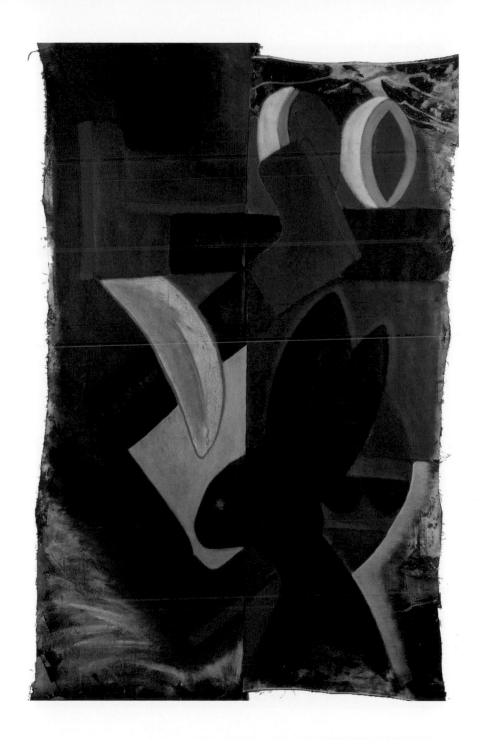

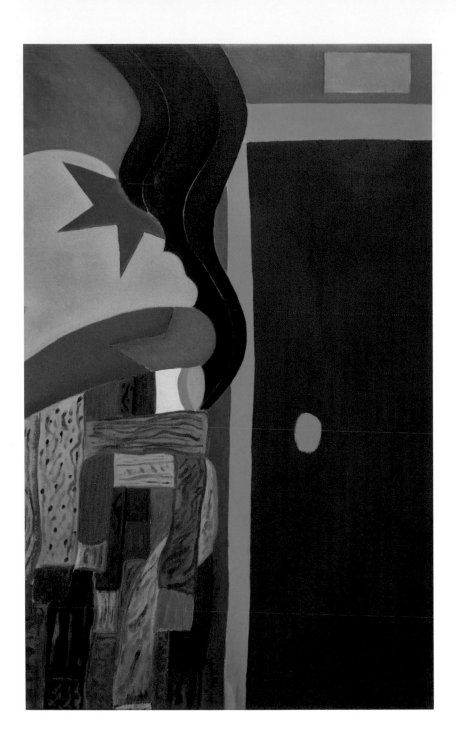

RUTH RUSS

Your Absence

It chills me, like a mime
who leaves the stage
without closing his doors—
and I cannot find them
to shut out the draught.

MATAFANUA TAMATOA

Organics in Ōtara

Chairs from Mitre 10
Humbled by heavy bones
A greying mattress
Wet, with less foam
And less comfort to give
Simi's suit from five White Sundays ago
Lint proud and unloved
Foreman's grill, blackened by the hassle of
Grilling for a family of six
Empty DVD cases, simmering in large boxes
Unwelcome and unlucky
As ripped pages of *Sweet Valley High* sway against the soft rain
The *Herald on Sunday* now soaked on a Tuesday
With big headlines of fading rugby players
And broke reality stars
Car tyres and a small bike from last month and last Christmas
All waiting patiently for the council to come.

SUGU PILLAY

Her Artful Memory

The man sitting next to her touched her midriff between her scarlet blouse and sari. Uma edged away from him as far as possible in the economy-class seats. The man didn't persist. Uma was too busy shedding a self she didn't recognise any more to worry about a pathetic pass from a total stranger.

Wellington airport in February 1973 was a homely place, like someone's sitting room, tatty and lived-in. Malati was waiting as promised. She drove Uma to her little house in Roseneath. One wall of Malati's sitting room was glass and looked out to the harbour. Uma was thrilled. Her first taste of looking-glass city! Malati's flatmate Vera had cooked wiener schnitzel for dinner. Malati, a Methodist, had perhaps thought to test the orthodoxy of a well-brought-up Hindu girl who was not supposed to eat beef. Uma inhaled her new self and dug into her schnitzel with trepidation. And found herself enjoying the meal.

The next day Malati drove her to Victoria House, the university hostel on The Terrace. The warden carried her suitcase—Uma's introduction to egalitarian New Zealand: in Malaysia the warden would have got a member of the domestic staff to do it. Uma was now ready to like this country, though at home she was known to growl if Fatimah did not have afternoon tea ready the minute she woke from her nap. She had many liberated ideas but living them was another matter. Action was always postponed to that ideal square of sunlit green she was going to get to some day. Plato awaited her there. She had much to converse with him about.

The warden showed her to a room in the old wing, a wooden house converted to a hostel. Character homes not being part of her mental landscape (though they would become one of her passions in later years), Uma grumbled and froze in her cold draughty room, and in a matter of days had got herself a room in the new wing of Victoria House. Here there were alternate floors of male and female residents. Richard Wong told her he had bought a pair of clogs with high heels to avoid contact with the daily layer of vomit and muck on

the floor of the men's toilets. Uma stored this bit of information just as she did her first sight of the glass-strewn streets of Wellington. She was aware of drink and vomit as part of the male mystique in macho novels (the pride with which this malodorous activity is written about!) but she was not prepared for all the broken glass. This was what happened when the pubs closed at 10pm, she was told. Customers drank at record speed, daring time to slow down, then got booted out to fight and break bottles over one another. Think what it would have been like some years ago when the pubs closed at 6pm, said Richard.

The MA course in English literature turned out to be a pleasant experience despite its many worrisome assignments. The classes were run seminar-style with ample time to read the set texts, which Uma did lying in her narrow bed, the warmest place to be. Except for Mei Lin, the other Malaysian on the course, all the students were Kiwis who had just completed their BAs. Uma had had two years of teaching experience in Malaysia and felt old. At first everyone ran to turn on the heater when she came in dressed in a sari, but they soon got used to it. She couldn't bear to see everyone in that awful uniform—jeans and jumper, and the same jumper every day! Even Mei Lin dressed that way. What they didn't know was that she was quite snug in her leotard tights under her sari.

Her favourite paper, on Dickens and Thackeray, was taught by Professor Mary Bloom, who had sketches of the London of that period all over the walls of her study. To Uma the room felt like a time capsule. She imagined herself running past Fagin's boys down some murky lane, or queuing with tearful Victorians for the last instalment of Little Dorrit. She could see herself in an elegant drawing room nursing a glass of mulled wine and smirking at Thackeray's witticisms on the rich and famous. Ah, gentle times, Uma thought, when men and women of Letters were treated as if they mattered.

However, it was on the New Zealand literature course that she really came into her own. Given her first assignment, she hurried to the library to read the critics. All she found were copies of Landfall, the sum total of critical writing on New Zealand fiction. How on earth was she to make her essay the authoritative academic artefact it was meant to be? Landfall had nothing much on Maurice Duggan, on whom she had chosen to write. Well, she got on with it. When the essay came back with an 'A', Uma realised she had a mind after all. She would always think of this course with gratitude.

Uma was also fond of Dr Smith, an Oxonian who was feeling his exile, and whose regular routine with anyone new was to raise one eyebrow ever so slightly and recount how his son's Kiwi father-in-law, a wharfie in Auckland, went to work in a taxi and had steak for breakfast. Uma's only complaint about Smith was that he treated her like some exotic creature, a Shakespearean headless wonder. If Uma was late for a tutorial and apologised, saying she had dawdled on account of the sunshine and the spectacular harbour views, Smith would latch on to 'dawdled', roll his eyes and say, 'Now where did you pick up that word?' She could see him turning this into a one-for-the-road tale to share at the staff club. Having heard something of her past from Malati, Smith also appeared to invest her with the tragic potential of a Hardy heroine. During class discussions of *Tess* he would turn to Uma as if expecting grand pronouncements on Love, Chance and Destiny.

Some of Uma's classmates took her to a poetry reading at the Wellington Settlement. Looking around the crowd that had come to listen to Denis Glover, she realised she was the only brown-skinned person present. Where were the Māori students she had seen depicted in the glossy brochures she received in Malaysia? She had met other Asians and a couple of Pacific Island students on campus and of course in the hostel, but she was yet to meet a Māori. She stilled her rambling mind as Glover appeared on stage. Drunk, incoherent and ranting, he nevertheless left his audience, including Uma, in awe. All filed out humbled by the presence of genius. Uma wondered what Baxter would be like.

The first Māori Uma met was a writer. It was quite by chance. Stella, a first-year student in the hostel who did not want to lose her waitressing job when she went home for the holidays, begged Uma to stand in for her. Thus it was, during a busy lunch hour, that she found herself serving this writer with whose face she had become quite familiar after repeated reading of his book of short stories. 'We are studying your book for the MA,' she gasped by way of introduction. He smiled and asked the usual questions. Where was she from? Why had she chosen to study in New Zealand? Then he said, 'You must write too.' For the rest of the day Uma went around with this horrible pain in her abdomen. Why had he reminded her of the novel held prisoner in her womb? Conceived in her teens, this creature had taken fright during her time at the University of Malaya. Refusing the comfort of birth, it lay leaden and despairing within her.

One day Uma received an invitation from her university-appointed mentor for a pot-luck dinner at his place. 'Oh, by the way,' he said, 'I hope you'll cook us a curry. You can do it at our place.' 'Yes of course,' gulped Uma, and then nearly fainted from the worry of it. She had never cooked anything in her life! It was sheer luck that soon after this invitation she met a Fiji Indian student who invited her for a chicken curry lunch at his flat, and then proceeded to cook the meal when she arrived. She was amazed at how easy it was. Onions, ginger, garlic, spices, curry powder, the chopped chicken and tinned coconut milk. It really tasted good. On the appointed day she arrived at her mentor's house with diced lamb and other ingredients. There she found a huge crowd. Uma panicked. Her mentor assured her that when everyone's dishes were laid on the table there would be enough for all—that was the meaning of 'pot luck', he explained. Uma wondered if he knew how much luck her pot of lamb needed. Amazingly, her friend's recipe worked. As Uma's lamb curry was consumed with appreciation she was fairly bursting with pride. How could she make this do-it-yourself society understand that this was a major milestone for her?

Uma's first date with Larry was memorable in a wholly unexpected way. As they walked back to the hostel after dinner they saw a woman staggering around, bleeding from a small cut on her forehead. Larry was all for walking off and minding their own business. This shocked Uma. She had liked Larry for his devil-may-care attitude, his fierce opinions and utter disregard for convention, the proof of which lay in the mould sprouting from unwashed crockery piled up in his kitchen. But not to assist someone who was clearly in need of help seemed callous and selfish. Ignoring Larry, Uma asked the woman if she could take her home or to the hospital. At first she couldn't make sense of her drunken slurred speech, but she finally understood that the woman's husband was in the pub across the road. Uma entered the seedy bar. Ignoring the whistles and catcalls, she sternly told the man pointed out to her that his wife was injured. The speed with which he sobered up was truly remarkable. He hurried out to take care of his wife, thanking Uma profusely. Larry transformed this incident into a tale of heroic proportions and repeated it to the whole MA class. Uma, who had felt brave and caring, now felt the storyteller had acquired the real glow. Perhaps, she thought, this is why writers got hooked?

One day Uma threw caution to the wind. When Andrew and some of her course mates invited her to a pub crawl, the quintessential student pastime, she

accepted. She had her first cocktail of unknown ingredients and learnt the art of 'shouting' a drink. Andrew kissed expertly but was disappointed she wasn't an Indian princess incognito. When the group adjourned to Andrew's flat, Uma was teased mercilessly until she accepted a joint that was passed around. She inhaled deeply several times as instructed, but nothing seemed to happen. After that she told her friends that she preferred to get her highs from books and music. She was never tempted again.

The other daring thing Uma did was to hitchhike around the South Island, an activity unheard of in Malaysia. Thumbing rides seemed a perfect way to travel. There was so much time to stand and stare. She was bowled over by the southern landscape, the rolling plains in cubist shades of green, the hint of purple in the hills. She mentally drowned in the iridescent lakes, the reality more fantastic than the rendered landscapes of Rita Angus. She insisted on walking up both Fox and Franz Josef glaciers, and was terribly embarrassed when the guide had to hold her hand each time for the descent.

Sadly the year was almost over and the dreaded exams loomed near. The first, on the 1890s, called for a formidable single three-hour essay. It was one of Dr Smith's papers, and when she arrived he was standing at the entrance to the exam venue. Her course mates saw him and begged to be allowed to take in their books and notes. Smith turned to Uma and Mei Lin who were standing apart silently and asked whether they had brought any resources. Dumbfounded, they shook their heads. Nothing like this would have been possible at the University of Malaya. To Uma's relief, Smith decreed, 'That's it. No books or notes allowed.' Oh, the glares from all directions. If looks could kill!

When the exams were finally over Uma was in for a shock. Every one of her fellow students disappeared. Her enquiries to the department secretary were deflected with, 'It's the big OE, you know.' Apparently being 'down under' bred a hunger for 'up yonder'. Europe called and Kiwis answered. Another mysterious phrase was 'godwits fly'. Uma was told a godwit was a migratory bird, but was unaware of the implications of this glorious phrase. Academia had yet to give its stamp of approval to Robyn Hyde. What was not on the New Zealand literature reading list did not exist. It was indeed some time before Uma learnt that the flight of the godwits was a colonial disease, well documented from Mansfield to Naipaul, and thus she gradually became acquainted with the New Zealand that lives in its metaphors.

CATHERINE TRUNDLE

Family of Sorts

A child sleeps on the window seat.
Evening lies across him
like melted glass.

He smells whole,
of sainted fists.

See how his mouth shines,
a barefaced lotus.

And watch
how his body draws in,

soft as hymnal
bright as animal

while we settle in
to the palm of our own silence
and drink up cupfuls of his

soft-limbed light,
his gravity sunk deep
along the coastline

of his little
shipwrecked hips.

CHARLOTTE GRIMSHAW

Extract from *The Mirror Book*, a memoir

A man I'd known at law school, Shane, offered me a room in his flat. I went to
have a look at it. It was an apartment built on the flat roof of a nine-storey
office block, the CML Building, in Queen Street. The building was scheduled
for demolition, and all eight floors below the flat were empty. To get to it we
entered the mall at street level and unlocked a door at the back of the mall that
led to a lift. We rode up eight floors and got out on the landing, after which we
walked the final flight of stairs to the flat, a single-storey concrete structure, its
ranchsliders opening onto a large roof terrace with a view over the buildings of
Queen Street.

I looked around, glancing into the bedroom, which was sunny and spacious,
the windows open onto the roof area. I checked the small dingy kitchen and
the terrace outside, where Shane's flatmate Karl was lying on the concrete,
sunbathing and reading a book. Karl was a policeman, relaxing before his shift
at Auckland Central. He was friendly. I noticed his book, a serious novel (how
surprising, how ingratiating) and that he was unusually handsome.

On the way back down Shane showed me some of the empty floors. The
furniture and partitions had been cleared; shafts of light through the dirty
windows lit up cobwebs and dust. On one level a huge metal safe stood in the
middle of a wide stretch of carpet. It looked stark, sinister. I felt frightened just
looking at it.

But down in the bright busy mall amid the shoppers and with a view of the
sunny street, I shook off the feeling of apprehension and said I would take the
room.

The rent was cheap because the block was due for demolition, and the
location was perfect. It would take me five minutes to get to work. Each
morning I exited the building, crossed the street, nipped up a back alley, took
the elevator and I was in the foyer of the law firm. From the roof of the CML
I had a view across the rooftops to my boss's office, so I could see when he'd
arrived at work in the morning.

The first Gulf War had started and I'd got addicted to CNN. Some lunchtimes I would sneak back to the flat so I could catch the latest on the war, which had its own logo, theme music and cast of characters: the ghastly Saddam Hussein, his degenerate sons Uday and Qusay, the Scud missiles he ineffectually lobbed into Israel, and the American president, whom I took for a fraud and a dissembler, not knowing what worse crooks and liars were to come.

(It was my intense, lonely surveillance of the first Gulf War that allowed me to dismiss early on and with complete confidence the big lie about Saddam having weapons of mass destruction. If you'd paid attention at all, if you'd watched his gimcrack Scuds damaging a letterbox in Tel Aviv, you knew it just couldn't be so.)

I made my new bedroom as comfortable as possible. The flat was shabby and stark, and my flatmates were messy, careless guys. The place was all very manly and butch, with Shane's collection of Marlboro cigarette packets, his guns (he owned a .303 with a telescopic sight that we messed around with on the roof; I don't know how we avoided an armed offenders callout), and Karl's weights, buckets of protein powder and workout gear. Also Karl's books. Karl actually read proper literature; moreover, his surname was absolutely improbable: Read. Constable Karl Read. Every time a letter came for him, I'd think it must be for my father.

On the subject of Karl's books: Constable Read read more than I did. In my last years at law school and while I lived with Alex, whose idea of great literature was a fat paperback by Robert Ludlum, and whose notion of fine writing was hilariously wide of the mark—browsing through the *Herald* he would pause, hold up a solemn hand and read out in a reverent voice some passage, often of sports writing, that he found especially powerful and I would press my lips together at how bad, how very bad, bad enough to make you scream with laughter, but I would feel a tenderness too, because one of the most touching things about him was the quaint purpleness of his speech, and I thought of it as the only thing about him that was innocent—during that time, something had gone wrong with my reading. It slowed, dwindled and limped along until, having grown up in the house full of books and having judged *reading* as the other necessary thing along with *roaming around*, I'd stopped completely.

I read legal cases and texts, but no fiction. There was something very wrong with this, I knew. It represented a kind of depression, a mental paralysis.

Looking back, it seems the most telling symptom of struggle and despair. I would glance at the improbable Karl, sunbathing and sipping his protein shake; I would marvel at his tan and his muscles and his good looks, but even more at the well-thumbed copy of *Catch-22* on his knee.

The way out of my struggle would eventually involve fiction. Reading was part of the salvation and the cure. Even though I'd made my way through an arts degree as well as the law, had spent years at university grappling with Chaucer and Katherine Mansfield and Henry James, it took me a decade of reading the classics to recover from the state I'd got into, to catch up and reach a point where I felt qualified to review books.

Now, on the roof of the CML building, I gazed at Constable Read with the numb respect of an illiterate.

At first it all went smoothly. Karl spent long shifts at Central police station. Shane (slow-speaking, humourless, gun-toting Shane) was either at work or crouched in his room on the phone, chain-smoking Marlboros and trying to get women to go out with him.

There were problems living on top of a dead building. It wasn't easy to get rid of the rubbish, so it tended to mount up and stink before we got around to lugging it downstairs. Pretty soon I couldn't bear going into the dingy kitchen, and so didn't cook but lived on takeaways and snacks.

I was still reeling from my troubles. I'd seen my best friend killed, and I'd lived through and left a violent relationship. I spent most of my time at the office and wasn't focusing on the flat. But the summer break came, work finished for two weeks, and Karl and Shane went out of town on holiday. Now I was completely alone.

On the last day of work I stayed late for the drinks in the boardroom. I emerged from the law firm and bought myself a takeaway. On Queen Street, using my first key, I unlocked the glass doors of the closed, silent mall. I walked past the empty shops, and used the second key to enter the second door. Now I was by myself in the huge building, with eight floors of vacant space above me.

It all crowded in on me.

I'd been desperate for a room and a solution after Alex, and I hadn't thought about it properly until now. Until I was alone. If people, rough sleepers or God knows who, had got into the vacant space during the day,

they could still be in here. No one would hear me call for help.

I stepped into the lift. What would happen if I got stuck between floors? Would anyone answer the call button of a lift in an unoccupied building?

The building was a trap.

I stepped out on the eighth floor and listened. From somewhere below I heard a metal clang. I ran up the stairs and locked myself into the flat. I dragged a deckchair out onto the roof and started to eat my takeaway, but I couldn't taste it. I listened and listened. Every sound made me freeze. The noise of the street floated up from below; all around me were high-rise buildings. I could see people in lighted windows, but I was alone.

I was locked in. It was fine.

But a new thought came to me. I got up and inspected the ranchslider doors. They led to the sitting room, and now I saw they didn't lock properly. I couldn't get the latch to work. There was an extra access point behind the flat that would allow people to get to the roof during a fire. I realised that if a person got into the building and accessed the roof, they would be able to enter the flat through the defective sliding doors.

I thought of the empty floors below. All that enclosed space, set apart from the street, was its own lawless territory, and I couldn't shut myself off from it. I couldn't protect myself. If anything happened I wouldn't be able to get out, and way up here, no one would hear me scream.

I was so frightened I lay in the deckchair staring up at the black sky. I didn't know what to do. I couldn't go back to Tohunga Crescent. I had no friend I could call on, nowhere else to stay until my flatmates returned. I'd been sad to be alone on a summer night after the work drinks, I'd felt lonely and ashamed of being lonely, but now I was terrified. I thought of leaving the building but I was too afraid; it would mean braving the stairs, the lift, the vacant floors, the mall.

In the days that followed I spent long, desolate hours walking around the city. I went to the beach by myself, to movies. I made sure I got home before dark, but once I was in, the night was the enemy and the ordeal. I sat on the deckchair paralysed with fear. I smoked cigarettes, staying outside on the roof until I was so exhausted I would creep into my room and sleep, waking with nightmares, praying for the dawn. Daylight would bring relief, but even during the daytime I was afraid, especially getting in and out of the building.

I yearned for safety, for human warmth and touch, and I didn't know where or how to find it. Along with the terror was helpless amazement that I'd got myself into this bizarre situation, marooned on top of a pile of condemned concrete above a labyrinth of dead rooms with no sure way to shut myself off, to be safe. But this is how it goes: when things go wrong it's a cascade. One disaster leads to another. Once you're vulnerable, circumstances get crueller, defences start to crumble, choices narrow, the choices you make are hurried and increasingly unwise. The worse things get, the more you lose your way.

Desperate, dying of shame, I went out and drank solo in a pub in Queen Street. It was a vicious circle: loneliness was so humiliating it couldn't be admitted, and the shame made me avoid contact.

Standing at the glass doors on Queen Street that night after the pub I was too afraid to go in, but I had nowhere else to go. I stood out in the street while it grew emptier and the feeling of danger increased; now there was no one in the heart of the city except drunks, street kids, the homeless, the people I feared could get into the building during the day when the mall was open, who could be anywhere on the empty floors, moving quietly upwards towards the roof.

I watched a drunk lurching along the street trying the doors of cars. It started to rain. I turned the key and opened the glass door. I locked it behind me, forcing myself to walk to the far end of the silent mall. I unlocked the wooden door, closed it behind me, and now I was alone in the dead building. In the lift I was so frightened I stepped outside myself. I had the stunned, reeling sense of unreality—the eclipse—that accompanies bad news.

Running up the stairs I made it into the flat, barricaded myself in and began another night of terror, another vigil.

★

There's that soft question asked in magazine interviews: what advice would you give your young self? Here, it would obviously be: get out of there. Pack your bags, check into a motel and never go back.

I knew I had to get out. The detail, the timing of my escape from the CML building isn't clear now—perhaps a reflection of how desperate I was. It's a blur. I do know this: the gun-toting Shane sent me on my way. Specifically, he decided I'd been rude to his aunt and uncle and asked me to leave.

I definitely *was* rude to his uncle. Shane must have come back from his

summer holiday, perhaps with his relatives in tow. I'd remembered details he'd told me about his uncle: that he was a devout Christian, and that once on his farm he'd tied a disobedient sheepdog to a fence and beaten it to death, just hit it and hit it until it died. Shane seemed to think this was evidence of his uncle's 'toughness' and 'resolve'.

I was disgusted by the story, and repelled by the sanctimonious bore and creep now parked in our sitting room and with my nerves shot and my bags packed and after probably a few glasses of wine, I burst out in a stream of rudeness about Christianity, God, hypocrisy and cruelty to animals. It was received largely in silence, but the next morning I found Shane had pinned an 'eviction notice' (written in felt pen on A4 paper) to my bedroom door. There was a line I remember about his aunt and uncle's Christianity being 'as much a part of them as the food they eat'.

Right, I thought. I'm having a nervous breakdown. Nothing matters any more.

There was ill will. I left, having lightly vandalised a few things (that's for the dog, I thought, putting my foot through something or other of Shane's).

I went to work. My days in the office had taken on a surreal, lightly garish quality. I was managing (trying) to keep up a front while everything was unravelling. I drifted and dreamed through the hours. I'd done detailed legal research for the partner that he'd later praised; now he'd given me a more complicated project, a step up and a reward. Some days I felt I was on top of it, but on others I couldn't focus at all.

I answered an ad for a flatmate in Gibraltar Crescent, in Parnell. Again I had to move fast and again the choice was bad. I moved in with three strangers who were orderly for the first few days, but soon took to rollicking home at 3am and going right on partying. They did this any night of the week. I couldn't find peace or space or get any sleep. One day I was sent by the partner to appear in the High Court on some minor matter and found I was so exhausted I could barely speak.

It was an era in Auckland when there were so many armed bank robberies that the *Herald* had started publishing a sarcastic daily column to goad and reproach the police, who were failing to solve the crimes. The column was called 'Today's Armed Robbery'.

It would transpire, after the police finally roused themselves to arrest her,

that a frequent visitor to the house at Gibraltar Crescent, the best friend of one of my flatmates, was the blonde girl getaway driver of the gang who were pulling off 'today's armed robbery'. High on adrenalin post-heist she would bang on our door at 3am, shouting for drinks.

All I knew was that I never got any sleep, and it was getting harder to go to work.

One night another of the flatmates tiptoed into my room and asked if he could join me in bed. When I said no, he wouldn't leave.

The next morning instead of going to work I sat on my bed and imagined hitting myself repeatedly in the face. I didn't know why, whether it was an expression of despair or a way of forcing myself to keep going. I was so stressed, so cornered and desperate, the only thing left was to imagine turning on myself.

After that I knew I had to move again—only this time I would get lucky.

I had a friend at work, Eugene, a lawyer I'd known since school. It turned out he was looking for a place, and he and I found a tiny two-bedroom house, an old railway workers' cottage in Avon Street in Parnell. We had a bedroom each, a little sitting room, a spacious back garden with a lemon tree.

Eugene was clever, civilised, witty, even a good cook. In the mornings he ironed his shirt, took a taxi to work and covered for me (I drifted and dreamed and often struggled in late) by turning on the light in my office and putting a cup of coffee on my desk so the boss thought I'd arrived. Eugene was a great guy, a real friend. For the first time, I'd found a place I felt safe.

My new flatmate did another great thing: he decided to invite Paul to dinner at Avon Street. We both knew Paul vaguely from work. I picture him in our tiny sitting room that evening, jiggling his leg restlessly, making the floor shake and looking unconvinced, as if wondering what he was doing there. Eugene had pinned up a lot of press photographs he'd collected when he'd worked as a journalist for the *Auckland Star*, and each time Paul shifted and fidgeted another photo fell off the wall and hit him on the head.

Eugene made a pudding that involved pears. The pears were undercooked and kept shooting off the plates, and amid the comedy of the flying fruit, Paul and I discovered we liked each other.

He was tough, funny, benign, and one of the things he liked best was reading.

Bathgate Series

Bars, 96 x 145mm
Cover, 95 x 145mm
Dome, 166 x 110mm
Love Ribbons, 118 x 145mm
No Ball Games, 95 x 145mm
Stile, 97 x 145mm
Smile in Blue, 93 x 145mm
Sky Light, 96 x 145mm

All on Epson Hot Press Bright Fine Art Paper

On his Saturday morning routine walk to Bathgate School, Dunedin artist Scott Eady always finishes with a quick visit to the South Dunedin St Johns op shop. On one of the visits immediately after Level 4 lockdown lifted, he bought a Box Brownie camera. The gear is old, tired and dusty—yet Eady has deliberately chosen not to clean the lenses. This gives us images where the sense of the onlooker capturing history is heightened: although recorded in 2020, the speckled or damaged patina immediately suggests the erosions of time. In these shots the seized moment seems to carry a halo of potential losses as the world heaves under the changes brought by Covid-19. While the empty public spaces in the images might make us think of the abandoned, neglected, the potential population decimation of a global pandemic, the very fact that the photographic equipment has been rescued and recycled, alongside the kinds of optimistically communal spaces Eady chooses to record, also suggest the structures and insistence of hope. This portfolio resonates with the slowness of the old photographic process Eady uses, which in turn mirrors the slowing down and necessary attention to small detail, of a repeated and circumscribed route, during 2020's social and travel restrictions, 'the great pause'.

JOHN ALLISON

Such Questions

how to paint sunlight
 is like asking just where does the sky begin ...?

awake at night I have such questions for Anubis
 (or for that shadow dogging him)

what exactly is the weight of a soul in the balance?

what is the furthest reach of breath in that moment
 when desire becomes another world?

is there a measure for what memory makes of a life?

is there a meniscus on the surface of community?

is there really empty space between sub-atomic particles
 or a presence we may never know?

when it comes to it and all has been said and done
 where do the dead dwell?

as a palimpsest scraped from this parchment?

in those reaches of the sky beyond our breath?

between the feathered plumes of words and images?

in that membrane bordering the landscape of belonging?

or in that weightless splendour of our wonder ...?

OSCAR UPPERTON

Of an Evening

I'm not the kind of friend you'd want to befriend.
Do you know what I do, of an evening? Well.
When the ships come into port there are bodies
on the ships and they must take the bodies
off the ships and if I hide my hair they will
show me a body and tell me how it came to die like that.
Then they ask, where are your parents? and I run, run.
The bodies are much bigger than me, long and puffy,
pickled like fish, and many of them are far from home
but some are coming home to Cork in a bottle.
There are always stories of the dead sailor shut up
in a barrel of rum and the other sailors drink the rum,
and the dead sailor tipped over the side and in the morning
swabbing the deck and his friends too afraid to touch him,
and the plague ships of course they come and anchor
and we wait them out onshore. They are a story telling itself
to itself, a very boring story where the same thing happens
over and over again.
I hide my hair and I say, what's this?
and people tell me things.

CINDY BOTHA

Zzzz

Zebra-bee, but nothing like a zebra.
Rather—the sunflowers distilled
to a scrap of yellow and black
which pauses in my palm, deliberates,
sticky as sponge-cake, pollen-smeary.
Simmering into mutter and hum,
nudging fingers, you're a scramble-bee,
somersaulting tumble-bee, dither and fuss

—but you lift off suddenly into dance,
leave the lemony spice of you,
tiny brittle zigzag of brisk feet.
Seduced by the seething jazz of rosemary
and lavender, their gassy blue, you—
small hive-hand—set the evening abuzz.

SARAH PATERSON

Dearest Phryse,

Now that you're dead, I'm getting to know you;
lost in your letter-forest, picking through the leaf litter
by leaves I live your life.

Your sister jokes with me using your childhood shorthand,
your mother worries over me, and starts to unravel before my eyes,
Jan is not my divorced mother but a young, passionate girl
in the throes of love with you, dreaming of becoming your wife.

In the leaf-forest, time is distorted, waiting for uncertain postal nymphs
to carry out their secret rituals, responding to last year's conversation
the week after you began a new one to the silence.
Your friendships are dictated by who has the time, energy, stamp money
to continue them over oceans.

Your old parishioners yearn for you in ink
while the flocks of your present tire of you
and one by one, I see them fall away,
disillusioned by your humanity, discovering you are not
Christ, after all.

The forest is churned up, renewed, damaged, and renewed again
by storms of apartheid, rebellions, colonisations,
the independence of nations and children
and strange flowers bloom:
Uncle Bill's Julius Caesar
a dusted-off Ipi Tombi record
gentle German shepherd puppies
Mrs King's tablecloth

Niumi's rattle.
And at forest's edge, you walk out, head high
preceding the hearse
stopping us in your tracks.

MARISA CAPPETTA

Winter Solstice Poem

The marigold seedlings bide their time in the cold frame
until the ground is warm enough for healthy growth.
I've moved a pot of strawberries
to their winter spot where they are bathed
in light diffused through too much atmosphere.

For now, they and I must make do with scraps of brightness.
I bide my time during the drawn-in nights
and miasmatic winter days searching for seeds
of discrimination in my heart. If they take root
I'll weed them out with a tea made from the bitter leaves.

simila similibus curentur

Note: *simila similibus curentur* is a term used in homeopathy meaning 'like
cures like'. In homeopathy it is thought that to subject the patient to a dilute
amount of the cause of an illness will also act as a cure.

essa may ranapiri

Kurangaituku & the Sirens

Kurangaituku presses the wind instrument to the side of her mouth
and blows all twitter and high-pitched resonance she's teaching the
others how to play their parts *you gotta make him think he's got u* they're
all following like synchronised ghosts one step out there is a
tie-yourself-to-the-mast-of-a-ship quality deep in their awkward
stuttering performance make men shipwreck over their own hunger
an ocean with too much water to drink alive drawing swords
to die on a song Kurangaituku thinks back to the Te Arawa
boy and his attempts to melt her wings right off their bones can
feel a tightening getting close to the sun wasn't something she was
invested in another foolish boy rushing too fast round the world

ZOË HIGGINS

Swinging a Bottle

Swinging a bottle from one hand,
My neighbour asks 'Why's the end
come now?' Her finger

rattles on blue glass, rushing a song
like swing time, it's spring again
and time to dig.

I soothe the ground over new seeds
and say nothing. 'Why now?'
again, what'd we ever do?

Finger stuck in neck of bottle,
reckless rattle going
fast as a hot horse down

the river. It's an honest rush,
born deep in the bones and springing
neck-high like corn that swings its

tassels in the spring wind.

ALICE MILLER

Earth

When I die I will have learned how not to.
That's what this body's built for, to know
not what it is, to shamble along our stone
floors, sun on back, wondering what to use
this planet for, while it's still

cold enough to walk on. As if it's for us.
As if it always was.
Walk in, walk on, walk through. I swam for all
the generations they gave me. I wrinkled
like a seamoth. I tried as best I could.
I'm sorry it's not enough.

Moko Taro

Tere slowly returned the receiver to its place on the little table. Above the phone there was a mirror. Tiny drops of white shell looped around her reflection, but this adornment did nothing to hide the grey hairs appearing at her temples, the grey smudges under her eyes. The narrow hallway, a dark little tunnel through the house, and now this phone call—both reminded her of how this place was still difficult to call home. This place where a stranger called to ask you to collect your son from the police station.

But now was not the time to gape at her reflection. Tere went to her wardrobe and considered what would be best to wear. It didn't help that she was alone. These big problems were usually solved together with William. But William wouldn't be home for hours and she couldn't have Puna waiting alone in that police station. She refused to picture him in a cell but instead imagined him on a bench outside the office, like a schoolboy who had misbehaved. Tere pushed coat-hangers along the wardrobe's metal pole, scrape, scrape, scrape. She paused at a long blue dress before deciding against it. The fabric floated around happily and she wanted to be taken seriously. Another coat-hanger was pushed along. Maybe this white blouse with the yellow flowers would do. Her younger sister had complimented her on it, and she knew more about the New Zealand fashions than Tere did. Under her corduroy blazer, the thick cotton would keep her warm. She chose her brown tweed skirt to wear with them as it seemed a serious garment. Something for dealing with people at the bank or the school or the police station.

After Tere had dressed she looked in the long mirror on the wardrobe door. She held her hair away from herself and twisted it into an arm-length rope before winding it around into a tight coil and fastening it with a turtle-shell comb. Next was the blazer and her handbag before a final check at the mirror again. Tere sighed as she smoothed down the right lapel of her coat. Even after living in this country for fifteen years, there was a mask that was

necessary for life outside the family and the Rarotongan community. She wondered if she would ever find the same sense of security she had on the island. But now was not the time to wonder, or to hope. Her son needed her to be strong and in control of this problem.

<p style="text-align:center">*</p>

Once outside, Tere locked the door. You didn't lock your door back home. Tere found when dealing with big problems that little problems started popping up in the back of her mind like boils. There were no warm oceans here to cure boils. Too cold. You were lucky if it was warm enough to bathe in December.

Walking down the front steps, she felt the taro leaves brush at her legs. Stop, Teremoana, those deep green leaves seemed to say, be calm, think about this one big problem. It had been a good summer for taro—warm and rainy—and the stalks grew tall from dark crumbling soil, the leaves grew wide. She had brought these dry-land taro back on her last trip to Rarotonga and planted them all along the front of their house where they could get the most sun. Maybe this would be the summer when the plants produced a taro crop rather than just leaves. Maybe. What would it take to grow root crops here in Auckland? The velvety green fans of the moko taro were still bobbing gently from her touch, bidding her farewell as she walked away.

<p style="text-align:center">*</p>

It would take twenty minutes at a steady pace to walk to the police station. Any faster would mean appearing flushed and flustered when she arrived. When she left the house she felt anxious, but as she walked she collected herself. Her thoughts developed in time with her steps. Her short wooden heels knocked out a rhythm on the concrete. Tok, tok, tok. Her boy was a good boy. Lots of energy as a child. Working at the factory, all that heavy lifting, had changed that. Tok, tok, tok. Puna didn't cause trouble. Why was he with the police? Maybe it was his friends. Tok, tok, tok. It was those searches they had started doing. Another big problem. Overnight the police were asking anyone they saw to prove they had a job. To prove they had the right to be here. They said they were looking for people staying illegally in New Zealand. Overstayers, they called them. Tere increased her pace.

Of course the word didn't apply to Tere's family. They all had New Zealand

passports. But somehow it did apply. The police had gone to the house across the road—the Tusitalas at number forty-eight. A lovely family. The husband worked with William (and Puna) and Tere often saw Losa at the shops. And obviously all the children went to the school together. Tere often saw them leaving for the Samoan church, a handsome family, the Tusitalas with their five children, tidy in their white church clothing, walking down the street. The older boys followed quietly behind their parents, while William yelled at theirs to get in the car.

It had been confusing to see the police at their house that strange morning. It turned out Losa's nephew had been staying there and his passport had lapsed. He'd been working at the factory too. Tere didn't remember the details. She avoided talking about it. But she did remember waking in the dark of dawn to shouts and bangs. A child had started to cry, loudly, terrified.

'William! Wake up!' she had cried in their reo, leaping out of bed in her nightgown. She had run through the house. No, the children were fine, no one was here, the girls were safe, asleep, the back door locked. But lights flashed from across the road onto the walls of the hallway. She rushed out the front door, worried for her neighbours, those children. She walked down the steps trying to understand what was before her. Police cars, children crying, lights ...

'Back inside, Miss,' came a deep voice from the darkness. Bewildered, Tere searched the dark and saw a shadow moving from one of the police cars parked in front of their neighbours' home.

'Did you hear me?' the voice said. 'Back inside, please.'

Tere stepped slowly back up the steps, flinching with fright as she nearly tripped on the taro leaves hanging over the steps. She pushed William back behind her as he hissed for an explanation, and shut the door quietly. Together they moved silently into the front room and stood at the window. The sky turned from dark blue to a beautiful rose colour as the police collected the overstayer from number forty-eight.

<p style="text-align:center">★</p>

Now the police insisted on checking the passports of anyone they thought was an overstayer, and it turned out most of them had trouble discerning between a Samoan person and a Cook Islander and a Fijian. But being a New Zealand citizen should count for something, shouldn't it?

Puna was a good boy. He didn't always think before he acted, he was impulsive, but he was good. And of course he didn't carry his passport. You didn't see the papa`ā carrying theirs around. It was impractical. Their papers were all kept in the bureau in the lounge. This had never been a problem— until now, when police officers are saying your son looked Samoan.

<p style="text-align:center">*</p>

At the front of the police station Tere stopped to catch her breath and slow her heart, but her heart would not do as she asked, it would not slow. She decided to take the handle of the front door and enter with her chin up. She was the daughter of an ariki and this situation was not beyond her. She had a New Zealand passport and her son would not remain here one minute longer. With her handbag under her arm she walked to the reception desk. A woman was standing behind a bench, reading. At Tere's approach, the woman managed to keep her face looking down as she raised her eyes above her glasses to meet Tere's.

'Yes?' she asked.

'I am here for Apaipuna Tua`ine.'

'Who?'

'My son, Apaipuna Tua`ine. He is here. I was asked to bring his passport so he can come home.'

'I'll get a constable.' The woman walked through a door, closing it behind her.

A few moments later she returned with a police officer. They all looked the same, these police officers: papa`ā men, very fit, tall, with hair growing down around their ears. This one smiled as he lifted part of the bench to pass through into the reception area.

'Hello, Mrs Too-ah … ah Twiney? Pooner's mother, isn't it?'

'Yes.'

'Good. Good. I'm Constable Burton,' the police officer said. He guided her to a small table by the wall and the rude receptionist returned to her bench.

'Well, just to let you know Pooner's okay,' the police officer said. 'He was fine but you know, we have to be thorough these days, the ministry and all, and he didn't have his papers.'

'We're Cook Island, Mr Burton. We are New Zealand citizens,' Tere replied steadily.

'*Constable* Burton.' He eyed her, 'Yes. But you know, it's hard to tell sometimes. Like I said, we've been given the order—we have to be thorough. Anyway, did you bring the boy's passport?'

'Yes,' Tere replied. She placed her handbag on the table, retrieved the passport and handed it to the police officer. As his thick fingers flicked aggressively through the pages, she felt a compulsion to snatch it back. He held it open to copy some information onto a form. And there was Puna's photo, aged twelve, big brown eyes and a suppressed laugh.

'Born at Middlemore, eh? A real Kiwi then. Thank you, ma'am. I just have to get you to sign some papers and we'll be all done. I'll go get your boy,' he said. He lifted the bench once more and disappeared through the door.

Tere held a lump tight in her throat, knowing she had to keep it there to stay in control. She gripped her handbag tightly, wanting to retrieve the passport but not knowing if she should.

A few minutes later Constable Burton returned with Puna following. At first Puna's eyes darted around, searching the room. But once he saw his mother, his eyes dropped with shame. Tere could have cried from relief to see him but she didn't move.

'Puna,' she said.

The police officer appraised the boy. 'Nah, a good lad, your son. Sorry about all this, but as I say, the rules have changed.'

<p style="text-align:center">★</p>

This comment caught her somewhere between anger and relief. She would not breathe properly until they left this horrible place. Her nostrils flared. Why was he here? No one had even told her. And this place. Its interior the colour of poisoned water, dirty green and grey, full of cruel people who invaded houses in the night like thieves. These police officers, casually hunting their sons around every corner, who saw brown faces as the cause of all problems in this false land. Even when they were 'good lads' and 'hard workers' and 'real Kiwis'.

Constable Burton handed back Puna's passport and pushed some papers and a pen across the table towards Tere.

'Sign here ...'

Tere did not bother to read what the papers said. Her priority was to get out

of there and she was not interested in wading through the English. She signed, and he flicked over to the last page.

'... and here.' She signed again and he gathered up the papers. 'That name ... do you know a boy Taps? Taps Twiney? He played on the football team at Marist with my youngest.'

'Tapukura is my eldest, Puna's older brother.'

'Ah, I see. I always thought Taps was a Māori.' Tere nodded simply because she hoped it would end the conversation sooner.

'Well, he was a beaut footy player. I'll take those papers.' He shuffled them and turned to address Puna, his tone light. 'And you stay out of trouble, eh.'

'Yes, sir,' Puna replied in a monotone. Tere almost coughed up her suppressed rage. She covered her mouth with the back of her hand.

<div align="center">⋆</div>

Puna was quiet on the walk home. His eyes stayed on the concrete path.

'Meitaki koe e tama?'

'I'm all right, Mum.'

They walked another few metres.

'Are you hurt?'

'No, Mum. I'm okay.'

He said these words but he wouldn't lift his head. His profile was handsome like William's: a straight nose, full lips and a strong round jaw. Long lashes hid eyes that looked at the ground, that couldn't bear that his mother had been dragged to the police station. Tere imagined he was now dreaming up the punishment he would receive from William. She worried for her sons in this country. It was meant to be better than what they had left. It was meant ...

Tere didn't recognise Losa until she was upon them. She was with her youngest daughter, who sucked her thumb. The boy, Logo, fidgeted at Losa's side.

'Hello, everyone,' Tere said, smiling to each in turn.

Losa looked up, surprised. 'Hello, Tere. Hello, Puna,' she said quietly.

Puna smiled at their neighbours, 'Hello, Mrs Tusitala.'

As they passed, Logo turned suddenly and exclaimed, 'Puna! Guess what?'

'What is it? What have you done now, Logo?'

'I didn't do anyfing,' Logo giggled, showing a joyful gap-toothed grin. 'I'm going to school tomorrow!'

'Eh?! I thought you were only three years old!'

The boy laughed loudly, placing his hands on his hips, 'No! I'm five!' He held one hand up, fingers splayed.

Puna shook his head, eyes wide with mock disbelief, 'Those teachers better look out!'

The boy laughed again, bringing a hand to his forehead. Losa smiled at Puna. 'Come,' she said to Logo.

Tere and Puna continued down the street. When they reached their house Puna turned to his mother.

'Māmā?'

'Puna.'

He spoke softly in their reo, chin up but his eyes respectfully downcast. 'I am sorry that you had to come to the police station but I don't know what I could have done to avoid it.'

She regarded him a moment. Her boy.

'I know, my son,' she replied gently in Māori. 'I will talk to your father.'

His shoulders relaxed on hearing this and he adjusted himself. He switched back to English, that funny nasal way of speaking he had picked up at school. 'Well, you must be tired from that walk. We'll go in and you can sit down, Mum. I'll make you a cuppa.'

She gave him the keys from her bag and watched him walk up the concrete steps to their home. Puna reached for the door and did not notice how, after he brushed past them, the moko taro bobbed in response. Welcome home, e tama. Tomorrow she would dig one up and see if the plant had grown a taro tuber. She imagined herself, legs wrapped in her old pāreu, hands in the dark earth, digging around a large taro, later cooking it up with the deep green leaves, onions, coconut cream and feeding it to her husband and children.

JESSICA LE BAS

Last Quarter

The hospital appointment

where the anaesthetist asks about your blood pressure
and you tell him it is just the moon; it always spikes
on the full moon

And he looks at you, brow raised
as he rolls his tongue around his mouth, looks out the window

and you want to tell him about the fish trap
 at Manihiki
and how you waited three hours on the shore of the lagoon
under the shade of coconut trees
 in 35-degree heat
while Papa White and Purotu and Miss Rauru waited
with their goggles and snorkels, and their kikau fronds ready
 at the edge of the reef
 underwater

And when you asked Mama Marama when they will come,
and how does she know this
she pointed to the half-moon watching from high in the sky
 and then they came

 one hundred angel fish

But you don't tell the anaesthetist this
because his conversation has already moved on

Now he is asking if you sleep well. Are you inclined to nap?
You roll your tongue around your mouth
and you look out the window.

NICK ASCROFT

Knock Knock. Who's There? Nietzsche. Nietzsche Who? Nietzsche to Open ze Door Please a Liddle Bit

I'm not that kind of comedian.
Not funny-haha. More funny-hmm.
Funny-curious.

You won't be gripping your sides, worrying about intestinal prolapse.
Hernia-proof comedy I am purveying.
Have you heard of alternative comedy?

Have you heard of meta-comedy, or anti-comedy?
Jokes that aren't meant to be funny in themselves,
but funny in their critique of the joke's teller,

funny in their misdirection or their structure.
How many home-DIY bores does it take
to put in a row of recessed downlights?

I am not that kind of comedian.
Nor will I be telling you about my hysterical misfortune.
I won't be saying, buses are weird aren't they?

I won't start a conversation between two characters,
and move to the left and to the right as I embody them.
I won't say, can I get a WOOT WOOT.

Pratfalls? Physical comedy? No.

This isn't a persona.
This isn't a humorous persona, such as a Lotto winner who

stays in their admin job at a pest control business
because they have no other friends.
Comedy has no friends.

Comedy is the last line of defence against dogma and puritanism.
The other lines of defence had best be
better suited to the job or we're all fucked.

And we are.
Only comedy can say this with a straight face.
Welcome to the gallows.

Not funny-oh-that's-delicious.
Not funny-thank-you-I-needed-that.
Not funny-funny.

But funny-sorry. Funny-that-can't-be-true-but-I-know-it-is.
Funny-sickened.
Funny-I've-fallen-and-I-can't-get-up.

Funny-the-last-eleven-years-of-Nietzsche's-life-
following-a-paralysing-stroke-and-psychosis.
I'm not that kind of comedian either.

Kaspar Limericks

There was a young cat with a curfew,
and did the fur fly when the fur flew!
With the lock on his door
he'd beckon a paw,
daring anyone out on his turf through.

||| |||

I may know not an ass from an asp, sir,
but there was a young cat, name of Kaspar,
who'd not save his own mother
—he'd be anywhere other—
as his heart was a cold rock of jasper.

||| |||

A plummeter, more than a diver,
from pratfalls on high he'd survive the
initial foray,
but don't check he's okay
or you'll end up awash in saliva.

HARRIS WILLIAMSON

In Defence of the Smoker

Her elbow, planted on the table,
offers up a slender freckled forearm.
At its end, two long fingers enclose
the cigarette like scissor-blades.
Grateful lips surround the filter.

She inhales, and blows a cloud that floats
into the path of pedestrians who shake
their heads in disapproval. Later, they will moan
about the tax they'll have to pay to keep her
alive when the creeping cancer comes.

But there's an austere beauty in her vice,
a fierce persistence in the way she huddles
with her fellow pariahs. Together they form
a pentagram of panther eyes and high cheekbones,
and their ash falls to the ground like grain.

Sure, she and they and all their like
are slowly dying, but so am I, I think,
as I watch them from an air-conditioned room.
Entranced, I breathe on the spotless window-glass
and make a wish for a life less sterile.

VAUGHAN RAPATAHANA

he papakupu o aroha

kāore he kupu ki tēnei reo
kia whakaahua i a koe.
e tarai ana ahau
kia kitea ētahi tūāhua.

kāore rawa.
mirumiru? he rite tangi ki te waireka.
mamahi? he pūhonga rite ki te kupu-ā-kaupapa ki te kura.
ātaahua? pono, engari he kīwaha tonu.
ko 'he tangata pai'
i tua atu o te whakarehurehu.

pai ake kia whakarere
te kōpaki i a koe i roto i te tā.

kei te noho pai koe i tua atu
i te toikupu;
i tētahi ture tātai i te katoa.

kāore e taea e ngā arapū ki te hopu te aroha.

a lexicon of love

there are no words in this language
to describe you.
I attempt
to discover some adjectives.

there are none.

bubbly? sounds like a softdrink.
diligent? reeks like school jargon.
beautiful? true, but so clichéd.
while 'a good person'
is beyond amorphous.

better to forgo
encapsulating you in print.

you exist well beyond
poetry;
any formula at all.

alphabets cannot spell love.

ngā wāna

kei te roto ahau.

e kite ana ahau
i ngā wāna.
kei te ikiiki rātou i ahau.
ko he tangata kē ahau.

e tere ana rātou
enanga nei he merekara.
e pūmau whakahirahira
ana rātou.
ko te māoriori rātou.

e kite ana ahau
i ngā wāna.

ko tāku whakakitenga.

ko he tangata
pai kē atu ahau.

the swans

I am at the lake.

I observe
the swans.

they transport me.
I am another man.

they glide
as if a miracle.
they exist
sublime.
they are serene.

I observe
the swans.

it is my epiphany.

I am
a better man.

CHRIS TSE

Identity Theft for the End of the World

Your porn name is the name of your
childhood pet + the first street you lived
on. Your Hollywood name is the make of
your first family car + a shard of glass.
Your death metal band name is your
greatest fear + the last thing you watched
die. Your poet name is the beginning of
time crackling in the air + a pearl in your
shoe. Your self-portrait is five times the
size of the largest lake + the divers who
get lost finding their way up. Your cause
of death is the harried look white people
give you before deciding which seat to
take on the bus + exhaustion. Your
medication is a parachute in an electrical
storm + the realisation that the drugs are
slowly killing you. It's easier to feign
belief in a world where your birth name
is heavy enough to sink a boat or has a
meaning that crosses languages. It's not a
controversy until your name is a magnet
+ full-page curses in the newspaper.
Your name is dirt in this town, but a
golden ticket in another. Replace all
canned laughter on TV with a father's
regrets and reframe all the violence on
the news as a makeover montage. Buy a
new name in monthly instalments and
prepare yourself for strange looks once

you realise you can stop thinking about being good and start speaking in motion detectors. Your way back into belonging is your porn name + your Hollywood name + your poet name + all your other names written on the back of an envelope then burned in your back yard while the townsfolk watch on, their hands wrapped around each others' throats. Remember, it's not courage if it's survival. When the fire dies, seize your chance to address them and welcome them to your new name, complete with its brand new motive. Tell them, *Hello, I'm here to haunt you.*

CHRIS PARSONS

Expedition

he often sets out, equipped in pyjamas
leaving our front door open
a book left by
someone losing their page

rudderless of memories
no lighthouses
no loved spires
no poured out headland

just wrinkled ranges of cortex
where weeds are marching
and the paths we loved
fading into hillside

'Alzheimer's'
a word that explains everything
a word that explains nothing
a word like a Black Hole

but at the edges
of golden moments
he can still see the far country
whispering Mass in his soft voice

Marine Snow

a coming-of-age film
 the crucial scene
 watch me drift
through the water
 bubbles erupting
 from my nose I want
to hold my breath better
 than I can stay in
 until my lips
turn blue

 when I was three I hated swimming
 I wouldn't take my feet off the bottom
one day the instructor said
 that a crab lived
on the bottom of the pool it would
 pinch my toes
 I got out of the pool

does the last
 of anything know
 it's the last
we give it a human name
 I'm not built
for this kind of grief
 I start to carry it
 around and put a little
 into everything I do
 now

the pot of coffee
is in mourning now
the laundry
drips wet tears

did you know it
snows underwater that's what
we call it when bodies
fracture and sink skin and scales
mixing
with plankton and dust I don't
want to eulogise anything
I want
a name
for the feeling

of never wanting
to see something
but being
glad

it exists

JASMINE GALLAGHER

Tying the Dogs Up

Crouching to get under
the branches
of the old macrocarpas.

On a little worn path, through long grass
blazed[†] at dusk
to tie the farm dogs up.

†. Today
I sifted through your desk drawer and found
a fine little cigarette tin filled to the brim
with un-cracked wishbones. And at the river one evening
not long after you died, wearing your old jacket, I found in the pocket
the pipe you filled with weed to ease the pain,
packed it and inhaled.
Then I remembered the lyrics on that cassette we went halves on
back in the day: 'Where were you while we were getting high?'

IAIN TWIDDY

Helter-

Crashed out of a job,
crashed out of a sky-scraping flat,
crashing on a sofa down under,

sitting here stuffing my legs,
trying to fit
in a kids'-size sleeping bag

brings back how it felt
slipping my feet
into the hessian sack

with the wind in a flap
at the top of the helter-skelter;
which was nothing to do

with a windmill, apparently,
even though it coned like one,
even though it smoothed creamily round and round,

even though you sailed
through the red and yellow lights
as brightly as flour down the chute,

as if the material
of that feeling of flight
would always be enough to cover

everything.

LYNDA SCOTT ARAYA

The Day the Elephant Came to Town

On the day the circus was to arrive, Clara woke early. Outside her window the cacophony of nature had begun. Magpies warbled, and sheep, deep-throated, called to their lambs, the sound reverberating from right across the river. Sometimes at night when she went to the lavatory Clara could hear the Waitaki. Its wide braids swept past the town, tangled, fierce and unpredictable. Shivering on the splintered seat, skinny legs dangling above the black and white tiles with spiders playing chess below, she would finish quickly and run back to bed to snuggle safely under her treasured quilt.

The older people talked of the early settlers in the area, about how brave they must have been. Such hard workers, building new communities, shaping the land and history. Men plied the barges, tying the sheep firmly for transport to another farm. Clara imagined the animals pushing in panic against fat woolsacks as they rode the water. How the men must have shouted as their loads shifted. Further upriver, other men combed the river braids for elusive gold. Women knitted the community together with their committees and meetings at the shop, prams lined up outside. Babies were born, many were mourned, and children were thrust early into a life of helping fathers and uncles to heave rocks from the fields and win the battle against rabbits and weather.

Now, with the stride of sun shafts through the gap in her curtains, Clara waited for Mother to call her. It was Clara's job to spread the tablecloth, to dole out fresh jam and make her choice of egg cup. She knew Mother was dressing in the next room—there was a sharp gasp as she snapped on her girdle, a barely suppressed giggle and Father's low laughter. She wished her parents would hurry up, but Father had the day off after ten days straight at the farm up the valley, and it seemed he was going to make the most of it. It was as though he had forgotten that this was the day—the day of Wirth's Circus.

*

Under her patchwork quilt Clara slowly traced her fingers across the various fabrics. There was the stiff grey material of one of Father's shirts, worn until its cuffs were ragged, and Mother's old dress material with the forget-me-not border. Her favourite was a piece of jaunty red cotton, as startlingly bright as the town's fire engine. It was from the dress Mother was wearing when she met Father for the first time, up at the hydro village where she worked at one of the general stores. A small group of men, Father among them, had shuffled in, their muddied and scuffed boots left outside. They had stood, grief-numbed and silent because of poor Reg who had drowned the day before in the river's icy swirling tumult. The men were after bereavement cards, and Father—or Tommy, as he soon became to Mother—needed a new tie for the funeral. Other men in the shop clapped the newcomers briefly on the shoulder. Everyone had heard the news but nobody was surprised. Life was brutal: cold houses battered by bitter winds, the relentless wrench of picks and shovels, the endless wheelbarrows and bone-shaking trucks.

Reg had been at the site for the past year. Always the last to leave a shift, he had never said no to overtime—not with a new wife seven months gone. Mother helped the men choose their cards and offered condolences for a man she barely knew. She felt inadequate; inappropriate even. Her red cotton dress had seemed brazen, too cheerful with its pert white buttons running down the bodice and its flared waist.

Still, life, as they say, had to go on. Soon Father was a shy but increasingly frequent caller at the shop. In later years Mother always laughed when she listed his purchases: a sewing kit on the first day, and on others an Eskimo Pie, shaving gear, a writing pad and a box of Tiger Tea. Really! she would exclaim. Ice-cream was a ludicrous proposition in winter when clothes hung stiff on the line and the dunny water froze solid. And, she would say— glancing around at her audience and pausing for effect—Tommy never even drank tea! Why he had bought it she would never know. It was always coffee for him! Father indulged her stories. She had snagged him for sure: hook, line and sinker, he would say. Fishing was his pastime, a way of explaining his place in the world. One of his old fishing shirts now made up a quilt patch, another piece of the family narrative.

As she waited for her parents to emerge, Clara ran her hand across the roughness of the patch from a shirt her grandfather had worn when rabbiting

in the high country behind Kurow. She couldn't imagine the harsh conditions he had faced—the long winters of frozen ground on Awakino Station, his beard of icicles. The 1895 snowfall, she had once heard her grandfather say, 'really sorted the men from the boys'.

1895 was a magical year—the year Clara's father was born, a long-awaited son to carry on the name, in a winter so severe that a plague of rabbits walked over rabbit fences that were buried in snow. Thousands more rabbits died and desperate sheep ate the wool off one another's backs. The thick snow lay on the ground for weeks, and the Healy brothers, crossing the Dansey, were lost for days. Dogs froze to death in their kennels, and poor Mr Home had be lifted from his saddle after a day out during which horizon and snow had become one. His teeth had chattered in time to the hail that chased him up the valley. He had sat stiffly in front of the fire, legs splayed and trousers dripping.

Clara's grandfather had stoically borne the winter storms, the drawn-out days of heaped rabbit carcasses and weeks away from family. Winter was when the pelts lay full and luscious in one's hands and the rabbits were at their fattest. He had broken his leg once, Grandmother had told her, when he jarred his foot in a burrow out on the job a few miles from the back of beyond. Not usually a man to curse, his profanities could be heard long before he reached the doctor's house—or so the joke went around.

Clara could just remember her grandfather, always sitting by the fire in winter and spitting his tobacco. His bung leg had never healed properly and he would prop it awkwardly on the log basket. Her grandmother, always busy with soup on the range, would step over him, sometimes pushing his leg off the basket with barely hidden frustration. Thick globs of winter soup clung to Grandfather's dressing gown, down which tea also ran in braided rivulets. Sometimes, as Clara sat on the hooked rabbit-tail mat at his feet, he would tell her tales of his mates and their exploits in the high country. He once also whispered about the time he fought his friend for the affections of her grandmother. Clara was intrigued: she couldn't imagine him as a romantic, someone who would playfully pinch a lady's bottom as she had once caught her father doing to her mum in the hallway.

But now Grandfather was dead, just another to be visited in the small cemetery a few kilometres out of town. Along with the Hilles, the Chapmans,

the McCaws and the Munros, he kept company with those who had died in old age as well as those less fortunate who had passed away in infancy or during the influenza scourge. Clara glanced up at the mantelpiece cluttered with old photos of relatives tucked in behind her great-aunt's brass filigree hand-mirror. Grandfather's pipe sat there now, its open mouth still breathing a piquant scent.

Finally, it was time to get up. Clara suddenly noticed the acrid smell of toast burning. Their old toaster, with the pull-down sides that exposed its glowing red innards, always burned the toast on one corner. Today would be a rush if she was going to secure the best viewing spot on the station platform when the circus train pulled in. She wanted to see it all—the lions imperiously pacing their wagon; the tiger thrusting its enormous shaggy head towards the crowd, jaw vibrating with a low threatening growl and its breath hot and meaty; the clowns with their dizzying antics and tap-dancing atop a flatbed, wavering on their stilts and thumbing their ridiculous oversized noses at propriety and convention.

But it was the elephant that Clara most wanted to see. She had examined the photograph in the *Timaru Herald*, balancing on a barrel, head held high, one front leg lifted and a ball poised on her trunk. A blanket fringed with velvet tassels was emblazoned with her name: Salome. Clara wondered what an elephant would think of such a life and whether she missed her family back on the savannah. 'Savannah' was a new word. Clara tried it aloud now, savouring the sound of it, mentally clapping out its syllables. It was on her spelling list for next week.

Mrs Whitman, the junior room schoolteacher with greying hair, a rumpled shapeless dress stretched over her bottom's large ledge and bunched stockings at her ankles, had been seen at the shop staring at the Wirth's poster, which showed Salome proudly balancing a trapeze artist. The 'old dear', as Mother referred to her, somewhat disparagingly, was lonely. The death of Mrs Whitman's youngest son in the Great War had scarred the widow. When the black-edged telegram had arrived a month after Passchendaele, the bottom had fallen out of her world. Now she kept herself to herself once the school week was finished, and in the staffroom she sat apart, spreading her coat and books on the chairs on either side. Clara often wondered how the old woman filled her time, keeping company only with

imagined horrors of her son's war and ancient photographs. Clara was sure the rest of Mrs Whitman's family seldom visited her.

At Friday's school assembly the talk had been all about the circus. The girls had whispered excitedly about clowns and dancers. The boys jostled one another and postured—jerseys pulled up to display biceps, they became a strongman or a gravity-defying trapeze artist. Most of all, though, everyone wanted to see the elephant. Mrs Whitman and her gaggle of new entrants had listened, entranced, as Mr Davidson the school principal explained that elephants lived in herds and were matriarchal. 'Matriarchal'. That was another word on Clara's spelling list. The students had sat listening, lulled by the rhythm of old Mr James's lawnmower as he methodically mowed stripes, the sweet smell of the cut grass drifting through the open windows. Mr Davidson talked of baby elephants holding the tail of the one in front, and of female elephants watching over the birthing of new life. Clara was in awe of the all-encompassing strength of these animals. They never forgot each other; even in death there was love. Clara imagined the dignity of an elephant's burial, its stark white bones becoming part of the skeletal ancestral sculpture of the dead.

<div align="center">*</div>

Now, and none too gently, she commandeered her sleepy sister Meryl to help, thrusting utensils at her, lobbing instructions at her across the table rubbed shiny by generations. It all had to be done perfectly. Mother was a stickler for housework, and Clara knew that she would not relax her standards even though this was the day the elephant was coming to town. Remembering to keep their elbows off the table, crumbs off the tablecloth and their mouths closed when eating, Clara and Meryl quickly ate their boiled eggs, thick runny yolk wiped surreptitiously from smocked frocks and a handful of Weet-Bix dropped to the dog at their feet. Just as they finished, the door burst open and in came their brother John. Like the girls, he was keen to see the circus. He had been checking traps with his good mate across at the Kurow islands and now flourished three good rabbits, which were thrust in the fridge. Mr Dwyer down the road, who bought them at a good price, would know to wait today.

The children arrived at the platform with minutes to spare. Already they could hear the squeal of the circus train snaking around the last few bends

into town. Clara pressed forward, dragging Meryl along with her. Craning her head, she imagined the teetering, twittering clowns, their makeup-thickened faces already stretched into well-practised smiles. The lions would be grumbling and growling over the wheeze and roar of the train, while the elephant, star of it all, would be proudly standing, trunk held aloft, nostrils tickled by the soot and the dust of it all.

At last the train stopped, belching its hot grimy fumes over the surging crowd. Grasping Meryl firmly by the hand, Clara squirmed past the mothers and prams, past the knot of young men trying hard to be nonchalant about the novelty of a circus in Kurow. The girls ran right along the platform to the back of the train to find the elephant. The lions, grateful for an end to the interminable shaking journey, lolled in the sun, lapping up the crowd's admiration. Clara barely noticed them, for she had seen the elephant. Salome.

Salome stood in a dilapidated railway wagon. Alone. Bolted in tightly with heavy rusted metal. Massive and stolid, she stood with her back to the crowd. Her large ears flapped slowly as a small band trumpeted her arrival. The wagon groaned as she shifted her legs, shaking out the cramp from standing for so long with buttocks pressed against unfriendly wood, one sturdy foot chained. Her red tasselled blanket was rumpled across her back and ripped in places, but Clara could still make out her name: Salome, a name of majesty and strength. The elephant gazed into the distance, her small eyes fixed on the rails she had just travelled, the curved metal that stretched an eternity, the wide shimmering sky. Her nostrils flared slightly as wafts of dusty warm earth were carried on the breeze. She could smell the coldness of the mighty Waitaki, and its earthy churning freshness stirred up a longing deep within her, an ancestral memory of a home far away.

Clara stood, conscious of the inconsolable sadness of the great beast. Standing on tiptoes she reached up to Salome. As she touched the softly bristled skin, its interlaced creases hot and gritty under her small hand, she bumped against someone else. Turning to proffer an apology she saw Mrs Whitman, dressed for the occasion in a long flowery dress, which the wind caught and lifted slightly like the sides of a grand marquee. She wore a bright pink sunhat, and from beneath it her eyes met those of the elephant. Clara wondered if the elephant remembered life as a calf, sheltered between her mother's thick legs and tickled by savannah grasses; whether Mrs Whitman

felt again the insistent pull of her son at her breast, heard the admiring clucks of the other young mothers around her.

Tenderly, the elephant unfurled her trunk and laid it against the teacher's chest. The old woman wrapped her fingers around it.

Mrs Whitman and the two girls stood apart from the crowd, the quick-stepping stilt-walkers, the snarling tiger and jostling children, the small mounds of dropped candyfloss melting on the platform. Bending down, Mrs Whitman picked up Meryl so that she too could touch the elephant, and together they gazed at the beast, another piece woven into the patchwork of their lives.

ALAN RODDICK

How Brian Didn't Meet the Poet

To the memory of Brian O'Rourke

No, I never met your poet—but
he did speak once to our English class.

I sat up front, and still remember
not what he said, but the way he looked,

his polished brogues, sharply creased trousers,
show-handkerchief in the breast pocket

with one for use tucked into his cuff—
I'd never seen a man so well dressed

and, what's more, he'd put on cologne.
In those days we hadn't heard of that;

all the men we knew of dressed to work,
they smelled of work, and Brasch smelled ... *beautiful!*

I don't remember what he read, no.

NORMAN FRANKE

The Smell of the Universe

Behind the alder shrubs memories
stand as snow clouds on the railway embankment.
The spring sowing is already sprouting
under melted snow, smashed greenhouses.

On your father's bookshelf you can find
the entire history of the twentieth century,
which no antiquarian will buy.
There is a new book about death and eternity
next to old family bibles.

According to a newspaper headline
the universe smells of burnt flesh.
It smells of kale and detergent
in retirement homes, of wingless windmills,
of Brahms' 4th Symphony on headphones
while it snows outside.

You sit on an express train
to the airport on your way to Aotearoa.
Provincial stations fly by,
too fast to take in their names.
The universe smells of half-frozen gravel ponds,
pruned orchards, hazy mountains, diarrhoea,
factories for abrasives, trench fractures, dementia,
it smells of your dad's Budni after-shave,
and of the sleet that hurries across the window,
unstoppable, into the past.

GAIL INGRAM

Grandmother and Granddaughter Choose a Tattoo

Blechnum filiforme (thread or creeping fern, pānako)

We pick you, creeping fern, with your hanging threads,
because your fronds come in pairs like the wings
of a pencilled bird, born of a heart in water,
you spring

upwards from rhizomes that bring
old-fashioned words to mind—lace, fishnet stocking—
walking up our limbs like fine crocheted gloves,
not quite

traditional like the popular silver feather—we don't play
the oaf's game or go to war—no thank you,
though we know you are of the koru, tightly
spiralled

mokopuna, representing new beginnings, the future
Aotearoa
and the past, together
we want you

to grow out of the moss and peat of our blood,
this mush of the forest floor under the skin,
sending us upwards into the ether,
the canopy;

a spore-bearer and a wild granny, who wears a streaked cap
for dying her hair, yes, we will keep your colour,
not black ink, but young lime
for us,

you will be our whakapapa when we link arms;
the ancient and new life will kiss.

NATHANIEL HERZ-EDINGER

Foreigners

Every year in the final days of the season, while the pool was being drained and the last few hungover Australians packed their bags, Damon Petrakis gave the new housesitters a tour of his hostel. He showed them how to air the rooms, feed Klara and keep an eye on the Albanian labourers, who weren't paid enough to keep an eye on themselves. Then, after all the tourists were gone, the Petrakis family became tourists themselves. They left winter, Villa Aqua and Greece behind for one of those warm countries—Mexico, Thailand, Kenya—where people treated them like Europeans. Damon liked to hire English-speaking housesitters, and this year he had found a nice quiet couple from New Zealand—Jack and Alana.

It seemed important to Damon that the labourers renovating his hostel were Albanian. Whenever Jack or Alana asked a question about them he answered with the same, simple fact: *they are Albanian*. What are their names? *They are Albanians, all Albanians take Greek names when they immigrate.* How much are they paid? *They are Albanians, you don't need to pay Albanians much.* Do their families also live on Santorini? *They are Albanian.* To start with Jack and Alana found it comical. But now, after two months housesitting at Villa Aqua and with Damon far away, they also referred to the two men as *the Albanians*. The fact of their *Albanian-ness* somehow loomed large. They couldn't see past it.

One afternoon the Albanians were sanding down the faded balustrade of the upper balcony and repainting it a deep wet blue that glittered in the sun. The whine of the electric sander kept interrupting the silence—a silence that Alana didn't even notice until it was interrupted again. She was weeding in the courtyard, freeing the feeble succulents from a choking mess of clover, and whenever the whine started up she glanced over her shoulder and watched the Albanians for a while. The older man hunched over the sander, weary, dazed. The younger man stood upright and gently, thoughtfully stroked the fresh woodgrain with an old paintbrush. He had just caught her gaze for the first time and he returned it steadily, his brush frozen mid-stroke,

bristles expectantly bent to the rail. Alana turned back to the flowerbed. She was squatting, her back sore, the pile of weeds suddenly vast. She stretched up to the sky and let it throb in her eyes. Some strands of cotton from a passing plane faded into the molten brightness. Klara dragged herself out of her pile of leaves and lazily, tenderly nudged the back of Alana's knee with her wet nose.

Jack paused at the threshold of the courtyard and watched Alana. She scratched into the knobbly spot on Klara's cookies-and-cream coat, making her tail thwack greedily against the concrete. He always felt most attracted to Alana in the early afternoon, right before a run. When they were both calm and full of energy. The way her singlet clung to her waist and flared out at her hips; her soft, creamy bare arms dappling in the shade from the bougainvillea. Klara hopped away from Alana and barked at Jack expectantly. She could smell the oceanic scent of healthy sweat on his clothes, recognised the bright red running shorts.

'Are you ready?'

'I'll just get changed.' Alana went back to their room.

The two Albanians descended from the balcony, wiping their hands on their jeans. They poured a bucket of dirty water down the drain and packed the ladder into the toolshed. The older man had watery eyes and a soft gut, and he mournfully announced their comings and goings in thick, weighty sentences.

'Today, we are finished.'

Alana noticed the younger Albanian watching her as she re-entered the courtyard in her shorts. He must have been the older man's son—his face was strikingly similar—yet he seemed to live in another world. He had none of his father's sloppiness. He wore the same dirty blue jeans, but they were close-fitting and their white splatters seemed to glow and burn like a Pollock painting. His bare arms were tanned and beautifully sculpted. Although he was already starting to bald and had the heavy brow and drooping nose of his father, his eyes were bright, defiant. He never spoke. The older man continued cryptically, 'Tomorrow we are working. The water is empty.'

'Okay, thanks guys, seeya tomorrow.'

Jack winced. Why did he thank them, as if they worked for him? As if he identified himself with Damon and his sinewy, high-strung trophy wife? Jack

tried to catch the younger Albanian's eye but he was too focused on Alana. A shadow of a smirk always hung on his lips; there was a pervasive *sharpness* about him. He made Jack feel aggressive, and subsequently petty. Why wouldn't he speak to them? The father nodded slowly and they piled onto their old brown scooter, the son holding a toolbox in each hand, gripping the seat with his thighs.

Alana watched them leave. There was something ridiculous about it—two men weighing down a tiny engine, spluttering up the driveway barely faster than walking speed. And it was a Sunday afternoon; they worked every day. The father was always so gruff and tired while his son carefully handled those ancient paintbrushes and, with sudden bursts of energy, heaved the scaffolding across the concrete.

The scooter vanished around a corner. Something about it felt unconscionably sad. Alana wanted to reach out to them, to share something, but of course it was impossible. What could she say?

Jack opened the gate to the beach road and Klara loped out with a deep joyous bark. They jogged slowly after her. Alana seemed suddenly nervous, quiet. She stared down at the ground, frowning softly. Out on the horizon a line of grey cloud was forming. Soon, a tight wind would whisk the dry leaves into strange formations and the greyness would rush forward to steamroll the sky into a dark low slab. Then the drizzle would start and, like someone turning up an untuned radio until the static deafens, it would build and build into a storm.

'I don't know why, but just as they left I felt so sorry for them.'

'For the Albanians?'

'Yeah. Like this deep sadness for them. It was strange ... I just felt this intense pity for them.' They jogged along quietly for a while. Damon had told them that a stream used to run through the bottom of the valley. To attract more people to the beach the government had built a road over it, and now every winter the stormwater tried to follow the path of the old stream. It eroded the hardfill, burst against the low concrete walls and covered the road with gravel and silt. People in passing cars threw bags of orange peel, coffee grounds, building scrap, plastic bottles and chunks of concrete, and it all congealed together, rotting and rusty.

Jack filtered all that out. He only saw the silver glint of the olive trees, the

wiry forlorn bushes huddled together against the wind, and the fine shining pelt of grass that covered the playful hillocks of pumice that seemed to bounce up and down along the valley like a rippling bedsheet, or the mountains of Jerusalem in a medieval painting. Into one of these hillocks someone had dug a small cave for their donkey. It wasn't a cheerful donkey. It was old and moody, and whenever Klara sniffed up too close it screamed in terror. Jack yelled at Klara to stop eating something from the overflowing dumpster on the corner.

Alana winced and pressed on. 'Do you ever feel that way?' He wasn't sure why, but this question made Jack uncomfortable. The imprecision. The sense that something obscure was at stake.

'Do I ever feel sympathy for someone, like, out of nowhere?'

'This really sudden, kind of choking feeling for someone … Like you need to help them or talk to them or something. But you can't.'

'I don't think so … I don't think I ever feel that way.'

'But do you think it's normal?'

'I think so. I think it's called sentimentality. I …' Jack forced himself to continue, 'I'm not a big fan of sentimentality.'

What did he mean by that, *not a big fan of sentimentality*? Alana looked up and stared straight ahead as she ran. A wall of greenish-red ocean rose up ahead of her. Soft, veiled islands floated along the horizon. The conversation was following a pre-ordained course. Whenever Klara barked at dinner— harmlessly, *fondly*—Jack would scold her. If she barked again he would jump up, flick her sharply on the forehead, drag her outside, shut the door, then sit down and keep eating quite cheerfully as if nothing had happened. Of course she shouldn't bark inside. They had to discipline her, it was part of their job. But to do it so casually, thoughtlessly, as if Klara didn't have feelings—not to *care*, not to be affected by Klara's pain, to treat it as simply irrelevant, meaningless—it was harsh.

'Why aren't you a big fan of it? Is there something wrong with caring about other people?'

Jack had known she was going to take something personally. What was he supposed to say? It was like she had adopted the Albanians and now she was protective of them. It was strange the way she doted on animals and people, seemingly at random. Of course Jack knew that *he* liked to be doted on. To lay

his head in her lap as she stroked his hair, kissed his neck and hugged him tightly, protectively. But this angelic way she treated the dog, accepting the necessity of discipline then turning up her nose at its actual execution, as if that made her a better, more noble person—it was silly.

'Of course it's good to care about others, but that's not what sentimentality is, that's not what pity is. Pity is just about your own needs. Like the whole African poverty porn thing. There's some bloated African kid with flies in his eyes or whatever, and it makes you feel bad. You want to get rid of your emotions so you throw down some money and forget about it. But your feelings don't actually bear any relation to the experience of the child. You don't have a real connection with him. It's the same with the Albanians: we don't know anything about them, we don't know their lives, so how can you say you actually care about them?'

'Does that mean it's wrong to feel bad and want to help someone? Like, first I should learn everything about someone and then start feeling for them?' Alana jogged ahead slightly and let the valley fill the silence. Klara panted, struggling to keep up. The whole valley rustled softly as a breeze flowed up from the sea, a breeze that darkened the clouds on the horizon and curled the waves into a white froth that sucked at the stones, leaving a faint chalky line along the shore. As she neared the beach the wind grew stronger and kept changing direction as if trying to slap her on both cheeks. Right, left, right. She stepped off the jagged edge of the road, down onto a cinderblock, a puddle of set cement and then the beach. Klara sniffed at the debris, oblivious to the waste and the ugliness. Alana looked out at the deep reddish glint in the middle of the ocean. *The wine-dark sea.*

Jack stopped at the edge of the road and saw Alana staring out at the waves. It was as if he was watching her from a great distance, through a powerful telescope. She faced away from him, dwarfed by the immense, moody, flattened ocean. The picture was crisply detailed—the pebbles under her feet, her goose-pimpled thighs—yet somehow remote. An eerie tension warped his sense of time. How long had he been watching her for? They seemed to be moving apart even as the next stage of the discussion drifted steadily closer. Jack jumped down onto the beach and crunched across the pebbles towards her. Alana turned listlessly away from the ocean and he replied briskly, as if she had just finished speaking.

'I think the issue is that sentimentality stops us from actually, genuinely connecting with others. Because instead of seeing them or really understanding them we just feel this little emotion that has nothing to do with them. We don't know anything about the Albanians. To actually empathise we'd need to know something about their situation.'

Even as the cold wind cut into her, Alana's cheeks flushed and she felt a prickle of sweat on her forehead.

'What difference does it make? How can you put everything into these little boxes, you know this person, you don't know that person, you feel this, you feel that, that's good, that's shit?'

'No, I agree that the world is fluid and complex.' Again his brusque, precise phrasing. 'Of course words just help us to understand phenomena by treating them in isolation. Even though nothing in the world is really isolated.' Klara interrupted with a booming bark and sat at Alana's feet with her cloudy eyes and invincible panting grin. She wanted to be thrown chunks of pumice to chase after and crush between her teeth until her gums bled. Alana wouldn't throw any stones. Klara would bark louder and louder, more and more exuberantly. Again that oppressive sense of *déjà* vu. Everything had already happened. It was getting cold. Alana knelt down to scratch behind Klara's ears and replied in a hurried, numb voice, as if talking to Klara.

'Well if everything is all *fluid* and *complex* then how do you know how I feel? How do you know that I don't see them as human beings and only ever think about my own feelings?'

She stood up and led Klara away from the waves. Jack called after her,

'I *don't* know. I'm just basing what I say on how you describe your feelings to me.' Puddle of concrete, cinderblock, street.

'Well I'm sorry that I don't know all the meanings of words as perfectly as you do. Sorry I didn't read through the whole dictionary when I was seven. I won't say anything next time, don't worry.' Jack felt like he'd been caught in some bizarre irrational trap. In a tense staccato rhythm he recited, 'I'm sorry I offended you. I thought we were just having a discussion.' He winced. It sounded so false and hollow. Alana snorted quietly, derisively.

They jogged the rest of the way back to Villa Aqua in silence. Jack had the first shower. He masturbated out of spite, fantasising about the chubby, timid Greek girl who weighed the vegetables at the supermarket. Then he began to

feel more and more persecuted. They had talked about his tendency to grunt and say nothing when he didn't feel like engaging in a real discussion. It was a slow, painful process, but he was making a conscious effort not to do this—today he had fought against his discomfort and tried to respond spontaneously, sincerely. He should have just grunted and said nothing. Whatever he did, his behaviour was twisted into an attempt to silence Alana and to judge her, even though it was blindingly obvious that it was *she* who silenced *him*, *she* who judged *him*. And the most frustrating thing was that there was no point in talking about it—it went around in circles.

He soaped himself aggressively, raking his fingernails through the hair of his armpits and crotch, then stood vacantly in the shower until it ran lukewarm.

Alana went back to their room, shaking with anger. She sat on their bed and tried to focus on the news on her phone. To feel this expansive, melancholy compassion for another human being—to feel herself caring deeply for someone, reaching out to someone whose language she could not even speak—only to be told by the person she loved that her feelings were banal, trite, pornographic—to be given a pompous, self-satisfied lecture on *her own feelings*, like she should be grateful for the lesson—and as if that wasn't disgusting enough—*I'm sorry I offended you. We were only having a discussion.* As if that was a sensitive, graceful thing to say. As if that was a *discussion*—to tread her most tender feelings into the dirt and then denounce them as dirty. And the humiliation of her own submissive silence. It was ridiculous. Yes, that was true—it was sad and ridiculous.

Jack came inside wearing his towel and they stared at each other for a moment. His long, pale, hairy body was somehow primitive. Sitting on the tightly made bed, Alana looked orderly, prim. Her eyes were shining. He looked away.

'You'll probably have to wait a bit, there's no hot water left.' They didn't talk about the discussion for the rest of the day. It felt less and less important. The next morning Alana got up at ten to eight to feed Klara and unlock the toolshed for the Albanians. Damon had told her she shouldn't give them the keys. Rain didn't come that day after all—the clouds simply hung in the sky.

DUNSTAN WARD

Fête du Muguet

Lily of the valley: all too apt
for a viral fête this first of May . . .

Our florist pot enshrines white sprays
borne home through empty lockdown streets:

flowers to celebrate life afresh,
silent bells for the thousands dead.

Their leaves seem raised acclaiming hands,
their heads are bent as if in grief.

Renaissance emblems, good-luck charms
a French king offered his court ladies,

ordaining 'Let this be done every year'.
We bow to breathe a perilous scent.

May Day messages: hope, distress.
Lethal love tokens, bridal bouquets.

The plague god's gift. Our Lady's tears.
Lilies of the valley of death.

REBECCA HAWKES

Trespassers Will Be Shot /
Survivors Will Be Shot Again

tell the poachers by their beams / shafting the wild dark / tell the possums / by
their eyeshine / the name of which chimes / rain on the roof of the killing
shed / tapatum lucidum / isn't it just / corrugated iron singing under frazzled
static moonlight / this is before rust / seeps lurid tendrils on the shed's
concrete floor / this is before the biggest clot of her life

halo of moths frothed to the lamppost / solo beacon for the dead state
highway / she waits just outside the cone of cloying light / knees clamped /
clammy on the step of the community hall / perched at the clavicle of
anywhere / locked church of the local / agnostics and war memorialists / to
gather in / its only prayer / we were here we were here we were here /
togetherish / the pines are a stand of ragged dark / the stars are greenish in
their shoals / the possums make routine mechanical shrieks and groans / she
gets in the car when it pulls over / headlights half dipped like shyness

limbs akimbo in the rhododendron grove / handpainted video surveillance
sign flaking off the gate / the car becomes a whole animal / bloated with
organs and breath / windows limned in wet air / personal fug / pure human
chemical nimbus / stringent antiperspirant / burger wrappers like pressed
flowers / cold fries fossilised under the seats / hard spirits in mountain dew /
until she is fluorescent all the way through / her head drumming a bruise
against the switches / coming so hard the car unlocks / rolls the window open

crick joints / unstick frigid skins / gluey eyed / birds tune up the pre dawn /
she treads home thrumming / still clammy but for some / hot sore core / she
has been stoking deep / but she is needed / in the killing shed / attending / the
peeled hogget / shorn and shorn again / beyond nude / decapitated / rigid /

draining / its ribcage slit to gape / adjustable mannequin / she imagines a wedding dress/ fashioned from corrugated iron / to rust in / the clot plops from the sheep's opened throat / holds itself together / stranded jellyfish in salt / it / slides out like a brand new body / freer than the one before

LYNN DAVIDSON

Walking to the Hoover Dam in February 2020

(recalled in April 2020)

It just feels
like an age since we
walked through tunnels
to the Hoover Dam.

Well we didn't walk to, we walked towards—
turning back before the actual dam. I
felt scared of it myself, just one small word
with all that water banked up behind.

We liked the hillsides
with their rocks and splashes of clean light.

The mountains were pink and dun and violet.

Lake Mead—old sand-maps tattering on its surface—
drawing from the Colorado River.
Diverting water into Mexico, Arizona, Nevada, California.

It all seems built so long ago, as though the dam and
reservoir were made, like land, at some beginning
time. Before America. But really
in the Great Depression.

What will we build now?

Or take down
 —dismantle

Or be holding, holding
holding

CILLA McQUEEN

Caselberg Trust International Poetry Prize 2020 Judge's Report

This year's bumper crop of 426 submissions perhaps owed something to the enforced introspective seclusion of pandemic conditions. The standard of writing was high and indicative of the thoughtful work involved.

Reading and rereading was like being in a huge Zoom meeting, each poet an individual voice. I was struck by the hours of concentration represented by each poem, the many difficult decisions a poet must make about such things as meaning, form, vocabulary, euphony and flow during the process of its creation.

Aware of the myriad paths of poetry and alert to widely varying levels of technical ability, I looked for works that were clear, insightful, distinctive, sensitively observed and subtly crafted. Evident in the best of them is love of language and the ability to use it well.

From the many poems I wish there were space to mention, here are some comments on a few in my longlist:

Musicality is a desirable attribute and was evident in many pieces. 'Sonatas' (by **John Kelk**) actually makes a musical score out of looking skywards through power lines, 'heart beats percussive feet … on cloudless days playing the Blues and in gales Doppler … magpies speaking pidgin in song thrush … escape on the silence of empty lines'. Rhythm is to the fore in 'Turf' (**Miriam Gemmell**): 'you don't wanna jolt outta/ you wanna hit he re/ you don't want deep hono/ you want dizzying sss/ you don't want a scatting busker holla/ you wanna live baby bae …'

Sensitive observation produced 'Waifs and Strays' (**Rebecca Hawkes**), a vivid picture of a young girl feeding lambs that 'brace their whole bodies against the force of their own suck' and 'drink up the world/ chugging hazy daylight from the atmosphere the churned sunshine lofty cream/ … while all

things birth and butchery happen/somewhere else'.

Three poems referenced the work of New Zealand poets Robyn Hyde, Ruth Dallas and Hone Tuwhare respectively. 'All That Remains of the Struggle' (**Kathleen Jones**) sees a view of the ocean with Robyn Hyde's 'blue shout of surprise'. Dallas's 'Milking Before Dawn' provides a sharp contrast with instructions for biosecurity in 'Anti-pastoral: Biosecurity Act 1993 section 130' (**Janet Newman**). Hone Tuwhare is present in a poem about prayer and poverty, 'An Ode to Hone in His Name' (**Kim van Rijn**).

Any of the above poems could have made the shortlist, but the five I chose showed excellent command of language and a distinctive voice:

First prize
'Sparrows' by **Tim Upperton** is a poem of structured simplicity as well as a remarkable piece of shape-shifting; it's of wider resonance and philosophical import than is at first apparent.

Second prize
'His Name Doesn't Fit' by **Giles Graham** consists of four economical stanzas of clear and sympathetic observation, tied together by an arresting final image.

Highly commended
- Sensitively written, 'Each Blackberry' by **Brett Cross** waits until the last line to reveal the sweetness of a father–daughter relationship.
- 'Catch and Kiss' by **Rowan Taigel** is a small drama, a rite of passage containing a vivid and effective simile.
- Hesitant and delicate, 'Letter I Will Never Post' by **Lily Holloway** has a mystery behind it, a hurt only partly revealed.
- 'Conversation with a Sea Lion' by **John Stevens** is relaxed in approach and language, the poet at one with nature.
- In 'Panegyric, Back Home from Hospital' by **Jane Simpson** there is sheer joy in every line.

TIM UPPERTON

Sparrows

Seven plump sparrows pecking
at something in the grass—
they were having such a good time,
obviously, they were going for it,
and right then the best thing
would've been to be an eighth sparrow,
pecking at the ground with my friends,
eating I don't know what—seeds?
But really enjoying myself,
these seeds are great, just great,
chucking them down, the sun
on my back, earth steady beneath
my clawed feet, and high in a tree a nest
I built myself and a mate to return to.

GILES GRAHAM

His Name Doesn't Fit

Like his clothes, rolled into limbs tucked
Up into crevices, dressed in a heap.

Like the milk that gurgles, drools
And is spit in blobs of fist faced decision.

Like his cry, that washes out of his heart
And tries to rest in ours.

Like the world is too big.
I watch him struggle to pull it all vastly
Through his eyes.

ANGELA POPE

Lies

This story is the winner of the 2020 Sargeson Prize, New Zealand's richest short story prize, named for celebrated New Zealand writer Frank Sargeson and sponsored by the University of Waikato. This year's judge was Owen Marshall.

When people ask me about the walking cane, I tell them I fell twenty metres to the ground and splat! I'm lucky I'm walking again. I should be in a wheelchair.

They always want to know how I fell, and this guy was no different. I knew what he was thinking, 'What a bloody shame, a girl like that.' He'd been in the shop a few times and we'd shared the odd joke, but if he thought that meant I was gonna spill my guts, he had it all wrong.

He stood waiting as I moved towards the food cabinet. There was the meaty smell of pie and a warm rush of oily air as I slid open the glass door. It was an awkward one-handed manoeuvre to scoop out the chips while I leant on the cane. It had been a bad day. The Gabapentin I'd taken that morning was starting to wear off and the spasms were beginning to kick in. I lost my grip and the cane clattered onto the cold tile floor.

'Shit!'

'Here, I'll get it for you,' he said, and then he was scooting behind the counter like a bloody Good Samaritan before I could even say 'Jesus!' under my breath.

'Customers aren't allowed behind the counter,' I told him, taking the cane from him and leaning it up against the back wall. I handed him his chips. 'You better get yourself on the other side of the counter before Mrs Lee sees you, or she'll have me fired.'

'Sorry, sorry.' His cheeks were flushed, which made his green eyes seem darker. Not that I was noticing. Just like I didn't notice how warm his hand was when he handed me the cane and how his fingers were long and slim like a pianist's.

'My Auntie Elsie was always knocking her stick over,' he said. He spoke in a

rush, like he was trying to cover up how awkward he was. 'So she got one of those walker frames.'

'Good for her. That's $3.' I gripped the counter for balance. I wasn't gonna use the cane again while he was in the shop.

He pushed the buttons on the eftpos machine but still he kept talking. 'My auntie has arthritis,' he said. 'So what about you? You didn't say.'

Sometimes I tell people I was a trapeze artist, how I flew through the air wearing a leotard, sequins sparkling under the lights of the Big Top. How I loved the whoosh of the air flying past my face, the thrill as my hands caught the bar at the very last moment. How my partner, Leonardo, was so shit-hot that every girl in the troupe wanted to shag him. How I gasped every time he caught me by the ankles and flung me through the air.

People love that stuff. I can see it in their eyes, the guys especially, imagining the high-cut leotard with the cute little skirt rippling in the air as I'm swinging on the high bar, my legs lean and tanned and muscled. Their eyes widen, taking it all in. And then I tell them that one day there was an accident. It was my fault. I spent a little too long rubbing in the fake tan on my inner thighs and adding the shimmer that would make my skin sparkle under the lights. When Leonardo went to catch me I felt his fingers grabbing hold like they always did. I gasped in ecstasy, but it turned to horror as I realised they were slipping, and I was going down.

'What about the safety net?' they always ask. I tell them the guy who was supposed to be in charge of health and safety was high on weed half the time. He didn't do the safety checks. The net gave way and I crashed to the ground.

People love that story, not just for the sexual thrill but because there's someone to blame. It gives them the chance to rant on my behalf and tell me they hope the bugger's gone to jail and how it's a terrible thing to be let down like that, literally, by someone not doing their job right. And then there are the ones who like to go on about drugs and how they're the scourge of society and how they have a cousin twice removed who was killed by a drug driver who was high on meth.

My second-favourite story is that I fell off a cliff trying to rescue a dog. People always want to know what kind of dog it was. Sometimes I say it was a bichon frise with a bouffy haircut; other times that it was a St Bernard and it was a hell of a job lifting that bitch but the adrenalin must have kicked in. People nod in

that knowing way, as though they spend half their life with their adrenalin kicking in and achieving unbelievable feats of strength.

If I'm in a foul mood I'll say the dog fell with me and it died, that as I lay there on the ground I held the dog in my arms and saw it take its last breath. Once I made a little kid cry with that story. If I'm having a good day, I'll say the dog was okay, that it licked my face as I lifted it up over the top, that I lost my balance then and fell.

Once I said I won a bravery award for saving the dog and that the Queen even wrote me a letter about it. I knew that was going a bit far when some kid came in and asked if she could see the letter because she was doing a project about it. I told the kid I had a brother who was one of those anti-royalists and he burnt the letter. I don't know if she wrote that in her project.

I chose the straightforward dog story for this guy. It was a toss-up between that and falling from a coconut tree while working with orphans in Nouméa, which was a new storyline I'd been working on. I wanted to watch his face while I told him I was shimmying up the tree in my bikini, but I thought better of it. I decided to save that story for another day, for some other stranger who thought they were entitled to know everything about me. I mean, how would they feel if I walked up to them and asked, 'Hey, tell me about the shittiest day of your life?'

'I was saving a dog stuck on a cliff.' I sighed. 'And I fell.' The pain levels were really kicking in now, spiking their way like needles through my vertebrae.

'What happened to the dog?' he asked.

'The dog went to the vet for a check-up and it had a bloody tumour, didn't it? Had to be put down. Shouldn't have bothered saving the fuckin' thing.' I'd gone too far. I knew that. But the pain was making me irritable.

'Right.' He picked up the pottle of chips and looked at me like he was all sad and disappointed at the same time. 'None of my business, eh?' Then he left.

I hobbled over to the back wall and grabbed the walking cane after he'd gone.

Mrs Lee says I shouldn't swear in front of the customers, but I know she won't fire me because I'm a cripple. She's never asked what happened to me, but I know she's listening when I tell my stories. She's heard a few different versions so she must know it's all lies. Once the guy had left she came out from the storeroom. She'd been eavesdropping again.

'He's a nice boy, that Marty. His brother died last year,' she said. 'Rolled a tractor on the farm. You're not the only person in the world with problems, Tracey.'

I felt a bit crap after that.

<p style="text-align:center">★</p>

I came to live with my nan after the accident. She didn't want me, but neither did anyone else. Nan lives in an old villa with large cold rooms and damp patches growing daily around the ceiling roses. The white paint on the walls is peeling and comes off like flakes of dandruff when you brush against it. The wooden floorboards are bare and scratched.

It's easy enough for us to avoid each other if we want and most of the time we do. But one morning, about a week after I arrived, I went into the kitchen for breakfast and Nan looked at me blankly and said, 'What are you doing here?'

I said, 'I live with you, Nan.'

'I thought I had rats,' she said. 'I kept hearing tapping up and down the hallway.'

'I have to practise my walking so I can get stronger.'

'I don't like rats,' she said.

'It's not rats, Nan, it's me.' I walked up and down the kitchen with my cane so she could hear the way it tapped.

'You been eating all the cornflakes?' she asked.

'No,' I lied.

'Must be rats then,' she said.

I went to the cupboard, but Nan was right. There was no cereal left.

'I can't afford to buy any more,' she said.

'It's all right, I'm loaded,' I said. I was joking, of course. The truth was, I was broke. ACC wouldn't give me the wages compo 'cos I'd left my job to go travelling the week before the accident, and so I was on the disability benefit, which wasn't a lot.

I found some bread, but as I went to put it in the toaster I saw it had mould growing on it. When I turned around to say something to Nan about it, she was holding a mirror up in front of her face and putting lipstick on her eyebrows.

<p style="text-align:center">★</p>

Mrs Lee's dairy was next door, which was about as far as I could walk back then. There was a walking frame sitting in the corner of my bedroom, and a wheelchair too, but I wasn't gonna use them. I got my walking cane and I walked—sixty-seven steps by the time I'd made it down Nan's garden path and through the gate and up the ramp into the dairy. It was good that there was a ramp because I couldn't get up steps easily yet. Later, Mrs Lee told me the ramp was there because she had a cousin in a wheelchair, and he always used to come by on a Friday for a hot chocolate in the days before he left town to go and live in the city. She was proud of him, she said, because he had a good job working for an IT company. I didn't know if she was proud of him because he was clever or because he was in a wheelchair and he'd still managed to get himself a job.

There was a card in the window of the dairy, advertising for an assistant. It was written in blue biro in capital letters. I asked Mrs Lee about it as I put a box of Weet-Bix on the counter. (She'd run out of cornflakes.) She asked to look at my fingernails and I held out one hand at a time, so that I could still hold on to the walking stick. I've never been one to bite my nails, and I hadn't been digging around in any dirt, so they looked okay.

'You can start tomorrow,' she said.

Mrs Lee gets this sad look on her face every now and then and asks me if I'm okay, like she wants me to talk about my life. Sometimes she even opens up a packet of custard creams so we can share them over a coffee in the back room when the shop's quiet. I'm not one for talking but I'll eat the biscuits. She was the one who said me and Nan needed some chickens. She stuck her nose over our fence one morning to check out the size of Nan's section. There were some battery hens that needed saving or else they'd be for the chop, she said. I told her it was a dumb idea and that the only chicken that was making its way into our house was from the frozen section of the supermarket.

She wouldn't let up about those chickens, though. It was like she was turning into one of those animal rights people. She put a sign up in the dairy window, and every time a customer came in she'd be on at them to get some. It began to feel like I was working for the fuckin' SPCA.

'If no one wants them, we could roast them,' I said. 'We could put them on special, do a combo with a scoop of chips and a milkshake.'

She frowned. 'I know life's hard for you, and this is your way of coping,' she

said. I nodded and pretended to be sorry. 'Looking after some chickens would give you a purpose in life, Tracey,' she said. I was trying so hard not to laugh that I had to pretend I was having a coughing fit.

In the end I gave in, partly because I was bored with her nagging, and partly because I wanted to meet the chicken farmer guy that Mrs Lee kept whingeing about. She made him sound so evil that I half expected him to walk out wearing a long dark robe with a mask like Kylo Ren. If he looked anything like Adam Driver, it would be worth getting those chickens. Shit, I might even make a few trips and get half a dozen more if that was the case.

Mrs Lee said she would take me to the farm in her pink Honda Jazz. Before the accident I wouldn't be seen dead in a Honda Jazz, let alone a pink one, but that's how much my life had changed. But it turned out to be a lie anyway.

'I've asked Marty to take you,' she said, as I put my coat on. 'Ruth couldn't make it.' Ruth was Mrs Lee's friend who sometimes helped out behind the counter. She was supposed to be looking after the shop while we went to the farm. I didn't believe a word of it and I was so angry that if Marty hadn't walked in right then and there, I swear, I'd have whacked Mrs Lee across the shins with my walking stick.

Marty seemed surprised too, when Mrs Lee told him that it was me, not her, going to the chicken farm. His face took on a scared kind of look, like a kid who's just been told he has to buddy up with the class bully.

I followed him outside to a black ute that was standing in the five-minute park outside the dairy. He hovered around and I could tell he was wondering whether to open the door for me, but I did it myself. He put the radio on as we pulled away. I got the impression he didn't want to talk to me just as much as I didn't want to talk to him.

He was in his work overalls and his dark hair was tied back in a man bun so I could see he had his ears pierced with small black studs. He had a light stubble across his chin. I turned away and looked out the window. I didn't want him to know I was looking at him.

'You like working at the dairy?' he asked after a minute or so. I wondered if he'd been thinking about what might be safe to talk about.

'It's okay.'

'What did you do before?'

'Roofing.'

'Ah, right.'

I could tell what he was thinking but I couldn't be arsed explaining that he had it all wrong. He could think what he liked.

After the accident, all I could think about was how I might get back to roofing. I missed the thrill of it, tiptoeing across the tiles of the city skyline. The world looks different from up high. You can look down over the top of everyone and most of the time they don't even know you're there because they don't bother to look up. They're too busy hurrying off to places, stooped, half of them are, like they've got a world of worry on their shoulders. You can't be like that when you're on a roof. If you were too busy thinking about other shit, you'd lose your balance and fall. There's nothing but you and the moment and the job right in front of you. That's what I loved about it.

As we pulled up in the unsealed driveway to the farm, a huge guy with calloused hands came out. He wasn't wearing a black cape and he didn't look like Adam Driver, but I tried to hide my disappointment.

'I went to school with George,' said Marty, as he got out of the ute. 'He's okay.'

When Marty said we'd come for some chickens, the huge guy strode off towards the big shed. He came out carrying two hens in each hand, upside down by the legs. Marty put the chickens in a large cardboard box in the back of the ute.

'You got a coop?' he asked as we pulled up outside Nan's place.

We didn't, but there was a big wooden kennel at the bottom of the garden. Nan had once had a great dane that had died and was buried near the rhododendrons. Mrs Lee had put peastraw in the kennel and said it would do for now. She'd given me a bag of chicken pellets and some scratch grain that she'd bought from the farm supplies shop. 'Just to get you started,' she said.

Marty lifted the box with the chickens and carried it into Nan's garden. I followed behind and watched as he put it down on the grass next to the kennel. He bent over and lifted the flaps of the box. The chickens were so still, I was worried they were dead already.

'They'll take a while to come right,' Marty said. 'It's a bit of a shock for them.' Gently, he turned the box over onto its side so that the chickens could get out. One of them stood up and ruffled its feathers a bit. Two of them lifted their heads. The fourth one lay there not moving at all. It reminded me of how

I was after the accident, the way I lay there in the hospital bed feeling broken. It made me want to tear up, so I had to look away. That's when I saw Nan watching us from the house. She was standing at the window, her hair sticking out in all directions like she'd stuck her finger in an electrical socket. I figured she'd lost her hairbrush. I'd seen it sitting in the bowl where the toilet brush normally went. I didn't want to think about what had happened to the toilet brush.

'I'll be going then,' said Marty. He was looking at me, I could tell, but I didn't want to meet his eyes. 'You okay?'

'Why wouldn't I be?'

'Okay, none of my business.'

'That your new boyfriend?' Nan asked, after he'd gone. She'd come out to the garden to see what was going on. 'Didn't you kill the last one?'

'Yeah, Nan, that's right. I killed him.' I turned to the chicken lying on the ground. 'Come on, hun,' I coaxed, but she didn't move.

'I'm not plucking them,' said Nan.

'We're not going to eat them,' I said.

'They'll all be dead before Christmas.' Nan's voice sounded creepy, like one of those people in a horror movie. I figured she'd been reading too much Stephen King. I'd noticed the books lying around the house, borrowed from the library's large-print section.

'Don't listen to her,' I said to the chicken. It cracked an eye open and stared at me. It kind of gave me the heebie-jeebies. 'I'm gonna call you Hannibal Lecter,' I said.

<p style="text-align:center">★</p>

Every morning when I came out to feed the chickens, the weirdo hen would be standing there on one leg with one eye open.

'You better lay some eggs,' I said, 'or I'm sending you to KFC.' She stared right back at me like she didn't give a stuff. Weird how she seemed a lot like me.

Mrs Lee asked me every day how the chickens were doing and if they were laying any eggs. I didn't tell her there'd been a few eggs without shells that had grossed me out. I'd thrown them away. I figured it must be my fault, that I must be doing something wrong. I did a bit of research on chicken nutrition. Sweetcorn seemed good, so I started sneaking a few tins out of the dairy to

give them. I even took some apple cider vinegar to put in their water. If Mrs Lee knew, she never said.

The first chicken died after only two weeks. It was lying there, its legs splayed out, when I went out to check for eggs one evening. I was worried it might be because of the sweetcorn coming out of a tin. I didn't tell Mrs Lee about it. I didn't want her getting upset.

When I told Nan she looked up from the Stephen King book she was reading. The book was upside down and she had her glasses on lopsided.

'I told you,' she said. 'Dead by Christmas.'

The next two chickens died in quick succession over the following week. I hid them all behind the rhododendrons, but I was going to have to bury them. I sat down on the grass and began to dig with a trowel. The soil was hard and it was taking a long time but I kept stabbing at the earth with the metal blade. Hannibal Lecter stood on one leg watching me the whole time. She was the only one still alive.

'Jeez, I'm shit useless,' I told her. I was just about ready to dig myself a hole and climb into it, I was that upset with myself. 'Just me and you left now, Hannibal,' I said.

The more I dug and the deeper the hole got, the darker my thoughts became.

'What's happening, Hannibal?' I said. 'Is Nan poisoning you all?'

The chicken blinked. Did that mean 'yes'?

When the hole was big enough I clambered onto all fours, crawled over to the dead birds and dragged them into it, one at a time. It didn't feel respectful, like a proper funeral should be, so once I covered them up I started to sing.

'Always look on the bright side of life.' It was what they'd sung at the funeral, apparently, the one I hadn't gone to because I was lying in the hospital with tubes sticking out of me.

When I finished singing I didn't know how I was going to stand up again. Nan had pulled the curtains inside the house, and it was starting to get dark. The cold was seeping up from the ground through my jeans.

Hannibal Lecter made her way inside the coop. I sat there alone in the dark. Next door I could see the lights from the dairy were still on. Perhaps when Mrs Lee closed up I would be able to call out to her. Or perhaps I would be out here all night, catch hypothermia and die. I wasn't sure which option I preferred.

'Hey.' I heard the voice in the dark. 'Are you okay?' It was Marty. 'I was just popping into the dairy for some milk and I heard you singing,' he said. He sounded nervous, like he was frightened I was gonna yell at him or something. 'Everything all right?'

'I'm stuck.'

Nan was sitting in the lounge in her pyjamas watching *Murder, She Wrote* when Marty helped me inside.

'You need to watch her,' she said. 'She killed the last one.'

Marty looked confused.

'I think Nan's been killing the chickens,' I told him.

'No, I haven't. It's the rhododendrons,' she said. She turned the volume up higher and tutted at us.

'What the fuck?' I said.

'You must be freezing,' said Marty. 'I'll put the jug on, yeah?'

In the kitchen I looked it up on my phone, and Nan was right. Rhododendrons were poisonous to chickens. 'Shit,' I said. 'I'll have to find another home for Hannibal Lecter.'

'What did your Nan mean, that you killed the last one?' asked Marty as he passed me a cup of tea.

'Don't listen to her, she's off her trolley,' I said.

The next day I told Mrs Lee the truth about the chickens, the whole story from start to finish, how they'd been dying on me and how I hadn't wanted to tell her.

'I'll take Hannibal Lecter over to my place,' she said. Then she looked at me real stern, like she was a school principal or something. 'You've got to stop telling lies all the time, Tracey.'

A few days after that Marty came back into the dairy. I hadn't seen him since the night I'd been stuck on the lawn in the dark.

'There's something I have to tell you.' I handed him his pottle of chips. 'I didn't rescue a dog.'

'I figured.'

'It was a car accident. My fault. That's how I killed someone.'

'That sucks.'

'Yeah.'

'I preferred the dog story,' he said.

The Landfall Review

Landfall Review Online

www.landfallreview.com

Reviews posted since April 2020
(reviewer's name in brackets)

April 2020

The Burning River by Lawrence Patchett (Ben Brown)
Listening In by Lynley Edmeades (Claire Lacey)
AUP New Poets 5, eds Carolyn DeCarlo et al (Claire Lacey)
Whitiki! Whiti! Whiti! E! by Monty Soutar (Vaughan Rapatahana)
Chosen Boys by Petra Molloy (Lynn Jenner)
Craven by Jane Arthur (Elizabeth Morton)
The Track by Paula Green (Elizabeth Morton)
At This Distance by Dunstan Ward (Elizabeth Morton)
Selected Stories by Vincent O'Sullivan (Michelle Elvy)

May 2020

Shakti by Rajorshi Chakraborti (Brannavan Gnanalingam)
By Sea Mouths Speaking by Denys Trussell (Janet Newman)
The Father of Octopus Wrestling by Frankie McMillan (Diane Brown)
Make It the Same by Jacob Edmond (Tasha Haines)
The Dark Island by Benjamin Kingsbury (Mira Harrison)
A Communist in the Family by Elspeth Sandys (Richard Bullen)

June 2020

Native Son by Witi Ihimaera (Simone Oettli-van Delden)
Someone's Wife by Linda Burgess (Emma Gattey)
Drongo by Ian Richards (Craig Cliff)
Back Before You Know by Murray Edmond (Anne Kennedy)
Conventional Weapons by Tracey Slaughter (Anne Kennedy)

The Ash, the Well and the Bluebell by Sandra Arnold (Carolyn McCurdie)
Rebuilding the Kāinga by Jade Kake (Gerry Te Kapa Coates)
#NoFly by Shaun Hendy (Gerry Te Kapa Coates)

July 2020

The Wild Card by Renée (Arihia Latham)
Year's Best Aotearoa New Zealand Science Fiction & Fantasy, ed Marie Hodgkinson (Gina Cole)
Friday Prayers by Tony Beyer (Siobhan Harvey)
By the Lapels by Wes Lee (Siobhan Harvey)
Neon Daze by Amy Brown (Siobhan Harvey)
Moral Sloth by Nick Ascroft (Siobhan Harvey)
Louise Henderson, eds Felicity Milburn et al (Michael Dunn)
Sado by Mikaela Nyman (Penelope Todd)
2000ft Above Worry Level by Eamonn Marra (Karin Warnaar)

August 2020

What Sort of Man by Breton Dukes (Vincent O'Sullivan)
High Wire by Lloyd Jones and Euan Macleod (Sally Blundell)
Always Song in the Water by Gregory O'Brien (Erik Kennedy)
Mary Shelley Makes a Monster by Octavia Cade (Erik Kennedy)
A Year of Misreading the Wildcats by Orchid Tierney (Erik Kennedy)
Protest Tautohetohe by Stephanie Gibson, M. Williams and P. Cairns (Jessica Thompson-Carr)
The Paper Nautilus by Michael Jackson (Penelope Todd)
In Fifteen Minutes You Can Say a Lot by Greville Texidor (Emma Gattey)

September 2020

Aspiring by Damian Wilkins (Breton Dukes)
Necessary Secrets by Greg McGee (Cushla McKinney)
You Have a Lot to Lose by C.K. Stead (Philip Temple)
Jobs, Robots and Us by Kinley Salmon (Victor Billot)
Moonlight Sonata by Eileen Merriman (Helen Watson White)
The Reed Warbler by Ian Wedde (Emma Gattey)

Revisiting Three Poets

by James Norcliffe

Eileen Duggan Selected Poems, ed. Peter Whiteford (VUP Classic, 2019; first published 1994), 227pp, $30; **Denis Glover Selected Poems,** ed. Bill Manhire (VUP Classic, 2019; first published 1995), 192pp, $30; **R.A.K. Mason: Uncollected poems,** ed. Roger Hickin (Cold Hub Press, 2019) 163pp, $37.50

These collections offer an opportunity to revisit three significant figures in New Zealand poetry and to ponder their ongoing reputations: the near-contemporaries Eileen Duggan and R.A.K. Mason and the somewhat younger Denis Glover. The Duggan and Glover collections are re-issues in Victoria University Press's Classic Series, each first published 25 years or so ago. The Mason collection is of previously uncollected poems and comes from Cold Hub Press, Roger Hickin's enterprising Christchurch venture.

It is difficult to imagine many people actively seeking out the poetry of Eileen Duggan (1894–1972) to read today. Her verse even in her heyday was old fashioned and in the Georgian tradition; she set her face resolutely against modernism. In her essay 'On Simplicity', one of a number of essays included in the book, she characterises poems written in the modernist style as obscure and 'crossword puzzles'. It's as if in answer to Pound's injunction to 'Make it new' she had

responded with an emphatic shaking of her head. In the conclusion of the essay she rather wistfully demands that 'honour must be paid to those who kept calling literature back to its aim. They are still calling.'

Simplicity and tradition meant that much of Duggan's poetry is almost invariably metrical and replete with archaisms and poeticisms that were already long out of favour when she was writing. Her favourite trope is the elaborate, sometimes surprising simile, usually in service of a poetic conclusion—although the surprise of the image is frequently undone by the conventional, often religious, thought. Here, for example, is the entire poem 'Admission' with its fascinating developed metaphor in service, finally, to the 'I who am unworthy trope' of the old hymn:

> Life dries out uneven. Vellum should be fair,
> With every little wrinkle scraped and stript.
> If the pen stumbles and must start anew
> It is the pelt that balks and blots the script.
> You write on me, but am I worth the care?
> Rough and uneven, I reject the word.
> Although I fear the stone will rasp clean
> through,
> Pumice my sheepskin into parchment, Lord!

Duggan was a devout Catholic. Only in some of her later work, written during the days of war and after, does she strike an almost Blakean simplicity free of much of the poetic ornamentation and, at times, gnomic utterances of the bulk of her work.

It is salutary to learn that, in her day, Duggan was arguably New Zealand's

175

most celebrated poet internationally. Her poetry was published in the United States and Britain and her major volumes were all first published in London by Allen and Unwin. Despite this reputation, Allen Curnow did not publish her in either of his two important anthologies, the canonical *Penguin Book of New Zealand Verse* (1960) or the earlier *A Book of New Zealand Verse* (1943). He admitted that there were some of her poems he would have liked to include, but the poet had declined to give her permission. Even so, Curnow damned Duggan with faint praise. He conceded—in 1960—that she was one of the 'better writers' included in C.A. Marris's annual *New Zealand Best Poems* (1932–43) but, given the extremely low opinion he had of Marris's selections, this was not saying a lot. In 1943 Curnow said tartly that in her early work Duggan's 'talents above the commonplace could be drawn into the habit of sentimental posturing' and '[her] latest verse does not lose that weakness of inviting a special sympathy from the reader: both attitude and diction implore him [sic] to adopt some slack "poetry-loving" frame of mind for the occasion of the poem ...'

Later anthologies have included Duggan. Vincent O'Sullivan's 1976 selection *An Anthology of Twentieth Century New Zealand poetry* included seven poems. Duggan had died four years earlier, so the problem of permissions had presumably passed with her. The *Penguin Book of New Zealand Verse* (Wedde & McQueen, 1985) included eight, and

Oxford's *An Anthology of New Zealand Poetry* (Bornholdt, O'Brien and Williams, 1997) included a surprising 17 poems. It is tempting to think this may have been the result of a reassessment of Duggan's work. Indeed, this may have been the case, given the fact that Victoria University Press had published the first edition of the volume under review not long before the Oxford anthology was gathered together. The book's judicious introduction by Peter Whiteford in 1994 no doubt prompted a reconsideration.

Curnow, Denis Glover et al. have been accused of a measure of chauvinism in their downplaying of women poets of the period, and a wish to redress this bias may have also have been a factor. And while Whiteford does point out Duggan's strengths beyond her poetic deftness— her 'keen awareness of the natural world, simple and direct portrayal of emotion, and a warmth of human understanding'—he also points out that all of this was part and parcel of the Georgian tradition, which, somewhat echoing Curnow, he describes as 'a blurred sentimentality, a reliance on poeticisms, fanciful and at times gratuitous imagery, and a tendency to avoid reality'. Add to this a frequent religiosity unfashionable in these secular days.

Denis Glover did not have a high opinion of Marris, or of Duggan. In his long satirical poem 'The Arraignment of Paris' (for Paris, read Marris), Glover unleashed a diatribe against the women poets Marris had championed,

specifically Gloria (Rawlinson), Eve (Langley) and Eileen (Duggan). Read today, it smacks of wince-inducing misogyny, but Glover would have insisted he was playing the ball. His main purpose was to mock Marris for the 'atmosphere of petticoats and frills' he had inflicted on New Zealand verse. Glover's particular beef was that the poetry of Duggan et al. was too pallid, too well-mannered, too 'lavender', and that, as far as Marris was concerned, the real stuff of poetry was too rambunctious for his 'dainty ears'.

Although he could turn a tender love lyric (as well as a lusty one) better than most, Glover's poetry was anything but lavender. No petticoats and frills here— rather, shovels, seaman's jerseys and beer or, as in 'Bulling the Cask', the penultimate poem in the collection, rum. He had assembled his own selected poems in *Enter Without Knocking* in 1964, an offering of over 130 poems drawn from his nine collections and including another eight uncollected poems. Naturally, all of his greatest hits were there: the wonderful sequences 'Sings Harry', 'Arawata Bill' and a number of the Mick Stimpson poems he would later develop into the 'Towards Banks Peninsula' sequence. And of course 'The Magpies'—without a doubt, New Zealand's best-known poem; so well known it has to all intents and purposes become a cliché.

We come to Glover anew with this VUP Classic. The first edition of this collection was issued in 1995, 15 years after Glover's death and almost 15 years after the final *Selected Poems* (Penguin) chosen by Glover and edited by Curnow. It's not surprising that Bill Manhire confronts the reality of 'The Magpies' in the opening paragraphs of his introduction to the new VUP collection and, in a masterful exposition, unpacks the poem, arguing not only that is it a fine piece but how it can be seen as a touchstone for Glover's language, tone and method throughout the entirety of his work: 'Glover's work as a poet, nearly fifty years of it, continually voices a tension between two kinds of articulation: lyric utterance, on the one hand, and on the other the gurgling, gargling sounds of fact and disenchantment ...'

Manhire's selection, as generous as *Enter Without Knocking*, revisits Glover's earlier collections and carefully subtracts here, adds there, to allow himself room for 40 or so poems written since Glover's slightly augmented 1971 edition of *Enter Without Knocking*. All of the canonical poems are there, as you would expect, as well as a number of other fascinating pieces, including a clever reworking of Blake's 'The Sick Rose'.

It is something of a relief to turn to Glover after Duggan. While it is grossly unfair to characterise Eileen Duggan's work (as Glover implies) as 'petticoats and frills', there is no denying that her work throughout is ever high-minded and purposefully serious. The same could never be said of Glover: there is too much of the joker in him, the balloon

popper and the wit. He liked nothing more than to skewer pomposity, to shock and challenge.

Here, for example, is the final stanza of his poem 'Lake Manapouri', written at the time of the protests about a proposal to drown the lake for a hydro-electric project:

> We laughed embraced in loneliness,
> Two of us filling that private
> Primeval Cathedral with a meaning.
> Later returning loved loving
> From the dark bush of undrowned bush
> We found our altar congregated
> With cabinet ministers
> As many as it would take
> Solemnly and without wonderment of praise
> Pissing to raise
> The level of the lake.

Glover was a consummate writer of light verse, and at times his poems shift between the light and the dark, although rarely unevenly. He was too sure of his craft for that. Glover brought the fastidious skills of the printer to the writing of the poetry. Reading the work is never less than entertaining.

Of course, 40 years after his death he can come across as blokey. His heroes (and perhaps alter-egos) Harry, Arawata Bill and Mick Stimpson all exemplified the Kiwi man-alone figure who was such a feature of New Zealand writing of the period. Glover was a man of his time: hard-drinking, outdoorsy, passionate about the sea and sailing. Perhaps no other New Zealand poet has written so extensively about the sea, and none has done so better.

One of the most valuable aspects of the VUP collection is Bill Manhire's introduction. He demonstrates here that he is not only one of our finest poets, but also one of our most astute critics. His examination of Glover is both affectionate and open-eyed, and his insights into the poet and the qualities of his work are always illuminating. He is aware that one of the dangers of assembling so many of Glover's poems in one volume is that reading them all at once can become a little tiresome for the reader as the 'tones and voices begin to repeat'; in a nice paradox 'the unpredictable gets wearyingly familiar'. All the same, he concludes that he likes 'every poem in this book'. That is a rare thing to be able to say about a poetry collection, but I am sure many of the book's readers will concur.

Whereas the Duggan and Glover collections are re-issues of volumes first published 25-odd years ago, and which, particularly in the case of the Glover, contain many much-anthologised and familiar poems, the R.A.K. Mason collection brings together poems previously uncollected. In putting this book together, Roger Hickin has done New Zealand poetry a valuable and important service.

Mason was not an especially prolific poet. His *Collected Poems*, published in 1962 by Glover's Pegasus Press with an introduction by Curnow, contained fewer than 70 poems gathered from his previous seven collections, all long out of print and some scarcely more than chapbooks. Three of these dated from

the 1920s, two from the 1930s and two from 1941. In addition, Collected Poems included three 'more recent' poems and seven 'from manuscript', although these are dated 1924–30. Thus the collection, which Mason selected himself, contained only three poems from the 20 years before the volume was published.

In the new book, Hickin has identified a further 30 or so poems plus a number of performance pieces for ensemble that were written in the period between Mason's Recent Poems of 1941 and the Collected Poems, thus dispelling the received wisdom that Mason had dried up or written little of consequence in his later writing life. Hickin also located about 30 poems from Mason's early period in the 1920s and 30s. R.A.K. Mason: Uncollected poems, then, opens up a generous cache of previously unavailable work from this important twentieth-century poet. That the book comes with a wide-ranging and erudite introduction from Robert McLean and scrupulous notes on each poem from the editor is a huge bonus.

Mason's is a singular voice, quite unlike the two contemporary poets and friends with whom he is usually ranked—A.R.D. Fairburn and the ebullient Glover. Mason was acerbic, stoic and far more politically to the left. He regularly references Christian elements in his work, but with the passion of an ex-Protestant turned Marxist atheist. He describes his own work in a famous few lines from 'No New Thing' (1934): 'For my bitter verses

are / sponges steeped in vinegar / useless to the happy-eyed / but handy for the crucified'.

Given that Mason was a ferociously talented poet and quite jealous of his own reputation, why did he not include the poems in this book in the Collected Poems? McLean addresses this issue directly in his introduction. A mixture, he suggests, of dilatoriness, indifference and overwork. He describes Glover's efforts to encourage Mason to get his collected poems into print as a 15-year 'almost Sisyphean campaign'.

While not all of the uncollected poems—especially the earlier ones—are indispensable pieces, all have interest and most have elements sufficiently striking to justify their inclusion. Hickin has combed Mason's papers, locating poems in notebooks, journals and on paper both in typescript and in pen or pencil. He has also included poems published in earlier volumes but not included in the Collected Poems. Many of the typescript poems were subsequently published in the socialist paper the People's Voice. By comparison, Duggan at the same time was publishing much of her work in the Catholic paper New Zealand Tablet.

The bulk of Mason's poems are first-person and often beset by pessimism and irony, but Hickin has also included a number of longer pieces written for group performance. In these mildly agitprop scripts, no doubt inspired by Brecht and the contemporary fashion for verse drama, the voice is quite different:

public, communal and mostly idealistic. They were also written for the ear and designed for the live audience. The flag-waving reads a little oddly today, but it is a useful reminder of Mason's commitment to working-class solidarity.

The collection includes several standout pieces that will add to our understanding of the poet. Many of the more personal lyrics, especially a number of love poems, are softer than those we usually associate with Mason. The wistful 'And this month I will go in fear', an unfinished poem Hickin uses to end the book, is very moving.

So, what of reputations? Posterity is an unreliable judge, but its judgement is aided by time. Glover died in 1980, Duggan and Mason a decade earlier. It seems to me, from the evidence of these books, that by insisting on and practising a poetic that had long passed its use-by date, Eileen Duggan trapped herself in the same poetry cul-de-sac as her English admirer Walter de la Mare. On the other hand, although quite different poets, Glover and Mason still have real resonance and relevance. The ebullience of the one and the dark intensity of the other speak to us still.

The Truth about Love
by Catherine Robertson

All the Way to Summer: Stories of love and longing by Fiona Kidman (RHNZ Vintage, 2020), 368pp, $40

This collection's subtitle, 'Stories of love and longing', seems to pitch itself squarely to female readers. This might seem fair given that the stories are about women (even the two with male main characters), but it doesn't do justice to the strength and quiet fierceness of Fiona Kidman's writing. 'Love' in these stories is rarely romantic; it is troublesome, perplexing and a cause of lasting regret. 'Longing' conjures images of pining Victorian heroines or dutiful women awaiting the return of their soldier husbands. What the women in these stories long for is nothing to do with love. They crave escape from responsibilities they never asked for, people who have disappointed them, lives that shutter and restrict them. 'I wanted to go along some track, some place,' says Bethany in 'Mrs Dixon & Friend'. 'But I never did.'

In a *Listener* interview after the publication of her previous short story collection, 2011's *The Trouble With Fire*, Kidman was asked if she saw herself as a political writer. She replied that while she certainly had her own stance as a socialist, left-wing feminist, conveying messages was not her first intent in her

writing. It's true that these stories are primarily character-driven, but each one shines a light on women's long and continuing struggle for autonomy— socially, sexually, politically. From Queenie and Esme in the 1920s ('A Needle in the Heart') to the unnamed narrator of 'Red Bell', set very recently in a Wellington supermarket, all these women are vulnerable, never fully in control. There is always some compromise to be made, or threat to be managed. Women's lives are, as one character says, 'a fraught and endless narrative'.

These stories span close to a century, and we can trust entirely that Kidman's portrayal of our country through the ages is spot on. After all, she has lived through eighty of those years, in rural and urban New Zealand. Through the lens of these women, we see what was involved in keeping a house, making a living, working the land. Most of the characters have little money, and it is the women who find ways to earn extra income. In 'A Needle in the Heart', Esme makes clothing to supplement her railway worker husband's meagre pay: 'On a good day, she could earn as much as Jim, not that she mentioned this because it made him angry in ways she couldn't understand.' In the title story, 'All the Way to Summer', narrator Mattie's father, back from the war, wants only to chat to his best soldier mate and read books, so Mattie's mother takes up the slack, first as a cook then as a fruit picker. Marianne Gittos, the minister's

wife in 'The Honey Frame', has invented an improved beehive and aims 'to sell honey to the people in Auckland'.

Kidman's late husband, Ian, was Māori, and she touches lightly on racial bias and the effects of colonisation. One story that appears to be about a man is really about how he treated women, in particular Māori women. 'Fragrance Rising' is a portrait of Gordon Coates, prime minister 1925–28, who had children by more than one Māori woman but abandoned them all for 'the Pākēha girl with a face like whey'. The refrain of the story is the phrase 'it will not do', uttered as an old-fashioned social reproof but applicable then as now to the behaviour of all those, individually and in government, who have abused their power.

While Kidman obviously has great respect for cultures not her own, there is the odd wince-inducing moment. The narrator of 'Red Bell', who is clearly Kidman herself, refers to a Cambodian supermarket worker's 'savage cheekbones', and in 'Silks', set in Vietnam, another Kidman persona's descriptions of her surroundings are entirely Euro-centric. To be fair, she acknowledges this with a brilliant turn of phrase after she dobs in a taxi driver who overcharges her and only afterwards realises that she might have endangered not only his livelihood but also his life: 'I looked at myself in the mirror that night, Western and virtuous and deadly.'

Ambiguity around sexual orientation arises in more than one story. In 'Tell Me

the Truth About Love' the main character, Veronica, realises late in her life the truth about the dynamics in her social group. Narrator Mattie in 'All the Way to Summer' says about her mother '… you'd swear, catching a glimpse of her hard at work in the orchards, that she were a man, with her overalls and close-cropped hair', and ends the story with this succinct hint: 'There they are, the four of them: my mother and my father and Frank and Petal.'

But more confusing and problematic than sexual orientation is the act of sex itself. Ignorance is rife, from Esme and her string of unplanned pregnancies to teenage Alice's fumble in a car with an older man in 'Circling to Your Left' that convinces her she's the one he will choose to marry. Mostly, this ignorance is a consequence of earlier times, where it was more important for a young woman to 'have started a box' than to be told how sex works. In more sophisticated later years, it's affairs that cause the damage: 'You can have him … if you want someone else's husband,' offers a woman in 'Marvellous Eight'.

The objects of desire, the men, on the whole do not live up to expectations. The women often settle for less. At the end of 'Circling to Your Left' Alice subtly backhands this compliment: 'She thinks of [Douglas] as tenderly as she thinks of any man.'

One man, though, stands out: Kidman's late and much-loved husband, Ian. The last two stories, 'Silks' and 'Stippled', are about their marriage, and the brief account of Ian's death is truly moving. In a single, lyrical paragraph, Kidman encapsulates their life together: 'We could look back and say fifty years of married drama and laugh, but it held the ring of truth and remembered fires, the silky fire of sex, the fiery night when we broke things, a couple of black ragers in our worst moments.'

Drama, laughter, sex and black moments. This is the truth about love.

Filling the hollow society

by Giovanni Tiso

Not in Narrow Seas: The economic history of Aotearoa New Zealand by Brian Easton (Victoria University Press, 2020), 688pp, $60

Some years ago, a friend on a brief visit from the UK asked me to suggest a few introductory books on the history and politics of New Zealand. I gave him three from my own library: W.B. Sutch's *Quest for Security*, Ranginui Walker's *Ka Whawhai Tonu Matou | Struggle Without End* and one of Jane Kelsey's books on the neoliberal reforms. The first two had been important texts in my own education as an immigrant in the late 1990s, while the third grappled with events that changed the New Zealand known by my partner, who finished university and left for her OE just as the first Bolger government came to power in 1990.

Making sense of the country in those years wasn't easy: it felt like the scene of a recent explosion, its collective trauma still largely unprocessed. In my search for clues I came across outgoing Prime Minister David Lange's valedictory speech, in which he took time to 'thank those people whose lives were wrecked by us, because we did do that'—an extraordinary admission for a politician to make, even while maintaining that his

government's actions were ultimately justified and necessary. Yet the public debate on this and other matters seemed practically non-existent: either I didn't know how to navigate the public sphere or there wasn't much of a public sphere to speak of. Brian Easton was one of the few exceptions, writing columns for the *New Zealand Listener* that laid out trails of crumbs into the economic events of the previous two decades: things I could read up on.

I never asked my friend if he read the books I gave him, but I find it useful to think of the value of national histories beyond the primary audience they are written for. The quest for security described by Sutch was a story I could relate to in my own country and, for that matter, in my own family, just as the struggle for self-determination narrated by Walker is both uniquely situated and paradigmatic of Indigenous movements elsewhere. I approached Easton's *Not in Narrow Seas: The economic history of Aotearoa New Zealand* in a similar way—as a book of this place, illustrating ideas that will be relevant in most if not all places.

It wouldn't make for a very punchy title, but it may be more accurate to describe the book—as the author does in its epilogue—as a history of Aotearoa New Zealand centred on the economy, rather than an economic history in a restrictive sense. Although narrower in scope and not aspiring to the same degree of impartiality, the closest precursor that I know of is Sutch's bestseller: that is, a history written by an

economist with a broad public in mind. While some of Easton's preoccupations—for instance, whether or not Muldoon was in fact a social conservative—may seem to belong to a general or political history, the book's most distinctive characteristic is the consistent focus on shifts in the country's political economy.

So, for instance, while the 1966 collapse in the price of wool is treated briefly in Michael King's Penguin History of New Zealand as a discrete event affecting a particular sector of the economy, Easton articulates its reverberations and long-term effects on policy and governance on the whole nation across several chapters. While this approach reaches the peak of its explanatory powers in the section on Rogernomics (more below), it is evident from the characterisation of early generations of Māori settlement as a 'quarry economy' dependent upon resource depletion, later supplanted in the 'Green Māori' stage by the institution of the rāhui. The quarry economy will make its return with colonisation and is shown to play a role in the early development of today's main urban centres, until the century-long shift to a political economy based around the unit of the commercial farm (although farming retains quarry elements in the present day, as the state of our waterways and its appetite for non-renewable phosphate attest).

Alongside this structural focus, there are a few recurrent themes. One is the notion of the 'hollow society', which describes the lack of institutional brakes between the government and the people, making it possible to enact blitzkrieg-style reform projects. Bruce Jesson originally deployed the phrase in his 1999 book on the neoliberal reforms, Only Their Purpose Is Mad, but the span covered by this book allows Easton to track this phenomenon to its very beginnings, with the establishment by Hobson of a central colonial government in advance of its (settler) society. A government that precedes social institutions rather than arising from them is persuasively presented as the constitutive element of a hollow society.

Another theme is the debunking of popular myths, and most especially depictions of the country as 'the land of the long pink cloud'. This refers to the preponderance of histories written from a left-ish academic (therefore largely city-centred) perspective, with a tendency to present rural Pākehā as reactionary and their economic activities as backward, as well as to present political progress as having mostly been driven by Labour, in spite of the relative infrequency of its terms in government. While the case for creativity and innovation in the farming sector is well made, it seems important to mention the formation of an actual union-breaking cavalry by the Farmers' Union during the strikes of 1913—something Easton leaves out. The omission is consistent with the scant treatment of labour disputes and protest movements, whose impacts on the political economy are either portrayed as

marginal (1913, 1951) or not entertained at all (Bastion Point). This in turn reflects a tendency in the book to equate politics with governance, leaving unanswered the question of what role, if any, political movements such as those for land occupations might play in filling the hollow society (Ihumātao hit the national headlines just as the book went to print).

While the book is impressive for both its scope and its detail, its greater value ultimately resides in the quality of its ideas and the clarity of its explanations. Issues such as the relationship between the terms of trade, employment, inflation and the policies that attempt to regulate all three are part of an education that can be hard to acquire, and too often political discussions suffer from our lack of literacy in these areas. Easton has the didactic verve of a Sutch, and perhaps the best thing I can say is that all of the book is absorbing and interesting, even as the range of its arguments is impervious to summary. It's an appeal that derives precisely from its shift in perspective, which makes even familiar stories read differently.

There is, however, an undeniable crescendo, a high point, and it comes with the discussion of Rogernomics. This is where the book's themes converge—from the hollow society to the centrality of the political economy—allowing Easton to write a powerful history, without narrowing qualifiers, of that revolution. The premise is that some form of modernisation was necessary, that the political economy had failed to

reckon with upheavals such as the permanent fall in the price of wool, placing intolerable stress on the country's finances. His conclusion, however, is that the path chosen—neoliberalism, defined here as a policy regime under which 'the role of unconstrained markets is maximised'—was an abject failure by its own standards, resulting in a decade of GDP stagnation and leaving people on lower incomes to pay the entire price of restructuring the economy. This is also the story of the brutal method by which these objectives were achieved ('by a small group isolated from their critics and from common sense'), and the further hollowing of society as dissenters were marginalised or saw their careers cut short, while (in what struck me as another blow to a popular myth) 'the vigorous public economic debate of the Muldoon era collapsed'.

There is no nostalgia for the pre-1984 times in this account, and Easton is more Keynes than Lenin: he would rather we had fixed the broken engine of the market economy according to a socially democratic model than look for an entirely new form of transportation. But even this moderate stance could place vigorous demands on our political system—a call to repair what remains of the failed reforms, including the never-reversed cuts to social welfare benefits, and to fill the hollowness of our polity so as to make it more democratic as it prepares to face existential challenges. Not one for grandiose pronouncements,

and perhaps mindful of the detachment required of a historian, Easton stops just short of making such a call. Instead, he concludes the final chapter of his magnum opus with a modest, understated defence of the role of public intellectuals—those solitary figures who did not flee the narrowness of the nation's public sphere, and in whose ranks it's not very hard to see the author himself.

A reviewer need not be quite so restrained: this is the culmination of the work of one such committed public intellectual, and an important contribution to the literature on Aotearoa New Zealand.

We Came Out of the Dark Loving
by Genevieve Scanlan

Mezzaluna by Michele Leggott (Auckland University Press, 2020), 202pp, $35

Mezzaluna is a beautiful book, and also a little overwhelming in the length and the depth of its material. It 'gathers thirty years of selected poems', presented chronologically in 10 sections named for the collections they originally appeared in. For those familiar with Leggott's work this may summon memories; for new readers it presents a map, with points of reference to work back to—and those new to her work may indeed feel drawn to seek out further references after reading *Mezzaluna*. Leggott's poems are full of detail and layers, sometimes seemingly resisting interpretation—or requiring of the reader a degree of existing, perhaps esoteric knowledge. These poems speak in Latin and in Māori, travel to Portugal and Taranaki, touch upon the carnal and the sacred, and reference everything from Egyptian love poems to the songs of Cole Porter. Leggott overwhelms the reader with a flurry of vivid, striking and often sensuous images, and it's a joy to surrender to the onslaught.

The book opens with selections from 1988's *Like This?*, and from the beginning there is a sense of energy and delight, a willingness to find beauty, an unabashed

romanticisation of everyday life. 'Garbo in a Gown' seems to set the tone, in which the beauty of one thing flows into another. Here, the romance of the silver screen flows into a personal context:

> ran the movie mid-afternoon it left me aching / looked at the moon high up where ice was cracking unseeable stars / ran after you through snow for the kiss / the one of course that blows it all apart– / was that the deeply satisfying meaning of the white dress?

This poem touches, too, on the filmic, romanticising, unreliable nature of memory: 'my hair your face / was it really that long or did you stand closer / than memory allows?'

Memory and relationship—and the role beauty plays in building them—seem to be prevailing themes throughout *Mezzaluna*. The beauty, that is, of words—of film or music, and of travel and exploration—of a gorgeous landscape. In 'Dear Heart', familial memories and local landscapes are intertwined with popular American music:

> it was a coast road / long past lilac time and well out of town / the sea out of sight and driving north / in the far south the radio swelled nostalgia ... you were picking out Mancini arrangements / Nat King Cole My Fair Lady

Describing a different kind of relationship, 'Oldest and Most Loyal American Friend' delightfully evokes the flights of pastoral pleasure-seeking fantasy so easily concocted between friends:

> we were seduced at once by / the little town (no poetry) and thought / what a happy life it would be / only to cultivate white / raspberries (sea also) iced / champagne by the approved method

In both these poems the warmth of solid relationship and the beauty of landscape, of music, of Mancini and champagne feel very much connected.

Sometimes the precise meaning of what's being evoked is less clear. But even when this is the case, tone and mood are vividly communicated. 'Reading Zukofsky's 80 Flowers' has a striking aural beauty, even for those (like me) who haven't actually read Zukofsky:

> roll your eleven weeks onto summer's late belly and look out / at the world with your black olive eyes / this was promised under the apple tree at Christmas / when you swam in deep pools of picture space nine days out / among the dream polaroids jacaranda diamante / simulacra of before and after / the visceral rub of pohutukawa in bloom

The sense of shared delight continues through the sections taken from *Swimmers, Dancers, DIA* and onwards. Sometimes this delight is explicitly sensual: 'I wanted to mouth you all over / spring clouds spring rain spring ... Rose and peony buds and tongue / ichthyous tumble honey and pearl'. This poem, 'Blue Irises', is an intoxicating tumble of gorgeous, verdant images:

> See how the roses burn! / The lovers in the fountain spoon each other up / their drenched talk stretches the library resources / and when pubis and jawbone snick into place / you face my delight an uncontrollable smile

This sense of romance permeates any boundaries in the poems, whether of geographical setting or era. The two

'Cairo Vessel' poems from Milk & Honey are described in the notes as 'a free variation on K.A. Kitchener's reconstruction of a fragmentary text in Poetry of Ancient Egypt'. It is a free variation indeed—in Leggott's hands the nameless lovers are unmoored from time and place, and given a persuasive universality. Decidedly non-ancient references slip in: a lyric from Cole Porter, then the wistful declaration 'I wish I were her pizza boy / always on the end of a string'. And, again, a heady sensuality: 'I wish I were washing out her clothes / even for just one minute / I'd be so happy to handle / filmy linen that had touched her body'. If a single line could, for me, sum up the joyous hedonism of Leggott's love poems, it is perhaps this, describing the night of a wedding reception: 'Everything is served in a jus, nectar and all the games to be played.'

As the collection moves on chronologically, of course, the resonance of Leggott's emphasis on the senses shifts. In writing of the loss of her sight, the same visceral quality given to descriptions of pleasure is turned to describing 'the smooth interior / of my despair'. In the section taken from As Far As I Can See, selections from 'A woman, a rose, and what has it to do with her or they with one another?' crystalise the experience with sometimes brutal clarity. From a poet with such a gift for detail, it is the sparest lines that feel the most stark and painful: 'I was hung on a hook three days and three nights, a corpse among corpses in the place of disaster. I saw nothing, heard nothing, was nothing.'

But even when describing this most personal, painfully isolating experience, Leggott maintains a sense of relationship at the centre of her poetry. Relationship that is complicated by, as well as aided by and built upon, the senses. 'I am not a daughter now,' she writes, 'and I cannot see my sons though I know they see me. This is the gate of tears, another farewell.' A page later she asks, 'If touch is a torch and the difference still you, can it matter so very much if I do not see your face? I hold you, I kiss you. How can I go on without you?' And ultimately, in these poems, it is relationship and connection that offers hope, in spite of loss: 'that one beside you / offering an arm in the dark'. The final lines of 'A woman, a rose …' are so strikingly beautiful: 'I (a stranger) sang the release of sorrows borne from one depth to another height. We came out of the dark loving.'

The collection moves towards its end with selections from Heartland, Vanishing Points and a coda consisting of the poem 'The Wedding Party'. It is in this latter half of the book—after journeys to Egypt and Portugal and all sorts of named and unnamed places—that the sense of Aotearoa New Zealand is the strongest. From reminiscence on 'the kid in the Health Camp / at Ōtaki' to the historical detail of the poem 'The Wedding Party', there is a distinct local specificity. And all throughout, the power of words— English, Māori, Latin—remains central for Leggott, in Aotearoa or anywhere

else. In 'More Like Wellington Every Day' she writes, 'hey poems we are free to go / a book is one thing the night sky / another pack up your things / and throw them into the back seat'.

Mezzaluna's dedication reads: 'for those who travel light and lift darkness'. Indeed, this is poetry that is deeply personal but leaves the door open to all kinds of travellers, all kinds of light. Determined to find beauty, and to come 'out of the dark loving', it is a collection that feels very much needed in 2020.

Our Tutelary Spirits
by Chris Tse

How to Be Old by Rachel McAlpine (The Cuba Press, 2020), 96pp, $25; **The Lifers** by Michael Steven (Otago University Press, 2020), 92pp, $27.50

I recall Rachel McAlpine reading her poem 'Before the Fall' at an event in the mid-2000s. I left with the tender image of a father bathing his children splashing around in my head, and I remember thinking it was one of the most moving poems I'd ever heard. I would later learn that the poem is one of McAlpine's greatest hits, having been selected for multiple anthologies and set to music since its publication. Hence my surprise to stumble across it again just a few pages into *How to Be Old*, McAlpine's latest collection. Even 27 years after its first appearance in her 1983 collection *Recording Angel*, 'Before the Fall' still packs an emotional punch, particularly now that it's nestled between two equally poignant poems about the shifting roles we assume as we grow older ('I need my mother. I need my father. / I am my mother. I am my father now.'). In one of those poems, McAlpine longs to give her sister Jill a big sister of her own:

> to shelter and protect you
> and hold your hand

and take the lead
on dark days
and on bright days too
the way big sisters do.

My friends and I are staring down the barrel at our forties and dreaded middle age; many of us are realising we're becoming more and more like our parents and experiencing timely reminders of our age, from the trivial (younger colleagues not getting our pop culture references) to the serious (a smorgasbord of worrying health issues).

'Ageing was once a thing of the body / a thing of the mind,' McAlpine writes, before listing the ways it has been used, co-opted and turned into something that needs to be dealt with: 'ageing became a public issue / a cause, a career, a competition / a project, a problem, a policy ...'

Throughout *How to Be Old*, McAlpine tackles head on this societal fear of growing old, but the poet herself takes on a stoic, even optimistic outlook, preferring to make the most of what she calls her 'bonus years': 'I'm old by the old arithmetic / but not by the new biology'.

It should be noted that this collection is about how to make the most of *being* old, and not a guide to *growing* old. McAlpine gives away no secrets about attaining longevity—in fact there are moments early in the book where she appears almost bemused that she's made it to the milestone of her 80th birthday: 'I knew all about old people. / You see them everywhere. But in a million years I never

dreamt / one day I would be them.' Instead, McAlpine's mission is to get us to think about how we talk about being old, even if the thought of ageing is 'scarier than getting pregnant / twenty thousand miles from home'.

The poet slyly titles the first section of her collection 'Not a Memoir', perhaps to strip the reader's expectations of sentimentality or the unexceptional that can attach to the word 'memoir'. 'This looks like the story of me,' she writes. 'I'm not the subject / and this is not a memoir. / This is the story of you.' But, as evidenced by family poems previously mentioned, McAlpine does draw from her own life experiences, illustrating her points rather than saddling them with a superficial significance. This collection doesn't seek to record a life story— McAlpine acknowledges that what's done is done. What's important is how you use what you've learned in order to live your life in the present, which includes knowing what you've got to let go. In 'Growing my Brand' McAlpine acknowledges the past versions of herself that have shaped who she is at 80. She's no longer a 'mournful poet / and strident feminist / (there was no other sort)' or the 'honorary geek' of the nineties and noughties, but a 'little old lady poet / a dear feminist poet'. We live in an age where the concept and value of youth as brand have been intensified by influencers and social media. McAlpine's poems remind us that no matter how wedded we are to wanting to be or appear young, there is nothing more valuable or

important than lived experience and the readiness to embrace who you have become.

Rachel McAlpine isn't the only one giving advice in this book. Her own musings are complemented with a series of tips from her five-year-old granddaughter and life coach Elsie, who covers topics from meditation and vegetarianism to dealing with home invasions by goblins. Elsie's tips are endearing and remind us that the story of being old has many parallels with the story of being young or middle-aged—or (to borrow a term from McAlpine) unyoung.

Her light touch and engaging voice fill her poems with irresistible humanity and plenty of humour, even when she tackles the accoutrements that come with being old: losing family and friends, the difficulties of making new friends, temperamental bodies, not being taken seriously or being seen as a hindrance. We're conditioned to believe that growing old, and being old, are a bad thing. Although death and mortality are felt in some of the poems, McAlpine quickly turns our attention back to the living and the many things there are to love about living into old age: 'she dragged her life out from under the bed / and made it dance again'.

★

In the space of a year, Michael Steven earned a hat-trick that many new poets would aspire to have on their CVs: his debut collection *Walking to Jutland Street*

was longlisted for the 2019 Ockham New Zealand Book Awards; he received the Todd New Writer's Bursary; and he was a Sarah Broom Poetry Prize finalist. However, Steven is no overnight sensation—these successes are the culmination of years spent writing, performing and publishing on the periphery, earning him an appreciative audience along the way.

In a 2011 feature for *Jacket 2*, editor and creative writing teacher Jack Ross included Steven among a group of 12 poets on the fringes of contemporary New Zealand poetry ('experimentalists, zealots, eccentrics, and prophets of various stripes') who he believed deserved a wider audience. It's interesting looking back at the dozen poets Ross selected to represent what he saw as the 'variety, excitement, and passion' in New Zealand poetry at the time. If a similar exercise were to be carried out in 2020, I'd argue that Steven would still have a place on such a list.

There's something about Steven's writing, and his impressive and illuminating second collection, *The Lifers*, that feels indebted to a very particular part of New Zealand's literary canon. Throughout my reading of *The Lifers* I could imagine tracing a line from Steven back through the bodies of work produced by David Eggleton, Ian Wedde, James K. Baxter (whose grave Steven visits in 'Yellow Plums') and Allen Curnow. Parts of *The Lifers* remind me of Wedde's collection *Good Business*, which brings together examinations of place

and the people who inhabit it (both collections also criss-cross New Zealand and the world).

Steven's poems are technically deft but not showy, emotionally resonant but not manipulative. As well as character studies, there are philosophical musings, excavations of personal history and love letters to hip-hop and 90s alternative rock. The way he writes about music is equal parts nostalgia and an appreciation of how it is created, particularly in the use of samples in hip-hop. Drum loops that have been 'chopped into more pieces / than sides of pork in Chinese butcheries' and 'the second renaissance of Gregory Coleman's "Amen Break"' ripple through the collection, along with distorted guitar riffs and rumbling basslines. These specific musical touchpoints not only situate the poems' contemporary settings, they're also analogous to the approach Steven takes in constructing his collection, by piecing together snapshots of his and others' lives.

Like the poetry of the aforementioned literary forebears, Michael Steven's work is mostly concerned with the lives of outsiders and those whom some would class as the downtrodden—people who are used as proxies for everything that is 'wrong' with society. In The Lifers we are introduced to addicts, drug dealers, drifters and getaway car drivers. In Steven's generous hands, they are all treated with humanity. As the book's blurb is right to point out, there is no sermonising, patronising or

romanticising in Steven's depictions of his subjects' lives. 'This is not abstraction,' he proclaims in one poem. The selective details and events he includes in his poems are presented as is—his intention is not to place them on a pedestal or under a microscope to make a point. Instead, what we're left with is an impression of what it's like to be on the other side of the divide at a time when the gap between the haves and have-nots is growing at an alarming rate.

Both Rachel McAlpine and Michael Steven, with their respective styles and life experiences, push back on stereotypes and burrow under the veneers we put up to shield ourselves from what we find difficult to acknowledge. The Lifers deals with what some might deem 'tough' subjects, such as crime and poverty, but the poet does not offer solutions or explanations— that's not the purpose of this book. The strength in these poems is their ability to challenge each reader's own experiences, prejudices and privilege. In the sequence 'Leviathan', Steven uses a journey from Auckland to Dunedin as a counterpoint to the lives of prisoners serving life sentences (the collection's titular lifers), emphasising the stark reality of a world behind bars where 'Their cold cells are a museum, open at 9am'. We're not told how to feel about them—nor are we given details of their incarceration—but the way in which Steven portrays them provides a way in to understanding what life is like when freedom is a distant memory:

> ... The lifers carry on.
> They walk their fates in thick woollen coats,
> addressing each other inaudibly—
> confessing and sanctifying their stories
> with hand gestures, glowing tips of
> cigarettes.

One of the things that interests me most as a reader of poetry is the ways in which a poet's oeuvre speaks to back itself. Poems and collections cannot be read in isolation, even if a poet's voice, style or interests shift dramatically over their career. Like McAlpine's nod to her past with the inclusion of 'Before the Fall', *The Lifers* feels very much like a continuation of Steven's first collection, not only in theme but also in form and style. Place, and the many ways it shapes us, remains an emphasis in Steven's poetry—for example his series of 'Dropped Pin' poems in his first book continues in *The Lifers*, mapping the world in which his poems exist.

In the poem 'Reading to my Son', Steven explains the place of the classics in one's literary education: 'there are books that teach of unappeasable forces: / deities that govern our nights and days, / dictating the impossible ways we must serve them.' I'd argue that this description could be applied to Steven's own book, where his subjects navigate the paths set out for them by more modern forces, with Steven as companion and witness. In the same poem, Steven assures his son that he will find his own 'tutelary spirits', but for the time being he'll learn about the world through his picture books.

What do we learn from *The Lifers*?

Perhaps it's acknowledging that no matter which path we're travelling, we're all just trying to 'Live closely to life' the best we can.

future Landfall editor swots up

ŌTĒPOTI – HE PUNA AUAHA
─────────────
DUNEDIN UNESCO
CITY OF LITERATURE

www.cityofliterature.co.nz

takahē magazine

CELEBRATING NEW ZEALAND LITERATURE AND ART
SINCE 1989

100TH ISSUE DECEMBER 2020

SUBSCRIBE @ WWW.TAKAHE.ORG.NZ

TAKAHEMAGAZINE TAKAHE_MAGAZINE @TAKAHEMAGAZINE

NEW BOOKS FROM
OTAGO

MAP FOR THE HEART: IDA VALLEY ESSAYS
JILLIAN SULLIVAN

Map for the Heart by Jillian Sullivan is a haunting collection of essays braiding history and memoir with environmentalism, amid an awareness of the seasonal fluctuations of light and wind, heat and snow, plants and creatures, and the lives and work of locals.

ISBN 9781988592565, paperback, $35

BUS STOPS ON THE MOON: RED MOLE DAYS 1974–1980
MARTIN EDMOND

Bus Stops on the Moon is a personal and cultural history. As memoir, it is a sequel to The Dreaming Land (2015). A troubled and restless young Martin Edmond is on his way to becoming the wiser, older man who will sit down and write both narratives. As cultural history, the book gives us a participant's-eye view of the early years of Alan Brunton and Sally Rodwell's avant-garde theatre troupe Red Mole.

ISBN 9781988592510, paperback, $39.95

NOUNS, VERBS, ETC.: SELECTED POEMS
FIONA FARRELL

One of New Zealand's most versatile writers, Fiona Farrell has published four collections of poetry over 25 years, from Cutting Out (1987) to The Broken Book (2011). Nouns, verbs, etc. collects the best work from these books, and intersperses them with other poems thus far 'uncollected'.

ISBN 9781988592534, hardback, $35

LETTERS OF DENIS GLOVER
SELECTED/EDITED BY SARAH SHIEFF

The brilliant, brave, hilarious, garrulous, generous, dangerous, drunken, gloriously stylish Denis Glover was a widely admired poet, an honoured naval commander, a gifted printer and typographer. In this magnificent jacketed hardback Sarah Shieff presents around 500 of Glover's letters to around 110 people, drawn from an archive of nearly 3000 letters.

ISBN 9781988592541, hardback, $79.95

 OTAGO UNIVERSITY PRESS
From good booksellers or www.otago.ac.nz/press

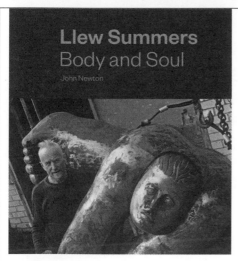

CONTRIBUTORS

John Allison's fifth collection of poetry, *A Place to Return To*, was published by Cold Hub Press in August 2019. A chapbook of new poems, *Near Distance*, is forthcoming in 2020. His poetry has been published in recent issues of *Landfall*, *Poetry NZ* and *takahē*.

Nick Ascroft is a science-fiction author and poet. He lives alone in Wellington with his family.

Wanda Barker's poems & flash fiction have appeared in recent issues of *NZ Flash*, *A Fine Line*, *Mayhem* and *Meniscus*. She published her first poetry novella, *All Her Dark Pretty Thoughts*, in 2017, and a novel, *All Our Tender Ruins*, is nearly complete.

Peter Belton is a Dunedin-based visual artist with a particular interest in writing about the stories of other artists' situations and, in another body of work, impressions recalled from childhood.

Victor Billot is a Dunedin writer. His poetry collection *The Sets* is forthcoming with Otago University Press (2021), and he has recently published a series of satirical verses on the ReadingRoom website.

Ella Borrie is a Wellington-based poet from Otago. She co-edited *Antics 2015* and her work appears in *Mimicry*, *Starling* and *Turbine|Kapohau*.

Cindy Botha lives in Tauranga. Having begun writing late in life, she's making up for lost time. Her poetry has appeared in *Landfall*, *takahē*, *Poetry NZ Yearbook*, *The Rialto*, *EyeFlash*, *Obsessed with Pipework* (UK) and *Poetics for the More-than-Human World* (USA).

Liz Breslin's poems have been published in New Zealand and overseas. She is the co-founder of Poetic Justice Wanaka.

Brent Cantwell is a writer from Timaru, South Canterbury, who now lives with his family in the hinterland of Queensland. He teaches high-school English and has been writing for pleasure for 24 years. He has recently been published in *Sweet Mammalian*, *Blue Nib*, *Verge*, *Brief*, *Mimicry*, *Foam:e* and *Landfall*.

Marisa Cappetta's published work is included in numerous New Zealand and international journals and anthologies. Her first collection, *How to Tour the World on a Flying Fox*, was published by Steele Roberts (2016).

Catherine Chidgey won the Acorn Foundation Fiction Prize for her novel *The Wish Child*. Her latest novel is *Remote Sympathy* (Victoria University Press, 2020). She lives in Ngāruawāhia.

Stephanie Christie (formerly known as Will) makes page poems, collaborates on creative experiments, performs her work and explores words as aesthetic objects. Her latest obsession is 3D poetry installations.

Jennifer Compton was born in Wellington and lives in Melbourne. She is a poet and playwright and also writes prose.

Lynn Davidson writes poetry, essays and fiction. Her latest poetry collection, *Islander*, is published by Victoria University Press and Shearsman Books (2019). She lives in Edinburgh and teaches creative writing.

Breton Dukes is the author of *What Sort of Man* (2020) and two previous collections of short stories, *Bird North* (2011) and *Empty Bones* (2014) (all Victoria University Press). He received the Creative New Zealand Louis Johnson New Writer's Bursary in 2011. Breton lives with his wife and three young children in Dunedin. His interests include cookery and swimming.

Scott Eady is a Dunedin-based artist and senior lecturer in sculpture at the Dunedin School of Art at Otago Polytechnic. His work is represented in public and private collections throughout New Zealand, Australia and Russia.

Fata Feu`u is an internationally recognised Samoan-New Zealand artist. He has been pivotal in shaping the interest in contemporary Pacific art globally and nurturing a generation of Pacific artists locally, leading to his reputation as the 'father of contemporary Pacific art'. Fata has works in major public New Zealand collections, including the Museum of New Zealand Te Papa Tongarewa and Waikato Art Museum in Hamilton. In 2001 he was awarded the New Zealand Order of Merit for Services to Art.

Norman Franke is a Hamilton-based poet, painter and scholar. He has published widely on 18th-century literature, German-speaking exile literature (Albert Einstein, Else Lasker-Schüler, Karl Wolfskehl) and eco-poetics. Norman's poetry has been broadcast on radio and published in anthologies in Aotearoa and overseas.

Jasmine Gallagher is a poet, critic and doctoral candidate at the University of Otago, where she is researching ecocriticism in contemporary New Zealand art and poetry.

Giles Graham grew up in Ōtepoti and the Maniototo. His poems have appeared in the *Otago Daily Times* and several small zines. He lives with his wife and their newborn son in Waimate, South Canterbury. As yet he has no published poetry collections, but he likes to think he still has time.

Charlotte Grimshaw is an award-winning novelist, short-story writer and reviewer. She is the author of 10 works of fiction, most recently *Mazarine* and *The Bad Seed* (Penguin, 2018 and 2019).

Rebecca Hawkes is from a farm near Methven. She now roams the slopes of Wellington and writes poems about flesh industries, human beastliness and joyous weeds. Her first chapbook, 'Softcore Coldsores', was published in 2019 in *AUP New Poets 5*. Rebecca is an editor for the poetry portal *Sweet Mammalian* and a member of the performance poetry cult Show Ponies.

You can find more of her poems and paintings at her online vanity mirror: rebeccahawkesart.com

Nathan Herz-Edinger is a Wellington-educated Cantabrian with a taste for coffee, Chekhov, hitchhiking and Adichie. He is always looking for new friends, and can often be found at Space Academy in Christchurch.

Zoë Higgins is a Pākeha writer of Swiss and British descent, living in Te Whanganui-a-Tara. Her work has been published in *Sport*, *Starling*, *Mayhem* and *Aotearotica*.

Gail Ingram is the author of *Contents Under Pressure* (Pūkeko Publications, 2019). She won the Caselberg International Poetry Prize (2019) and the New Zealand Poetry Society International Poetry Award (2016). She is a poetry editor for *takahē* and a short-fiction editor for *Flash Frontier*.

Ash Davida Jane is a poet and bookseller from Pōneke. Some of her recent work can be found in *Peach Mag*, *Best New Zealand Poems* and *Scum*. *How to Live with Mammals* is forthcoming from Victoria University Press in 2021.

Pippi Jean was in fact named after the book character Pippi Longstocking. She is an aspiring writer with works published in *Signals*, *Starling*, *National Schools Poetry Award* and her local newspaper.

Stacey Kokaua is a writer and creative based in Parihaumia/Portobello on the Otago Peninsula. Her work focuses on the diverse roles of Moana women navigating life in Aotearoa and beyond.

Jessica Le Bas has published two collections of poetry: *incognito* and *Walking to Africa* (Auckland University Press, 2007/2009). She won the 2019 Sarah Broom Prize for Poetry. Her 2010 novel for children *Staying Home* will soon be released as *Locked Down* (Penguin Random House, 2021).

A.M. McKinnon was educated in Christchurch and overseas and lives in Wellington. He has studied writing under Diane Comer and Anna Jaquiery through courses at Victoria University.

Alice Miller is the author of a novel *More Miracle than Bird* (Tin House, 2020) and a forthcoming poetry collection, *What Fire.*

Art Nahill is a physician-poet who has survived 2020 thus far and is living in Auckland.

James Norcliffe is an editor, poet and writer of fiction, mainly for young people. He has published over a dozen novels for young people and 10 collections of poetry, most recently *Deadpan* (Otago University Press, 2019). This year, with Michelle Elvy and Paula Morris, he co-edited *Ko Aotearoa Tātou | We Are New Zealand* (Otago University Press, 2020).

Jilly O'Brien has had poems published in *Landfall*, *Cordite*, *takahē*, *Catalyst*, *The Blue Nib*, *The Spinoff* and *Blackmail Press*, as well as in anthologies worldwide. Her poetry has been displayed on the ice in

Antarctica, on benches in Dunedin, and on the back of parking tickets. This year she was runner-up in the Monica Taylor International Poetry Competition, and highly commended in the Charles Causley International Poetry Competition.

Chris Parsons writes poetry when he should be elsewhere. He crops up in places like *Blackmail Press*, *Poetry NZ*, *Snorkel*, *Southerly*, *takahē*, the *Otago Daily Times* and *The Typewriter*.

Sarah Paterson is from Dunedin but now lives in Auckland with her husband and two sons. She was the co-editor of *Aiblins: New Scottish political poetry* (Luath, 2016), and is the operations manager of UpsideDowns.

Wyoming Paul is a 26-year-old writer and bookseller from Auckland. His writing has been published in *The Spinoff*, but most of the time he works as a business copywriter.

Robyn Maree Pickens' poetry has appeared in the *Brotherton Poetry Prize Anthology* (Carcanet Press, 2020) and *Fractured Ecologies* (EyeCorner Press, 2020).

Sugu Pillay has a master's in creative writing from the IIML, Victoria University of Wellington. Her fiction and poetry have been published in New Zealand journals and anthologies.

Angela Pope is studying creative writing through Massey University. She lives in Dunedin with her husband and youngest son.

essa may ranapiri (they/them/theirs | Ngāti Wehi Wehi) is a poet from Kirikiriroa. They have a poetry book called *ransack* (Victoria University Press, 2019). They are very tired and will write until they're dead.

Vaughan Rapatahana (Te Ātiawa) commutes between homes in Hong Kong, the Philippines and Aotearoa New Zealand. He is widely published across several genres in both of his main languages, te reo Māori and English, and his work has been translated into Bahasa Malaysia, Italian, French and Mandarin.

Catherine Robertson's six novels have all been number one New Zealand bestsellers. She is a regular guest on RNZ's The Panel and Jesse Mulligan's Book Critic slot. She is on the board of Verb Wellington, and she and poet Jane Arthur are the proud owners of Good Books, a Wellington bookshop. Catherine's next novel, *Spellbound* (Black Swan), will be out in 2021.

Alan Roddick has published two collections of poems and is working on a third. As Charles Brasch's literary executor he has edited three collections of Brasch's poems. He lives in Dunedin.

Ruth Russ lives near Nelson and writes around four sons. Her writing has appeared in various literary journals under the pseudonym Reade Moore.

Genevieve Scanlan holds an MA in English from the University of Otago. Her poetry has appeared in *London Grip*, *Poetry New Zealand* and *The Rise Up Review*,

and she was a participant in the Fortune Theatre's 2017 Emerging Playwrights Initiative. She lives and works in Dunedin.

Lynda Scott Araya lives in Otiake in the Waitaki Valley and has a background in education. Most recently she has been published in *The Blue Nib* and has work forthcoming in *Prospectus: A literary offering*. Her story was inspired by a photograph of a circus elephant being unloaded in Kurow in the 1930s.

Tracey Slaughter's latest works are the novella *if there is no shelter* (Ad Hoc Fiction, 2020) and the poetry collection *Conventional Weapons* (VicoriaUniversity Press, 2019). Her story '25:13' won the 2020 Fish Short Story prize, and her novella was runner-up in the 2020 Bath Novella-in-Flash Award. She teaches creative writing at the University of Waikato, where she edits the journals *Mayhem* and *Poetry New Zealand*.

Matafanua Tamatoa has written many pieces but few have seen the light of day. Follow her @the_enquiring_mind on Instagram to see a few.

Jessica Thompson-Carr (Ngāti Ruanui and Ngāpuhi) has a degree in English and art history and is working towards a master's. Jessica currently works as an artist under the name Māori Mermaid.

Giovanni Tiso is an Italian writer and translator based in Wellington. He is online editor of the Australian literary journal *Overland*.

Catherine Trundle is a writer, mother and anthropologist based in Wellington. She

writes flash fiction, poetry and ethnography, and experiments with unpicking the boundaries between academic and creative genres. Recent works have appeared in *Landfall*, *Not Very Quiet*, *Plumwood Mountain*, *Poetry Shelf* and *Flash Frontier*.

Chris Tse is the author of *How to be Dead in a Year of Snakes* and *He's So MASC* (Auckland University Press, 2014 and 2018). He and Emma Barnes are co-editing an anthology of LGBTQIA+ and takatāpui writers to be published by Auckland University Press in 2021. He is *The Spinoff*'s Friday Poem editor.

Iain Twiddy studied literature at university and lived for several years in northern Japan. His poetry has appeared in *Salamander*, *Cordite*, *Pedestal Magazine* and elsewhere.

Oscar Upperton's first book, *New Transgender Blockbusters*, was published by Victoria University Press in 2020. He lives in Palmerston North. This poem is an extract from his as-yet unpublished collection 'The Surgeon's Brain', which follows the life of renowned surgeon Dr James Barry.

Tim Upperton is a writer from Palmerston North. His second poetry collection, *The Night We Ate the Baby* (HauNui Press, 2014), was an Ockham New Zealand Book Awards finalist in 2016. His poems have been published in many magazines, including *Agni*, *Poetry*, *Shenandoah*, *Sport*, *Landfall* and *takahē*, and are anthologised in *The Best of Best New Zealand Poems* (2011),

Villanelles (2012), *Essential New Zealand Poems* (2014) and *Obsession: Sestinas in the twenty-first century* (2014).

Dunstan Ward was born in Dunedin and lives in Paris. His second collection of poems, *At This Distance*, was published by Cold Hub Press (2019).

Yonel Watene was born in 1989, of Māori (Ngāti Maru [Hauraki], Ngāpuhi) and Greek descent. He lives and works in Tāmaki Makaurau Auckland.

Harris Williamson is a student and amateur creative writer from Christchurch. He is currently studying English at the University of Canterbury.

Sophia Wilson's writing most recently appeared in *Love in the Time of COVID (A chronicle of a pandemic)*, *Flash Frontier*, *Australian Poetry Anthology*, *Ars Medica*, *Not-Very-Quiet*, *Intima*, *StylusLit*, *Corpus* and elsewhere, and has been recognised in various national and international competitions. She is based in Woodside, Otago.

Sharni Wilson is a New Zealand writer of fiction and a Japanese-to-English literary translator, whose work has appeared or is forthcoming in *takahē*, *Pidgeonholes*, the *Stockholm Review*, *Best of Auckland* and Asymptote's 'Translation Tuesdays'.

Anna Woods' fiction and poetry has been published in a number of journals and anthologies, including *Landfall*, *takahē* and *Poetry New Zealand*. Awarded a 2019 mentorship by NZSA, she is currently working on her first novel.

CONTRIBUTIONS

Landfall publishes original poems, essays, short stories, excerpts from works of fiction and non-fiction in progress, reviews, articles on the arts, and portfolios by artists. Submissions must be emailed to landfall@otago.ac.nz with 'Landfall submission' in the subject line.

Visit our website www.otago.ac.nz/press/landfall/index.html for further information.

SUBSCRIPTIONS

Landfall is published in May and November. The subscription rates for 2020 (two issues) are: New Zealand $55 (including GST); Australia $NZ65; rest of the world $NZ70. Sustaining subscriptions help to support New Zealand's longest running journal of arts and letters, and the writers and artists it showcases. These are in two categories: Friend: between $NZ75 and $NZ125 per year. Patron: $NZ250 and above.

Send subscriptions to Otago University Press, PO Box 56, Dunedin, New Zealand. For enquiries, email landfall@otago.ac.nz or call 64 3 479 8807.

Print ISBN: 978-1-98-859263-3
ePDF ISBN: 978-1-98-859265-7
ISSN 00–23–7930

Published by Otago University Press, 533 Castle Street, Dunedin, New Zealand.

Typeset by Otago University Press. Printed in New Zealand by Caxton.

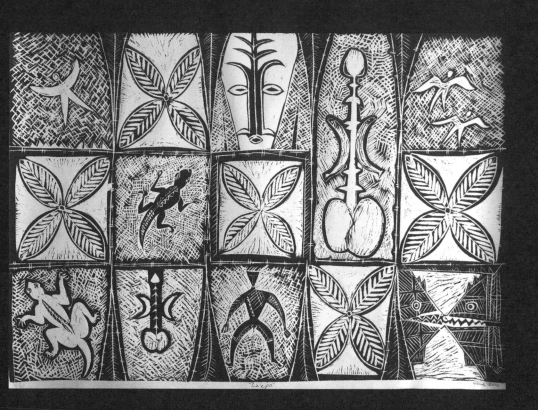

"Lā'epā"